T0367111

SPECTRUM OF
FASHION

SPECTRUM OF
FASHION

Maryland Historical Society

Baltimore, Maryland

2019

Published on occasion of the exhibition *Spectrum of Fashion*

held at the Maryland Historical Society in Baltimore, Maryland,

from October 5, 2019, to October 4, 2020

Individual orders: www.mdhs.org or 410-685-3750 ext. 377

Copyright © 2019 by the Maryland Historical Society, 201 W. Monument Street,

Baltimore, MD 21201

All rights reserved. No part of this publication may be reproduced, stored in a retrieval

system, or transmitted in any form or by any means, electronic or mechanical, including

photocopying, recording, or any information storage or retrieval system, without prior

written permission from the Maryland Historical Society.

Exhibition curated by Alexandra Deutsch, with Allison Tolman and Emily Bach, Maryland

Historical Society

Catalogue articles written by Alexandra Deutsch

Barbara Meger

Nora E. Carleson

Norah Worthington

Catalogue entries written by: Allison Tolman and Emily Bach, with Barbara Meger

Editorial board: Alexandra Deutsch, Allison Tolman, Emily Bach,

Colleen Callahan, Martina Kado

Photography by Dan Goodrich, Maryland Historical Society

Designed by James F. Brisson

Printed and bound by The Sheridan Press, Hanover, Pennsylvania

ISBN 978-0-9965944-5-5

This catalogue is dedicated to

BARBARA P. KATZ

whose generosity and encouragement

have inspired all of us who work

with this collection.

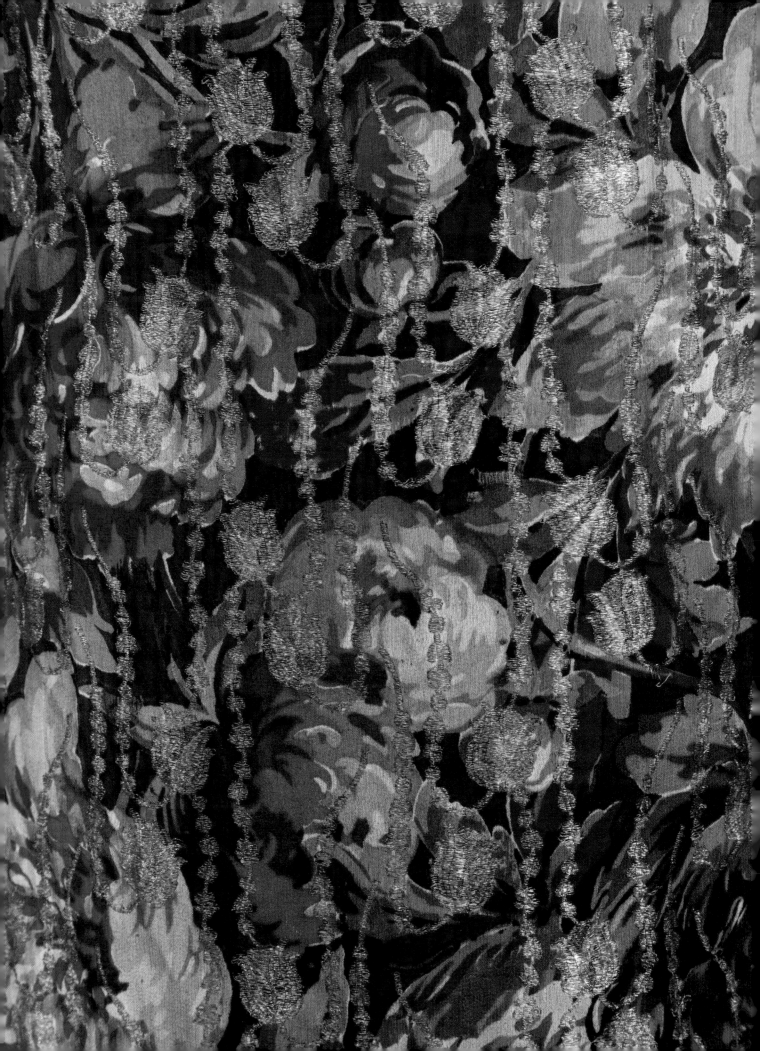

CONTENTS

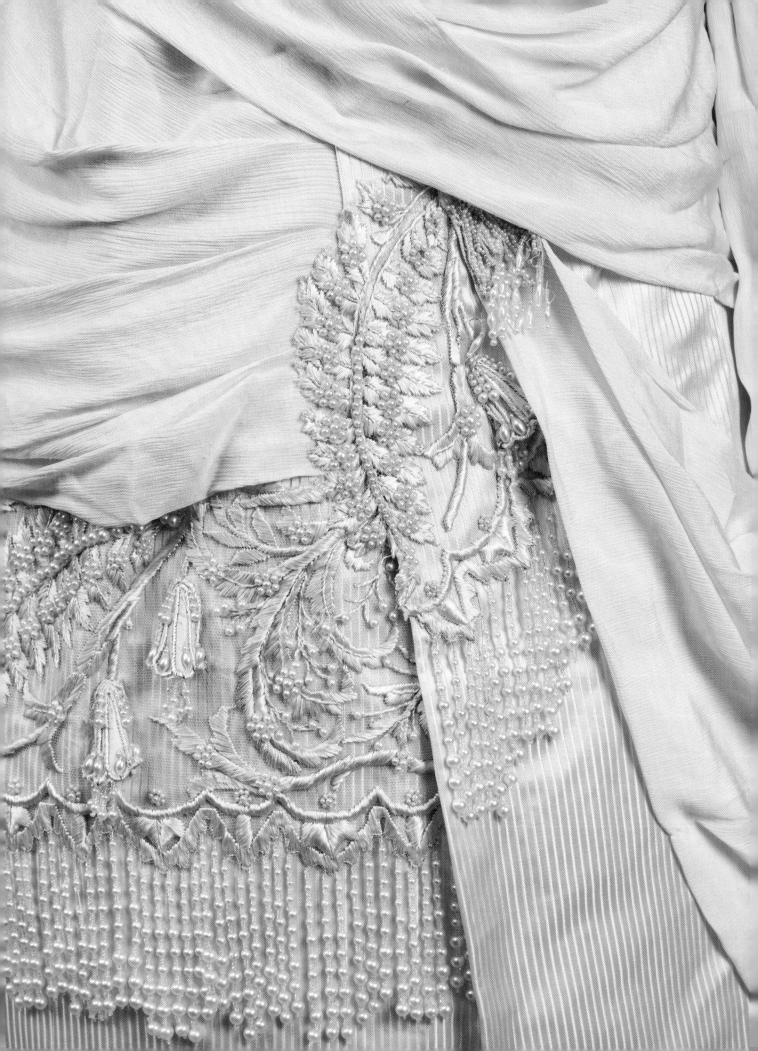

PATRONS OF STYLE

This exhibition was made possible through the generosity of:

Richard C. von Hess Foundation

Mrs. Barbara P. Katz

PNC Bank

The Helen Clay Frick Foundation

Maryland Heritage Areas Authority

Baltimore National Heritage Area

With Additional Support including the Adopt-a-Mannequin program from:

Ms. Elizabeth Benet

Mr. Richard L. Berglund

Stephanie Bradshaw, CEO, STEPHANIE BRADSHAW

H. Clay Braswell, Jr.

G. Brian Comes and Raymond Mitchener of Ruth Shaw

The Costume and Textile Specialists

Colonel John Streett Chapter, National Society Daughters of the American
Revolution

Curt Decker

Mr. and Mrs. Chandler B. Denison

Executive Alliance – A Catalyst for Women Leaders

Walt and Debbie Farthing

Mr. and Mrs. Ross P. Flax

Marguerite Mullan Greenman

Caroline Griffin and Henry E. Dugan, Jr.

Ms. Louise Lake Hayman

Mrs. Barbara L. Hecht

Mrs. Edie Hostetter Hess

Board Members of Historic Hampton, Inc.

Historic Hampton, Inc.

Margaret Allen Hoffberger

The Jane Austen Society of North America, Maryland Region

The Joseph Mullan Company

Ms. Rebecca Katz

lori k.

Mr. and Mrs. Tim Krongard

Mr. Michael Bruce Lanahan

Mr. William Wallace Lanahan III

Mr. and Mrs. Jack Donald Letzer and Allison E. Letzer

Mr. Mark B. Letzer

Mary Young Pickersgill Chapter, U.S. Daughters of 1812

Mrs. Barbara Lanahan Mauro

Mrs. Barbara Meger

Suzanne Love Merryman

Ms. Claire Miller

Dr. Richard M. and Sandra C. Milstead

Ms. Terry H. Morgenthaler

National Society of the Colonial Dames of America in the State of Maryland

Mr. John J. Neubauer

Ms. Elizabeth Nilson

Thomas and Carol Obrecht Family Foundation

Corinne Dorsey Onnen (Mrs. Ferdinand H. Onnen, Jr.)

Mr. Jeffrey C. Palkovitz

Sylvia Lee Parker

Mrs. Katherine W. Power

Mr. and Mrs. Richard C. Riggs, Jr.

The Robinson Family of Serenity Farm

Mrs. Julia Browne Sause

Nancy E. Smith

Maxine Stitzer-Hodge

Mrs. Sarah Wells Macias

Ms. Marianne D. Wells

Mrs. Nancy Wells Warder

Claire McKnew Whedbee

Hilles Horner Whedbee

Rosalie Jenkins Whedbee

The Wieler Family Foundation

Ms. Renée Wilson

The Women's Committee of Historic Hampton, Inc.

With special thanks to Barbara P. Katz who has funded our annual Fashion Archives internship program for the last four years that has led to so many amazing discoveries. With an additional thank you to Nancy E. Smith who has been a stalwart champion of the Adopt-a-Mannequin program.

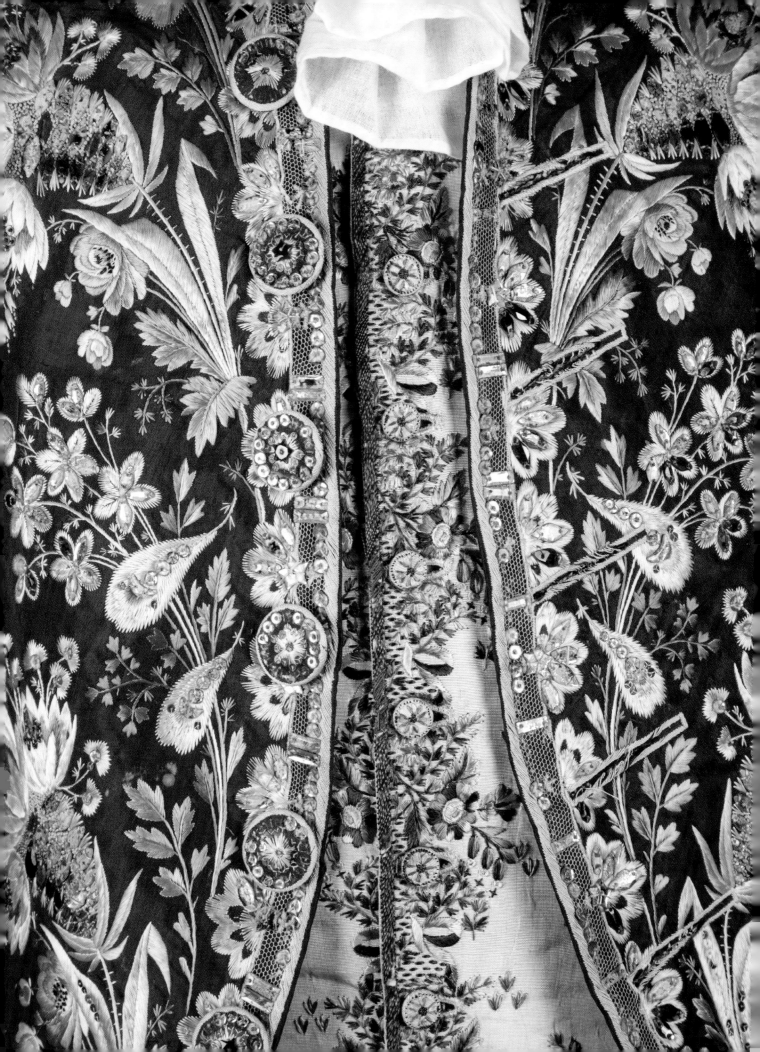

DIRECTOR'S FOREWORD

FASHION is, in the same instant, a sign of the times and timeless. One of the youngest fields in the study of material culture, costume history has illuminated our knowledge of the past for less than a hundred years. With our vast and unique collection of clothing, the Maryland Historical Society is proud to be at the forefront of such a vibrant and dynamic field. The institution's holdings number more than 14,000 garments and accessories spanning the period from 1724 to 2019. This encyclopedic collection is a treasure trove for costume historians and a remarkable source of public history.

This catalogue, which accompanies the exhibition *Spectrum of Fashion*, is by no means a complete inventory of our collection. The exhibition is a sampling of garments that allows us to study fashion through the centuries, but even more importantly it serves as a social history of the women and men who wore them: telling the story of the United States through the lens of Maryland, how we dress tells the story of how we live. The *Spectrum of Fashion* showcases close to one hundred garments that were worn by a duke and duchess, a first lady, an opera singer, a World-War-II supply driver, a nurse, an editor, a suffragist, a smuggler, formerly enslaved individuals, politicians, socialites, artists, scholars, designers, philanthropists, and many others.

A decade in the making, the exhibition and catalogue for *Spectrum of Fashion* have been an enormous undertaking. Through the generosity of former Board of Trustees Chair Barbara P. Katz, interns have been working with the collection for four summers and helping our curatorial staff both identify and preserve the material. Alexandra Deutsch has been invaluable as the visionary lead curator of the exhibition, and Allison Tolman and Emily Bach have also assisted in creating an incomparable exhibition. The Richard C. von

Hess Foundation was the main supporter of the exhibition and without them it would never have happened. Special thanks are due to Thomas Hills Cook for believing in the project and in the Maryland Historical Society. We are also grateful to PNC Bank and the Helen Clay Frick Foundation for their support of the exhibition.

Mark B. Letzer
President & CEO
Maryland Historical Society

ACKNOWLEDGMENTS

THIS EXHIBITION AND CATALOGUE would not have been possible without the help of countless individuals who have contributed in various ways to the preservation and interpretation of the Fashion Archives collection at the Maryland Historical Society. Special thanks go to Thomas Hills Cook and the Richard C. von Hess Foundation, who provided the lead gift for the exhibition, to PNC Bank, particularly Will Backstrom, and to Barbara P. Katz, who supported this exhibition and publication. Both Mr. Backstrom and Mrs. Katz have long been champions of this collection. Thanks are also due to the Helen Clay Frick Foundation and particularly Martha Frick Symington Sanger for her longstanding support.

The Adopt-a-Mannequin donors have played a key role in the support of this exhibition and their generosity allowed us to significantly expand the scope and scale of the installation. We must also thank our Adopt-a-Box donors who have supported the rehousing and preservation of the Fashion Archives collection: that rehousing effort has led to many of the discoveries seen in these pages. We are particularly grateful to the remarkable summer interns both past and present who have uncovered many previously unknown, historically significant garments in the Fashion Archives collection.

Special acknowledgement should be given to Charles Mack of Charles Mack Design and Sally Comport and Lindsay Bolin of Art at Large who designed the *Spectrum of Fashion* exhibition and guided the aesthetic inspiration for this project. Thank you to Mark Ward of PM Exhibits who, along with his team, fabricated the exhibition. Heartfelt thanks goes to the contributing authors Barbara Meger, Norah Worthington, and Nora Ellen Carleson who shared their scholarship with MdHS with an unmatched generosity and

enthusiasm. Particular thanks must go to Barbara Meger, MdHS's longtime curatorial volunteer, who has not only assisted with research for this exhibition, but has also conducted multiple conservation projects to ensure that several garments in need of stabilization could be included. Thanks are also due to volunteer Seeley Foley who undertook all the genealogical research that this exhibition and catalogue demanded and helped us make many new discoveries about the wearers of these garments. Thank you to Colleen Callahan and Newbold Richardson of the Costume and Textile Specialists who were not only consultants for this exhibition, but who, since 2008, have supported the staff's efforts to preserve this collection. We are also grateful to our colleague Dr. Karin J. Bohleke, Director of the Fashion Archives and Museum of Shippensburg University, who has been a constant source of information and guidance, and whose deft conservation has helped to transform several important garments in the collection. We are also grateful to Gregory R. Weidman, Curator, Fort McHenry National Monument and Historic Shrine and Hampton National Historic Site, who provided key information for the garments associated with the Hampton estate. Thank you also to Jim Brisson who designed this catalogue with the artistry and patience that makes him a joy to work with on any project. Thank you to Colleen Callahan who served as lead editor for this publication and who has always enthusiastically promoted the importance of MdHS's Fashion Archives collection.

I am grateful to all my colleagues who have helped to bring this exhibition and catalogue to fruition. Thank you to MdHS President and CEO, Mark B. Letzer, who always promised me that we would one day have a costume exhibition at the museum, to Allison Tolman who, in a mere four years, mastered the preservation and history of the Fashion Archives collection, to Emily Bach, whose devotion to the Fashion Archives collection has inspired all of us who work with her, to Martina Kado for her meticulous editing, to Paul Rubenson for his work installing the exhibition, and to the Advancement team—Katherine Holter, Delainey Peterson, and Clay Braswell—who have supported the Adopt-a-Mannequin and Adopt-a-Box programs. A note of special appreciation goes to Daniel Goodrich, Maryland Historical Society's Photographer, who brought the exhibition to life in the pages of this catalogue

through his masterful photography. To all those colleagues who have preceded us at MdHS, particularly Enolliah Williams, we are also eternally grateful for the work they did to preserve the collection that is now acknowledged as one of the most powerful collections at MdHS.

Alexandra Deutsch

Vice President of Collections and Interpretation

June 2019

Rediscovering and Preserving the Fashion Archives Collection at the Maryland Historical Society

By Alexandra Deutsch

THE MARYLAND HISTORICAL SOCIETY's costume collection, now known as the Fashion Archives, is a vast repository of stories told through clothing, representing Marylanders from 1724 to the present. Numbering close to 14,000 garments and accessories, it is one of the most comprehensive and diverse regional collections in the country. Founded in 1844, the Maryland Historical Society was, for over a century, one of the only institutions in the state actively collecting clothing. This early and longstanding initiative provided the foundation on which the encyclopedic Fashion Archives now stands. When cleaning out their trunks, attics, and closets, people turned to the Maryland Historical Society to preserve not only their families' clothing, but also the personal histories inherently woven into the garments.

Collections records indicate that the Maryland Historical Society began actively accepting gifts of costumes and accessories at the end of the nineteenth century. At that time, early examples of clothing and accessories for women, men, and children began to enter the collection, particularly examples dating from the colonial and federal eras. By the 1940s, costume was acquired annually and the collection began to grow exponentially. To date, the MdHS has purchased very few garments for the collection, the vast majority having been gifted by members of the community.

By the 1970s, the Maryland Historical Society regularly exhibited the costume collection in the rooms of its then headquarters, the historic Enoch Pratt House, located at 201 West Monument Street. Within these rooms, depart-

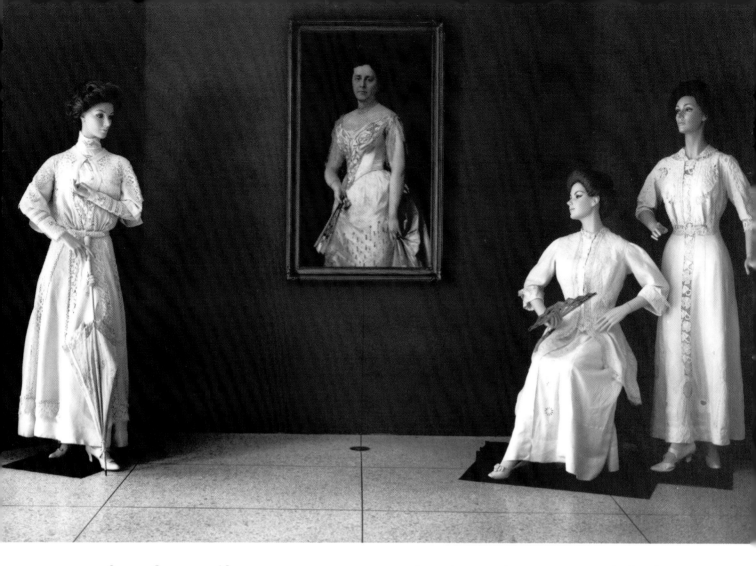

Summer Costumes and Paintings of Scenes in Maryland exhibition, photograph from 1978, Maryland Historical Society.

ment store mannequins dressed in period garments surrounded by decorative and fine arts created compelling vignettes. The *Baltimore Sun* continually reported on these popular installations. In 1970, the MdHS mounted *In and Out of Fashion, Costumes and Customs 1750–1959 and Beyond*, an exhibition that included department store mannequins donated by Hutzler Brothers and Stewart and Company. Posed in the rooms of the Enoch Pratt House, each form engaged in various activities, from an elegantly attired lady riding in an eighteenth-century sedan chair to a gaggle of 1920s flappers gathered around abathtub—a reference to the "bathtub gin" associated with Prohibition. That same year, Eugenia Calvert Holland, who served as Assistant Curator at the MdHS, noted that museum staff "were obliged to remove the bright lipstick and nail polish and adjust the posture of some."[1] A small publication complemented the installation, composed entirely of line drawings of a selection of the costumes on view.

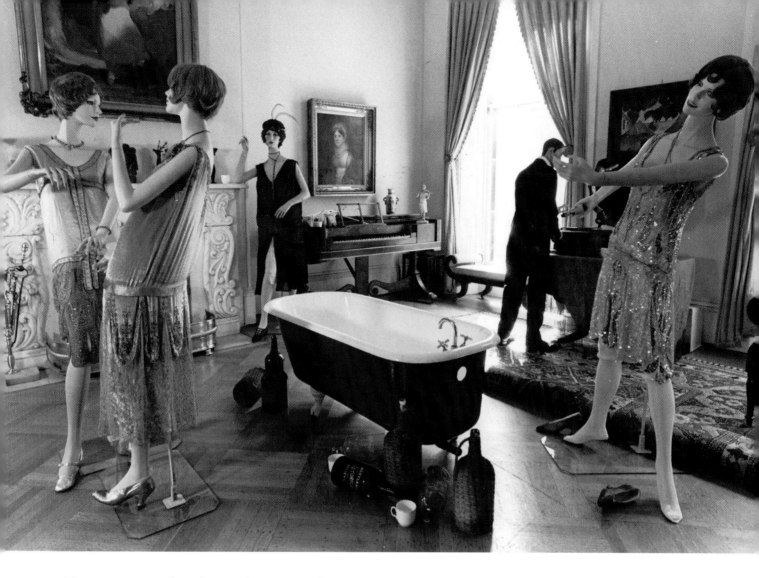

The organization of a collection this vast was first undertaken by Enolliah Williams (known as "Miss Nola"), the museum's gallery assistant from 1959 until her retirement in 1985. With the support of Holland and, later, Director Romaine Somerville, Williams masterminded a meticulous storage and record-keeping system for the collection, cleverly utilizing the institution's limited resources. When speaking of the collection's early days, Somerville recollected visiting the Metropolitan Museum of Art in New York and viewing its costume storage. She remarked how she "felt quite hopeless after seeing their storage and knowing how we could never achieve that at the Society." Despite this, Somerville pushed forward, purchasing as many acid-free boxes as she could for Miss Nola. "She was a very hard worker, very diligent, a very organized person," Somerville added.[2] These admirable characteristics are evident to the staff who now work with the collection. Despite the lack of resources, Williams gathered cabinets, installed shelving units, repurposed file

"Bathtub Gin Party, 1928," from the exhibition *In and Out of Fashion, Costumes and Customs 1750–1950,* photograph from 1978, Maryland Historical Society.

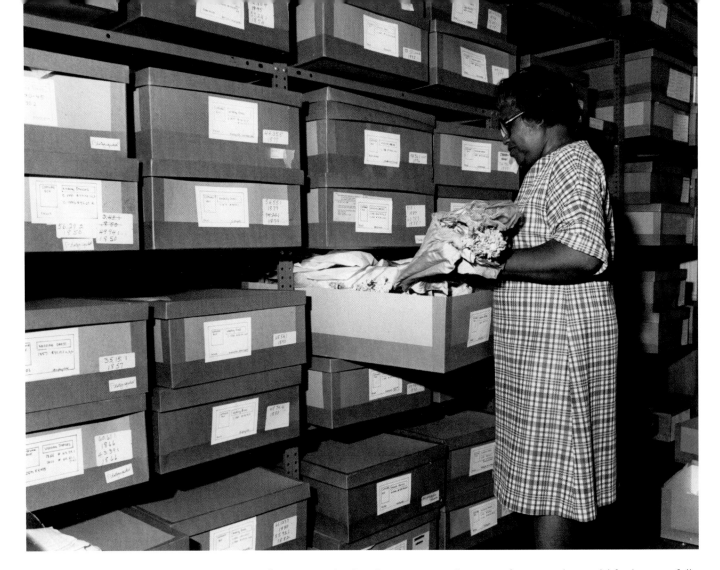

Enolliah Williams meticulously packs
and organizes the costume collection
in repurposed shelving units.

drawers, and utilized every piece of storage furniture she could find to carefully
pack away the collection. For each garment and accessory, she meticulously
recorded pertinent details on blue index cards, noting any condition issues,
providing its measurements, listing its exhibition dates if previously displayed,
identifying any corresponding accessories worn with a piece, and document-
ing the object's history and provenance. Undeterred by the lack of funds,
Williams's scrupulous system of organization made the more recent efforts of
rehousing and preserving the costume collection possible. With her blue cards,
carefully numbered boxes, and keen sense for organization, Williams ensured
a lasting legacy for the collection.

By the late 1980s, the Maryland Historical Society began to be famous
for a different collection of textiles. The Baltimore Album Quilts and samplers
were internationally known and began to draw attention away from the
costume collection, resulting in fewer and fewer installations that included

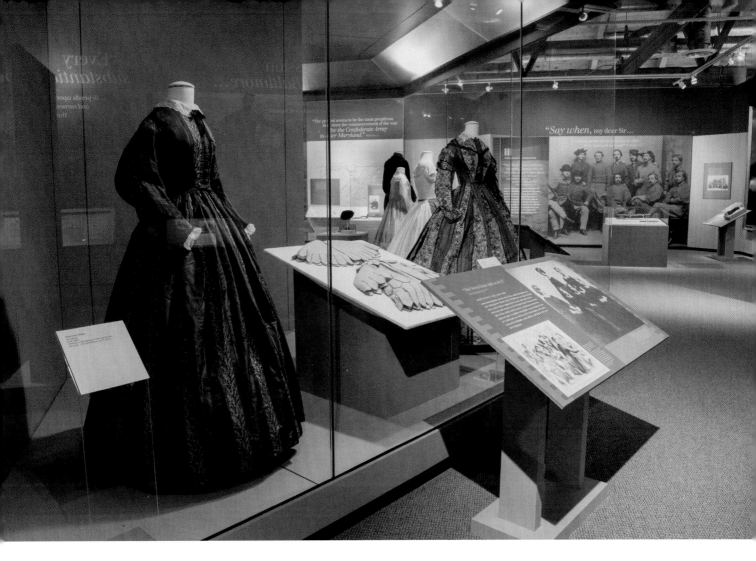

Divided Voices: Maryland in the Civil War exhibition, 2009, Maryland Historical Society.

clothing. There were a few exceptions, including an exhibition featuring the work of Frederick-born designer Claire McCardell in 1998, titled *Claire Mc-Cardell: Redefining Modernism*, and an installation displaying the Duchess of Windsor's clothing in 1999, entitled *Wallis: Duchess of Windsor*. Both gained national attention because of the iconic women they highlighted, yet due to shifting institutional priorities by the turn of the millennium, costume no longer garnered attention as it had in the past.

In 2008, the collection languished in the Enoch Pratt House, much of it untouched since the days when Williams first packed it away into storage. Recognizing the power of costume in a museum setting, resurrecting the collection became a curatorial priority. An immediate challenge emerged because the digital collection management system, which identified and tracked the rest of the MdHS's collection, had not included the costumes. Thankfully, Williams's blue index cards proved to be a roadmap to the collection and,

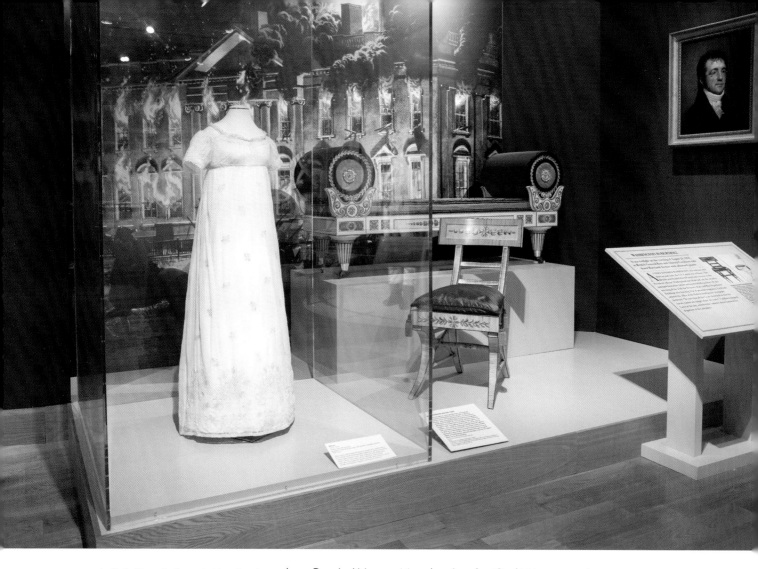

In Full Glory Reflected: Maryland during the War of 1812 exhibition, 2009, Maryland Historical Society.

when *Divided Voices: Maryland in the Civil War* opened in 2011, costume once again served an integral role in an exhibition. Rare and nationally significant examples of both Union and Confederate uniforms, coupled with examples of women's and children's clothing, found a place beside the museum's exceptional collection of Civil War-related objects. Inspired by the public's positive response, costume was again used in the 2012 exhibition *In Full Glory Reflected: Maryland during the War of 1812*, showcasing notable federal-era clothing. That same year, the curatorial staff, with the help of longtime volunteer and needlework expert Barbara Meger, began a multi-year analysis of the clothing, accessories, and lace associated with Elizabeth Patterson Bonaparte, the Baltimore-born woman who in 1803 married Jérôme Napoléon Bonaparte, Napoléon's youngest brother. The exhibition *Woman of Two Worlds: Elizabeth Patterson Bonaparte and Her Quest for an Imperial Legacy* in 2013 not only shared examples of Elizabeth's clothing and accessories with the public, but

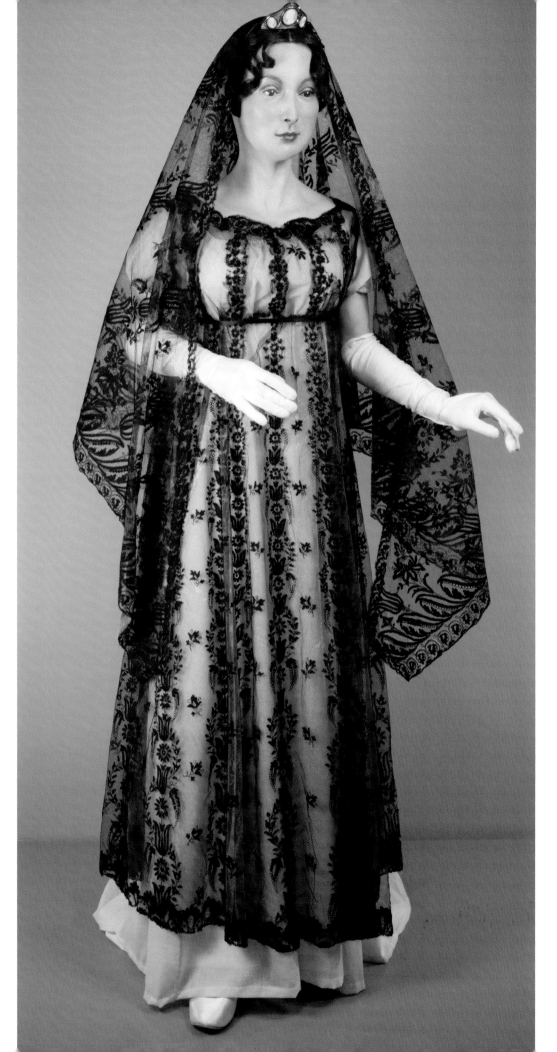

Lace over-dress and mantilla, given to Elizabeth Patterson Bonaparte by Jérôme Napoléon Bonaparte, with reproduction underdress, 1805, French.

Maryland Historical Society, Gift of Mrs. Charles J. Bonaparte, xx.5.162

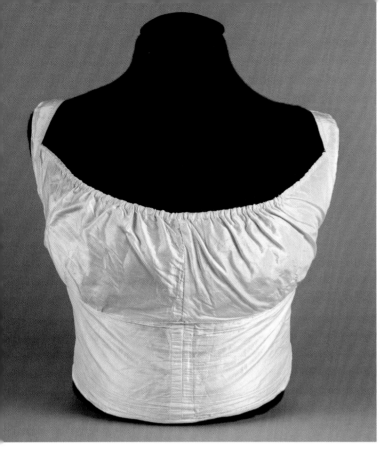
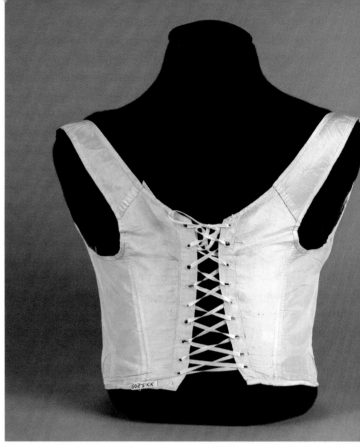

Silk corset worn by Elizabeth Patterson Bonaparte, 1800–1810, possibly French.
Maryland Historical Society, Gift of Mrs. Charles J. Bonaparte, xx.5.209

the preparation for the installation and its subsequent publication by the same name led to rare discoveries. Those findings included the extraordinary lace gown and matching mantilla given to Elizabeth by Jérôme in 1805, as well as a very early, unboned silk corset dating between 1803 and 1805 that had previously been thought to be a fabric scrap.

As attention for the costume collection grew, so too did the need to assess and preserve it. Although the garments and accessories were often found in surprisingly good condition, despite their long residence in the non-climate-controlled Pratt House, it became evident that a complete rehousing in conservation-grade materials and comprehensive digital cataloguing was necessary for preserving the collection in perpetuity.

The greatest leap forward for the collection arrived in 2015 when Barbara P. Katz, Maryland Historical Society's first female Chair of the Board of Trustees and champion of the costume collection, sponsored stipends for three summer interns, who devoted ten weeks to rehousing and cataloguing the collection. Guided by strategies employed by The Costume Institute at the Metropolitan Museum of Art and the Philadelphia Museum of Art, methods of storing the costumes and accessories were developed. The first group of interns processed

"Fifty Years of Bathing," from the exhibition *In and Out of Fashion, Costumes and Customs 1750–1950*, photograph from 1978, Maryland Historical Society.

and photographed almost 800 garments and conducted primary research on selected pieces, helping the MdHS launch its first blog devoted to historic clothing. Four years later, thanks to Mrs. Katz's unstinting generosity, the internship continues to fund interns each summer. In 2015, the museum also launched the Adopt-a-Box program, an initiative that allows patrons to sponsor a box and all the materials required for proper archival storage. Both the summer internship program and the Adopt-a-Box project have enabled the museum staff, interns, and volunteers to process several thousand garments. Such a reinvigorated preservation effort has led to numerous and exciting discoveries, a selection of which is highlighted in the *Spectrum of Fashion* exhibition. In fact, some of the greatest discoveries in the collection were made because of the careful research done by summer interns.

In 2018, the announcement of the Richard C. von Hess Foundation's providing the lead gift for this exhibition marked a turning point for the Fashion Archives. It promised the broader public an opportunity to learn about the holdings' depth and breadth on a scale never attempted before at the Maryland Historical Society. The Adopt-a-Mannequin program, launched in 2018, has supported the exorbitant expense to custom-carve each form to suit the period garments and complete the conservation needed to stabilize them. It allows patrons to sponsor a specific piece or person in the exhibition to which they connect. To bring the *Spectrum of Fashion* exhibition to fruition marks the culmination of a decade-long dream that began for the staff in 2008 when our eyes first scanned the hundreds of untouched costume boxes in the Pratt House. From livery worn by formerly enslaved men Tilghman Davis and Tom Brown at the Hampton estate in Towson to a Givenchy gown worn by the Duchess of Windsor, the Fashion Archives' holdings tell a spectrum of stories.

This catalogue, made possible through the generosity of Mrs. Katz and PNC Bank, marks the first full-color publication devoted to the Maryland Historical Society's costume collection, a significant milestone for the institution.

The essays by Nora Carleson, Barbara Meger, and Norah Worthington embody this exhibition's theme that focuses on the "spectrum," or diversity of powerful and captivating stories that costume reveals. From Carleson's essay delving into the life of Baltimore designer Lottie Barton and her important

contribution to the history of couture in Maryland, to the newly discovered livery identified by Norah Worthington, to the fresh perspective on Claire McCardell offered by Barbara Meger, this publication powerfully illustrates that the Maryland Historical Society's Fashion Archives is as varied and compelling as the individuals it represents.

Fashion exhibitions uniquely humanize history by bringing the stories of the people who wore the clothing, and the world they inhabited, to life. *Spectrum of Fashion* is an array of stories about real people who shaped the history of Maryland, as well as that of the United States. It is a testament to the power of clothing as a document of not only the past, but also the present. As the Fashion Archives collection continues to grow with the acquisition of pieces by Maryland-born designers like Bishme Cromartie, Christian Siriano, Jody Davis, and Ella Pritsker, it is a reminder that institutions must not only collect historic garments, but also fashions of the present. It is only through thoughtful and active engagement that a collection can be both relevant and inclusive. The *Spectrum of Fashion* exhibition is a testament to the power of this collection that has yet to be fully tapped through publications and exhibitions in the future.

NOTES

1 Gabrielle Wise, "Historical Society's Costumes Span Two Centuries of Nation's History," *Baltimore Sun*, June 2, 1970.
2 Phone interview with Romaine Somerville, former Director of the Maryland Historical Society, June 4, 2019.

Claire McCardell— Maryland's Legacy to Fashion

By Barbara Meger

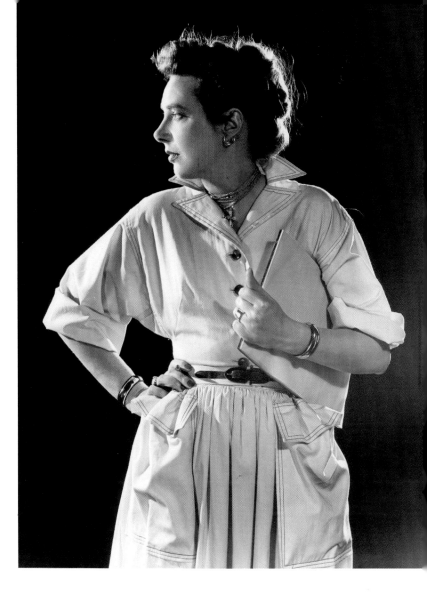

Claire McCardell holding notepad and pencil with white collared dress.

Photograph by Wynn Richards, Maryland Historical Society, H. Furlong Baldwin Library, PP238.04.21

TODAY, COMFORT IN OUR CLOTHING is something we take for granted. We do not give a second thought to jamming our cell phone into a convenient pocket, donning a pair of leggings and putting on a pair of simple flats to start our day. Without Frederick, Maryland-born Claire Mc-Cardell, our clothing choices and, thus, our lives would be much more complicated. Outside the world of fashion, however, her name is now virtually unknown. Maryland can proudly claim her as one of the most influential ready-to-wear designers of the twentieth century. McCardell is credited with creating the practical, comfortable, and common-sense "American Look": a legacy which continues to be vital and relevant in twenty-first century fashion.

Born in 1905, from an early age Claire McCardell became interested in fashion, watching the family seamstress and cutting paper dolls from her mother's magazines. Unable to persuade her parents to support her chosen career, she initially attended Hood College in Frederick, Maryland, as a home economics major. Two years later, in 1926, she enrolled at New York's Parsons School of Design to study fashion design. Further education took her to Paris, where she studied the work of the couturiers of the day. A particular favorite was Madeleine Vionnet, whose bias cuts and sense of construction greatly influenced McCardell's own designs. After returning to New York and gradu-

ating from Parsons, McCardell worked at odd jobs including a stint at painting rosebuds on lampshades before landing a position in 1931 for the mid-market dress manufacturer Townley Frocks. She began as a model, then an assistant designer, and in 1940, she was designing for the company under her own label: Claire McCardell Clothes by Townley.

In the 1930s, it was customary for American designers and manufacturers to travel to Europe twice yearly to sketch and bring back the latest French fashion designs for their American customers. McCardell, however, paid more attention to local and street fashion when she traveled abroad, and returned

Figure 1. White cotton *piqué* and lace dress, 1952, designed by Claire McCardell, worn by Claire McCardell's sister-in-law, Mrs. Phyllis McCardell.

Maryland Historical Society, Gift of Mr. and Mrs. Adrian McCardell, 1977.68.1

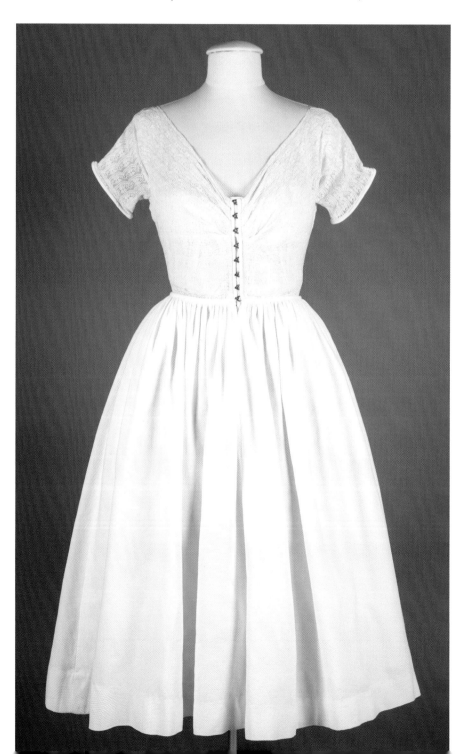

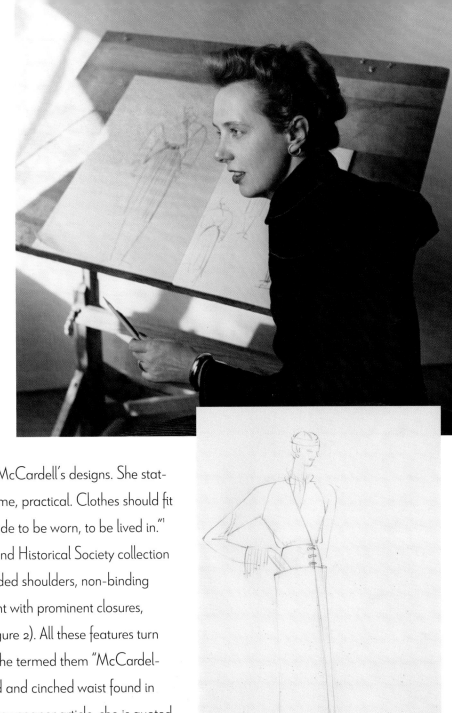

Claire in front of drawing board.
Photograph by June L. Dahl-Wolfe, 1958, Maryland
Historical Society, H. Furlong Baldwin Library,
PP238.06.003

with fresh ideas to incorporate into her own designs. One such example is the metal buckles and fasteners she found on professional ski equipment: many of her designs feature prominent metal fastenings. Certainly these elements served a function, making it easier to get into and out of the garment, but they were also design features. McCardell could make humble hooks and eyes look anything but utilitarian, as seen on the white *piqué* and lace dress shown in Figure 1.

Ease and comfort are staples of Claire McCardell's designs. She stated: "Clothes should be comfortable, handsome, practical. Clothes should fit the individual and the occasion. They are made to be worn, to be lived in."[1] An undated (about 1931) sketch in the Maryland Historical Society collection from very early in her career shows soft rounded shoulders, non-binding raglan sleeves, a wrapped asymmetrical front with prominent closures, and pockets incorporated into the seams (Figure 2). All these features turn up time and again in McCardell's designs: she termed them "McCardellisms."[2] McCardell rebelled against the fitted and cinched waist found in 1950s' styles of Dior's "New Look." In a 1954 newspaper article, she is quoted as saying: "I am not in favor of any silhouette that compresses the figure, either in the waistline, hipline or the bosom. I think real fashion is always a design that lets the natural figure show to best advantage."[3] Earlier, in 1938, she had introduced a dress design that has come to be called "the Monastic" because of its similarity to clerical cassocks. The design flowed straight from the shoulders without waist definition and it was left to the wearer to belt wherever and as tightly as she pleased. Such adjustability was integral to the majority of McCardell's designs. The pumpkin and black rayon *faille*

Figure 2. Sketch by Claire McCardell, c.1931.
Maryland Historical Society,
Gift of Robert McCardell, 1998.43.15

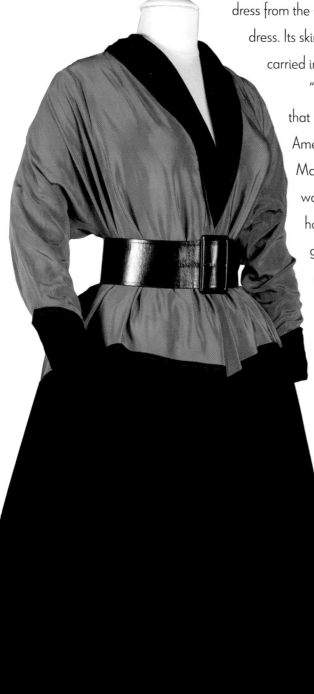

Figure 3. Pumpkin and black rayon *faille* trapeze-style Monastic dress, cinched by a coordinating leather and fabric sash, Claire McCardell Clothes by Townley.

Maryland Historical Society, Gift of Center Stage, 1998.10a-c

dress from the 1950s shown in Figure 3 is a later interpretation of the Monastic dress. Its skirt flares from the hip creating a trapeze silhouette, a look which carried into the 1960s.

"I've been really selfish about designing. I've made clothes that I'd like for myself, and I guess that I'm lucky that lots of other American women feel the same way about my clothes," said McCardell in a 1947 radio interview.[4] An avid skier and outdoorswoman, McCardell began incorporating hoods—"Superman" hoods," as she called them—into her own sweaters and other garments as early as 1942. They were practical, eliminating the need for a hat, and they were comfortable. Hoods became a design feature of her Monastic dress, jersey tops and dresses, evening gowns, and even a bridal gown. Today, "hoodies" are common streetwear seen everywhere.

Pockets are another signature feature in most McCardell designs, even in evening gowns. She noted, "I hardly ever make a skirt without pockets because I noticed that men always look so happy with their hands in their pockets. So I thought, 'why shouldn't women have pockets too.'"[5] Most of her pockets are hidden in side seams, but others are focal points of the garment, such as the breast pockets inserted into the front shoulder dart seams of her black and tan raincoat in Figure 4.

This same raincoat, dated to 1949, illustrates another "McCardellism" that we overlook today because it is everywhere. Denim blue jeans had been around since the 1870s, thanks to the combined efforts of Jacob Davis and Levi Strauss. The jeans' ruggedness and durability are credited to added metal rivets on the pockets and double-stitched seams. McCardell took the double-stitching, traditionally stitched in a contrasting color thread, and not only used it for the strength it added to seams and edges, but turned it into a design feature. She coordinated and contrasted the thread color with other parts of the garment, making the double-stitching an accent or focal point for her designs, as illustrated in Figure 5, a detail of Figure 4.

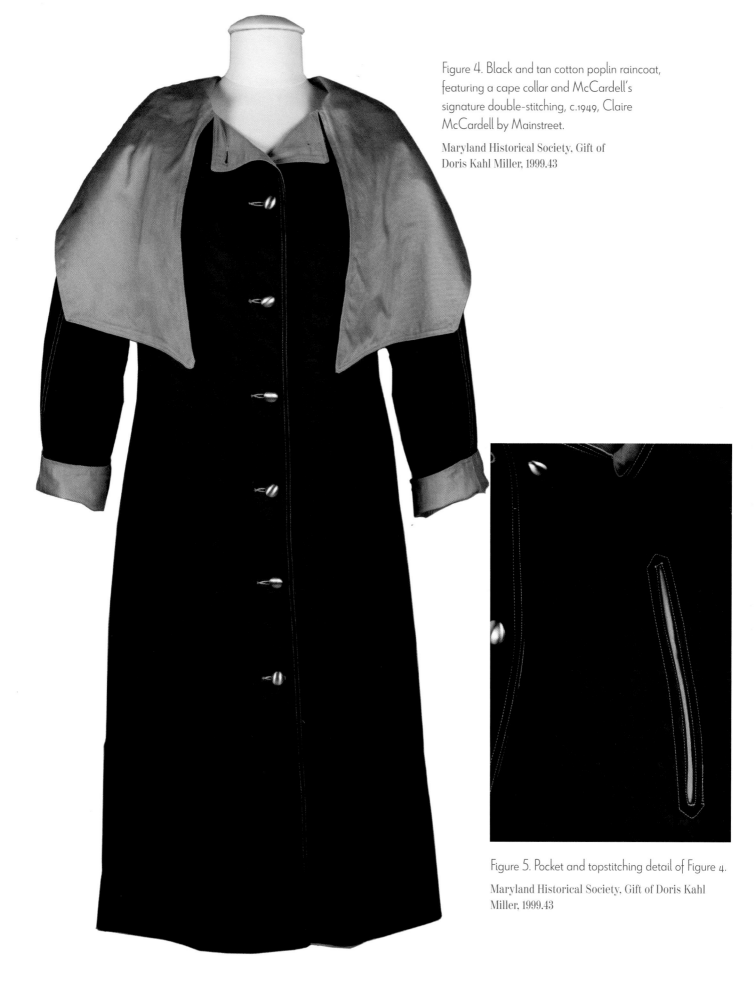

Figure 4. Black and tan cotton poplin raincoat, featuring a cape collar and McCardell's signature double-stitching, c.1949, Claire McCardell by Mainstreet.

Maryland Historical Society, Gift of Doris Kahl Miller, 1999.43

Figure 5. Pocket and topstitching detail of Figure 4.

Maryland Historical Society, Gift of Doris Kahl Miller, 1999.43

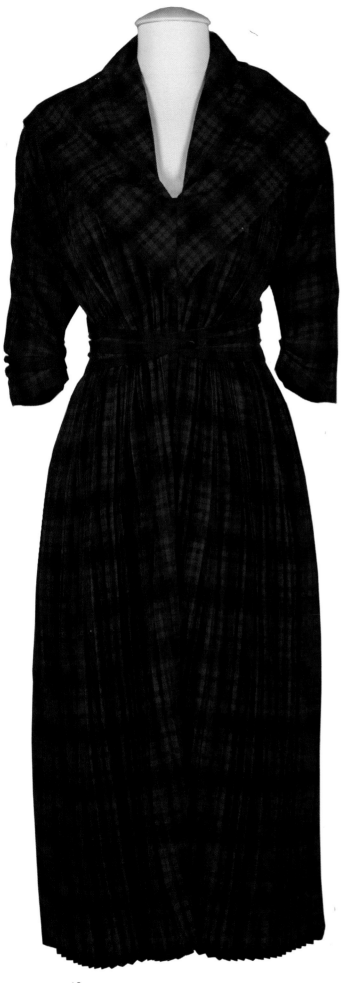

Toward the end of World War II, a commercial heat process was developed to permanently pleat fabric. At last, the general public had access to fabrics which mimicked the pleated silk Delphos gowns produced using a secret method by Spanish designer Mariano Fortuny at the beginning of the twentieth century. McCardell was quick to pick up on this new capability. In an undated (probably spring of 1950) review of Townley Frocks' collection, a Maryland newspaper reported: "Pleats are the main story for spring, Miss McCardell believes, and she offers them in versions never seen before. . . . 'Don't worry about the cleaning problem,' she assures us. 'The pleats are permanently pressed into the fabric. They won't come out when dipped in cleaning fluid and they do not need to be pressed separately.'"[6] Indeed, several garments in the MdHS Fashion Archives, including the red and black wool plaid dress in Figure 6, showcase this trend.

Wrap-front dresses have become ubiquitous as a garment to easily get into and fasten to one's own comfort. The late Diane Von Furstenberg is often given credit for inventing the style because of her 1970s' bestselling version, but Elsa Schiaparelli came up with an apron-based design in 1930, followed by Claire McCardell's "Popover" in 1942. McCardell had been tasked by the editors of *Harper's Bazaar* to come up with a comfortable garment suitable for the busy schedules

Figure 6. This 1948 wool dress illustrates one of many evolutions of the Monastic dress. In the late 1940s, McCardell began using commercially permanently pleated fabrics for her designs. This dress is a pinnacle example of her technical design skill: a triangular collar inserted into the slashed-front opening, a self-belt attached at the back, and push-up three-quarter length sleeves with added gussets for wearing ease.

Wool Dress, 1948, designed by Claire McCardell, worn by Claire McCardell (1905–1958).

Maryland Historical Society, Gift of Mr. and Mrs. Adrian McCardell, 1977.68.5

This dress is exhibited through the generosity of Walt and Debbie Farthing.

of housewives and mothers whose duties had increased with the onset of World War II. McCardell looked to herself for inspiration: "First of all I am a woman. Quite secondary, I am a designer. . . . Most of my ideas come from trying to solve my own problems. . . . I need a dress that can cook dinner then come out and meet the guests."[7]

The original Popover dress, which sold for an affordable $6.95, was made up in denim and even had a matching oven mitt. It was an immediate success, earning an honorable mention at the fashion industry's Coty Awards for that same year. The Popover was offered by retailers, including Lord & Taylor and Best & Co., for years because it took on many forms and was made up in various fabrics, including the green and black cotton plaid version shown in Figure 7. This dress showcases another of McCardell's strengths—her ability to engineer plaids and stripes into intricate patterns that served as integral components of the overall design, also seen in the red and black plaid dress in Figure 6. It is said that necessity is the mother of invention. Around the same time McCardell introduced the Popover, she was confronted with the rationing of leather needed for soldiers' shoes during World War II. When she could not obtain suitable footwear to coordinate with her designs, McCardell discovered that ballet slippers did not fall under the rationing restrictions, so she took to covering the slippers with fabrics to match or coordinate with her garments. She contacted Capezio, the major manufacturer of ballet slippers, and asked the company to add soles to their shoes. Capezio began producing a line of simple leather flats with McCardell's design input and the ballet flats were a huge success. Flat sole shoes made sense "to accompany her inventive clothes for the active woman."[8] By the 1950s, ballet flats had become the favored footwear of both the ingénue and the beatnik. They were resurrected in the late 1980s, due in part to frequent photographs of Diana, Princess of Wales, wearing them.[9] Today, most women have at least one pair of flats, if not more, in their closets.

Figure 7. Green plaid cotton Popover dress features bias-cut bodice manipulated so that neckline and sleeve edges are cut on grain, 1950s.

Maryland Historical Society, Gift of Nancy Ackler, 1998.30.2ab

Dancers, gymnasts, and circus performers had worn leotards since the late nineteenth century, but it was Claire McCardell who, in 1943, introduced the leotard into mainstream fashion. Her version was an all-in-one wool jersey sweater and tights combination to be worn alone or to layer under other garments. Featured on the September 13, 1943, cover of *Life*, they were referred to as "funny tights."[10] Another article from an undated and unknown periodical in the MdHS H. Furlong Baldwin Library manuscript collection notes, "The new one-piece *leotites* . . . fit like a second skin. . . . Designed not only for dance classes but to wear under skirts, shorts and kilts on college campuses and in the country."[11] In a 1971 tribute, the *Washington Evening Star* credits McCardell as "the first to put women in leotards and pose other clothes over them. It was the prelude to layer dressing as we know it today."[12] Now, nearly fifty years since that article was written, we are still layering skirts and oversized tops over bodysuits and leggings.

McCardell's own comfort and practical mindedness led to her creation of separates. Weary of packing cumbersome trunks with multiple outfits for trips to Europe, she came up with a wardrobe of wool jersey knit separates that could be rolled and tucked into a single suitcase. It would be some years before this interchangeable wardrobe would catch on, but it has become a staple and now forms the basis for American sportswear.

In 1954, Time Inc. named McCardell to an advisory panel for the creation of a magazine that would become *Sports Illustrated*. McCardell wrote in an insert article to the premier issue, "Women Are What They Wear": "Sports clothes changed our lives because they changed our thinking about clothes. Perhaps they, more than anything else, made us independent women."[13] Two years later, along with Rudi Gernreich, McCardell was presented with *Sports Illustrated*'s 1956 American Sportswear Design Award, which acclaimed McCardell as "the leading innovator of women's sports clothes in America . . . the leading prophet of the American look—the look of long, lean ease that makes them the best-dressed women on beach or field."[14]

McCardell's influence on fashion was having an effect, and it was recognized. Diana Vreeland, then fashion editor at *Harper's Bazaar*, wrote in a letter to McCardell, "It is the most curious thing as I look at the French dresses

in 1956 I recognize so many of the dresses you made in 1946 and so do many other people. You thought of everything that was delicious and fun and full of style as an idea, and we really do appreciate it."[15]

For Claire McCardell, the function of each of her designs dictated the form it was to take, from the Monastic to the Popover to her leotard. She was featured on the cover of *Time* on May 2, 1955, and said in an accompanying article, "Clothes may make the woman, but the woman can also make the clothes. When a dress runs away with the woman, it's a horror."[16] During McCardell's career, the majority of big name couturiers were men: Christian Dior, Cristóbal Balenciaga, Jacques Fath, Emilio Pucci, to name a few. In fact, as noted by the late-twentieth-century fashion designer Christian Lacroix, "Male couturiers in particular have always been more inspired by a fantasy image of femininity than by the structure and function of a piece of clothing designed to comfortably fit a body, serving it rather than subjugating it."[17]

Responding to a statement in the *New York World Telegram* by Fath who claimed, "Women are bad fashion designers, . . . the only role a woman should have in fashion is wearing clothes," McCardell said, "'Ah Men'—They never understand the way clothes feel—Their lines are often harsh and masculine. . . . Men designers all must go to a woman for final judgment. She may be a model—she may be a premier—she may be a wife. There is always a woman behind the thrown [*sic*]. Some day [*sic*] all designers will be women. Men, I hope, will be busy with masculine things."[18]

As a woman, McCardell instinctively knew how to incorporate what she felt was comfortable, appropriate, and functional into her designs. Fortunately, the garment industry caught on. A retrospective article on McCardell that appeared in *The New York Times* in 1981 is still relevant in 2019: "The designer . . . made clothes that not only met the needs of her time but also look right today. The rest of the fashion world has caught up with her once-revolutionary insistence on clothes that are primarily comfortable and nonrestrictive, made of natural fabrics and follow and enhance the lines of the body. They do not scream 'look at me,' and consequently transcend ephemeral fashion, achieving permanence as style."[19]

Sadly, we will never know what else McCardell might have bequeathed to the world of fashion; she died from colon cancer at the height of her career in 1958, at the age of 52. In letters of condolence that came to the family, hers was a loss that her fellow designers noted. Rudi Gernreich wrote, "she will join the few who have stepped into the realm of the legend."[20] From Emilio Pucci, "I have always admired her work immensely, and felt for her a sincere admiration. I know that her disappearance has deprived the world of one of its very great designers of all time."[21]

In its June 1958 article, "A Tribute to Claire McCardell," *Harper's Bazaar* noted that "she gave American fashion its truest expression." In the same article, the magazine noted it had recognized McCardell in 1944 as creating "a race of clothes that is inwardly, outward in the American grain. These clothes do not stem from Paris; they have their roots in our own history, our own psychology. They are related to the frugal modesty and dignity of the dresses of pioneer women, to the stitched and riveted sharpness of our workmen's overalls, to the almost abstract garb of our great escape figures of the comics: Flash Gordon, the Phantom."[22] Thank you, Claire McCardell, for giving us the embodiment of the "American Look."

NOTES

Much of the research for this essay came from the Claire McCardell Collection, 1923–1995, MS3066, gifted to the Maryland Historical Society's H. Furlong Baldwin Library by Robert and Adrian McCardell in 1998–1999.

1 Ruth Mugglebee, "McCardell's Party Dress," *Boston American*, April 2, 19–, MS 3066, Box 2, Folder 8, H. Furlong Baldwin Library, Maryland Historical Society, Baltimore.

2 Kohle Yohannan and Nancy Nolf, *Claire McCardell: Redefining Modernism* (New York: Harry N. Abrams, 1998), 40.

3 Gaile Douglas, "Dior's Line Not So Flat; Sweater Look End Is Near," unidentified newspaper clipping, 1954, MS 3066, Box 2, Folder 7, H. Furlong Baldwin Library, Maryland Historical Society, Baltimore.

4 Transcript from radio program *The Betty Crocker Magazine of the Air* from September 10, 1947, MS 3066, Box 4, Folder 6, H. Furlong Baldwin Library, Maryland Historical Society, Baltimore.

5 "Three Views of the News," photocopy of NBC script from August 24, 1947, MS 3066, Box 4, Folder 6, H. Furlong Baldwin Library, Maryland Historical Society, Baltimore.

6 "McCardell Does It Again," unidentified newspaper clipping, MS 3066, Box 2, Folder 6, H. Furlong Baldwin Library, Maryland Historical Society, Baltimore.

7 Rochelle Chadakoff, "McCardell's Popover/Designing a Fashionable Victory on the Home-
 front," *The Frederick News-Post*, November 23, 1992, MS 3066, Box 2, Folder 10, H. Furlong
 Baldwin Library, Maryland Historical Society, Baltimore.

8 Mary Trasko, *Heavenly Soles: Extraordinary Twentieth-Century Shoes* (New York: Abbeville
 Press, 1989), 63.

9 Caroline Cox, *Shoe Innovations: A Visual Celebration of 60 Styles* (Buffalo, NY: Firefly Books,
 2012), 100–102.

10 Yohannan and Nolf, *Claire McCardell: Redefining Modernism*, 68.

11 Unidentified newspaper clipping, MS 3066, Box 3, Folder 1, H. Furlong Baldwin Library,
 Maryland Historical Society, Baltimore.

12 Eleni [Sakes Epstein], "Timeless Design of McCardell and Adri," *Washington Evening Star*,
 October 27, 1971, MS 3066, Box 3, Folder 1, H. Furlong Baldwin Library, Maryland Historical
 Society, Baltimore.

13 Unidentified typescript dated April 29, 1954, MS 3066, Box 3, Folder 16, H. Furlong Baldwin
 Library, Maryland Historical Society, Baltimore.

14 Jo Ahern, "Women Are What They Wear," *Sports Illustrated*, June 4, 1956, MS 3066, Box 2,
 Folder 10, H. Furlong Baldwin Library, Maryland Historical Society, Baltimore.

15 Diana Vreeland, letter to Claire McCardell dated November 24, 1956, MS 3066, Box 1, Folder
 12, H. Furlong Baldwin Library, Maryland Historical Society, Baltimore.

16 "Fashion: The American Look," *Time*, May 2, 1955, 85–91, MS 3066, Box 2, Folder 7, H. Furlong
 Baldwin Library, Maryland Historical Society, Baltimore.

17 Christian Lacroix, Foreword to *The House of Worth, 1858–1954: The Birth of Haute Couture*
 by Chantal Trubert-Tollu, Françoise Tétart-Vittu, Jean-Marie Martin-Hattemberg and Fabrice
 Olivieri (London: Thames & Hudson, 2017), 6.

18 Private correspondence between Hope Johnson and Claire McCardell dated January 12 and
 14, 1954, MS 3066, Box 1, Folder 8, H. Furlong Baldwin Library, Maryland Historical Society,
 Baltimore.

19 Bernadine Morris, "Remembering Claire McCardell," *The New York Times*, February 20, 1981,
 MS 3066, Box 3, Folder 1, H. Furlong Baldwin Library, Maryland Historical Society, Baltimore.

20 Rudi Gernreich, letter dated March 22, 1958, MS 3066, Box 1, Folder 11, H. Furlong Baldwin
 Library, Maryland Historical Society, Baltimore.

21 Emilio Pucci, letter dated March 31, 1958, MS 3066, Box 1, Folder 11, H. Furlong Baldwin Library,
 Maryland Historical Society, Baltimore.

22 "A Tribute to Claire McCardell," *Harper's Bazaar*, June 1958, 108, MS 3066, Box 6, H. Furlong
 Baldwin Library, Maryland Historical Society, Baltimore.

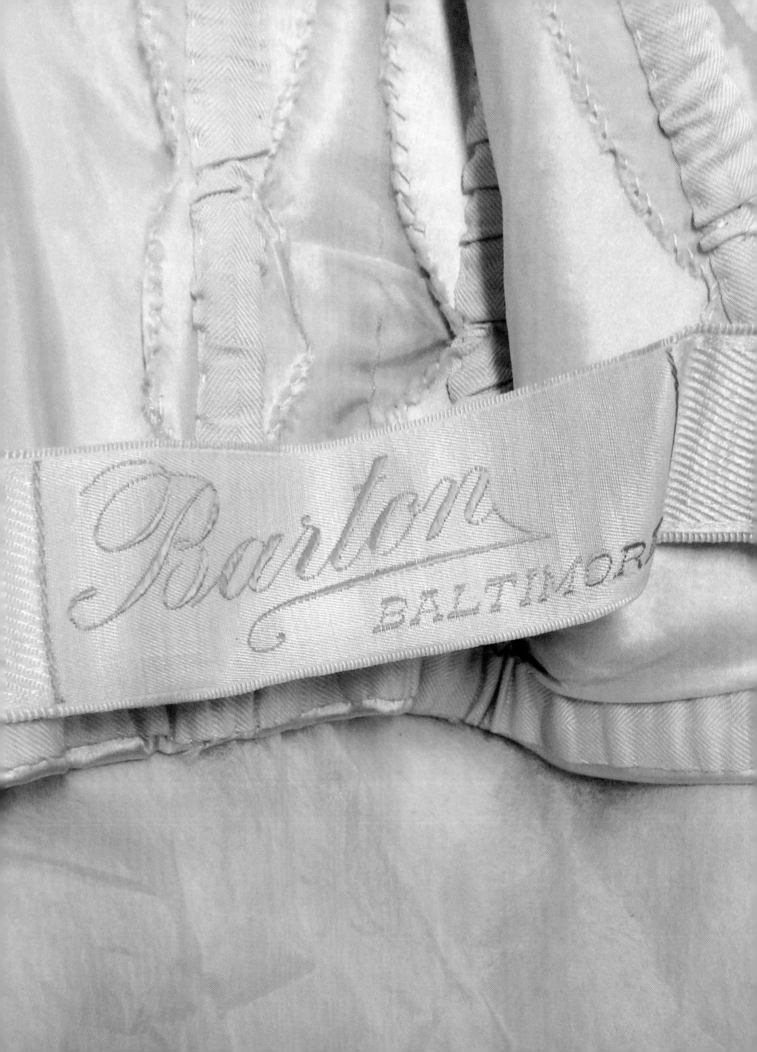

Lottie Barton, Nineteenth-Century Baltimore's Premier Modiste and Fashion Smuggler

By Nora Ellen Carleson

In March 1893, newspapers across the United States reported the sensational story of three American dressmakers detained overnight by New York Customs House officials. Though the news of dressmakers smuggling goods into the country was commonplace, the value attributed to the goods these women attempted to sneak into the United States was extraordinary. The women were detained for endeavoring to smuggle nearly five thousand dollars' worth of European couture into the United States. Among the women detained was Miss Lottie M. Barton of Baltimore.[1] Although this incident appears to be Barton's first encounter with fame at a national level, she was well-established with members of high society in Baltimore and Washington, D.C. These elite women knew Barton as an importer of stylish goods and a *modiste,* a fashionable dressmaker of the highest caliber with over twenty years of experience.

Charlotte (Lottie) M. Barton was born to Ignatius D. (1825–1903) and Mary J. Barton (1831–1895) in Baltimore, Maryland, around 1852.[2] Lottie was the eldest of five children; she was followed by Mary J., Jr. (b.1854), Clementine (b.1856), Rose (b.1861), and Frederick (b.1863).[3] Lottie's father, Ignatius, worked as an editor, newspaper reporter, and printer.[4] Her mother, Mary, although listed in multiple federal censuses as a homemaker, evidently worked as a dressmaker because Baltimore city business directories also list her, sometimes under the name "Mary J. Barton," as an established dressmaker as early as 1867.[5]

FACING PAGE: Wedding dress (label detail), Lottie Barton, Baltimore, MD, 1889.

Maryland Historical Society, Gift of Mrs. C. Stewart, 1945.45.1 a-b

As with many other families of modest means in the nineteenth century, the Bartons took boarders into their home for additional income in the 1860s. One boarder, Clementine Olmier, a French woman, lived with the Bartons for nearly thirty years, as the family climbed the social and financial ladder, even after Lottie Barton made a name for herself as a dressmaker in the 1880s and 1890s.[6] Olmier likely had a hand in shaping young Barton's life. Moreover, though Barton's younger siblings were formally educated, the future dressmaker received her education at home.[7] As Barton was home-schooled, Olmier might have taught her the French needed to successfully navigate the world of Parisian couture.

In the early 1880s, Barton began her career as a dressmaker at 206 North Howard Street in Baltimore, more than likely sharing the premises with other dressmakers or professionals. Although no garments appear to survive from this point in Barton's career, newspapers published later in her career reveal that Lottie's early designs, as well as those made in the 1890s and 1900s, reflected her regular travels to England, Brussels, and France. Barton was inspired by European fashions and, like many American dressmakers, copied the designs of French couture houses, especially those of the House of Worth. Traveling abroad not only provided Barton opportunities to discover the latest European trends, but also presented her with the opportunity to bring fashions and dress materials back to the United States.[8]

In the latter half of the nineteenth century, American dressmakers commonly copied European couture for their clients. The copying of foreign, and especially French, styles was necessary for success in cultured society, since European-style clothing was an important marker of elite taste and class. Further associating themselves with Parisian couturièr(e)s, many men and women, like Barton, took on the French moniker of *modiste*, meaning a fashionable dressmaker or one who creates clothing in the newest styles, to denote their acquaintance with French fashions. Self-defining as an American *modiste* or advertising *robes et manteaux* (dresses and coats) quickly identified Barton as superior to the majority of tailors and seamstresses. They, along with seamstresses, tailors, and embroiderers, reproduced clothing designs and ornamentation with exquisite skill and craftsmanship, despite the United States'

lack of industrial training schools found in Sweden, England, France, and other European countries. Yet, Americans did not only copy European garments. They also created their own designs inspired by the popular styles of the day, often with nods to French fashions.

Throughout the latter half of the nineteenth and first decades of the twentieth centuries, elite dressmakers like Barton and the majority of American department stores regularly acted as importers of fine foreign clothing in addition to creating their own garments.[9] They purchased European fabric, accessories, and complete garments in the hope of selling them to their American clients. Dressmakers used trim and textiles to create new garments, while complete dresses, suits, and cloaks acted as samples or stock. Samples on display allowed a customer to see a style and have a similar one made, often with personalized trimmings, fabrics, or colors. On occasion, stock garments were sold directly to clients with skilled seamstresses custom-fitting the gowns for the clients. As only the wealthiest women had the money to have made-to-measure gowns created for them at European couture houses, this service offered more women the ability to purchase European couture that appeared made just for them. When sample gowns became outdated, they were used for fabric and trimmings or sold as stock at a reduced price.

Along with the luxury of foreign textiles and garments came remarkably high import tariffs and duties. As historian Hind Abdul-Jabbar points out, beginning in the first half of the nineteenth century, and continuing well into the 1890s and beyond, importing European fashions often cost nearly fifty percent of the goods' value. Wanting to keep costs down for their clients and acknowledging society's advantageous view of them as respectable, professional women, many American dressmakers smuggled French, British, and Belgian dress goods into the United States for profit.[10] They relied on their anonymity as females, often traveling together, and their social skills derived from interaction with the social elite to avoid scrutiny from customs officials. Nevertheless, smuggling became such a common endeavor for these women that newspapers and magazines regularly reported on these incidents and published satirical cartoons of women packing trunks to the swelling point and dressed with layers of trim wrapped and hidden under their skirts (Figure 1).[11]

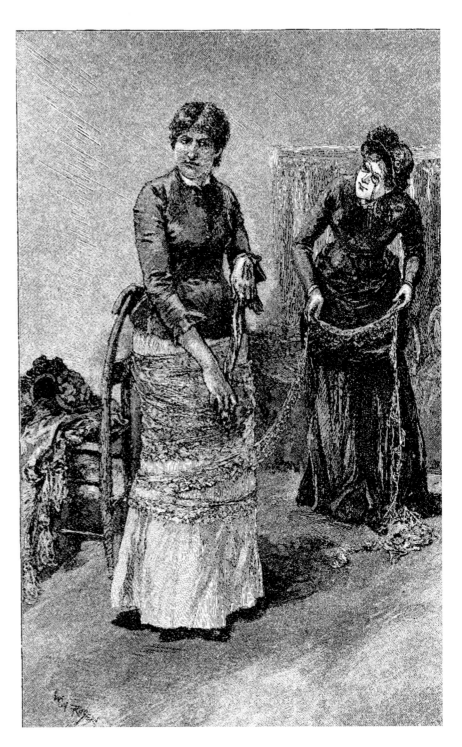

Figure 1. "Female Smuggler before and after Examination," *Harper's Magazine,* June 1871.

Newspapers had reported the lurid tales of female dress smugglers for nearly half a century when customs officials detained Barton and her cohorts in 1893. However, as Abdul-Jabbar details, by the end of the century, U.S. Treasury officers were especially attuned to monitoring American women's spending overseas, so much so that a special office in Paris was created to monitor unusual spending and report it back to customs officials in America.

With this knowledge, customs officials knew in advance whom to search upon arrival in the United States.[12] This is what might have happened when Barton arrived in New York on March 16, 1893.

The New York *Sun* reported that Miss Lottie Barton, along with fellow dressmakers Miss N. Sheehan and Miss Kate Holland, attempted to smuggle nearly five thousand dollars' worth of dress goods into the United States (approximately $142,000 worth of merchandise in today's dollars).[13] The newspaper's headline and lead read: "Tearful Smugglers Plead / Painful Plight of Collector and Surveyor / Surrounded by Weeping Milliners, They Refuse to Yield to Supplications or Sophistries and Decide to Give The Suspected Trunks Into the Hands of the Appraisers."[14] Throughout the narrative of the search and seizure, the reporter wrote regularly of the wails, pleas, and sobs of the dressmakers, "save Miss Barton."[15] Stoicism may have been part of Barton's character, or she might have encountered customs officials before and been prepared for a confrontation.

Beyond the dramatics of the seizure, newspapers stressed the extraordinary quantity of goods confiscated. Newspapers like the New York *Sun* detailed the entirety of the goods found in the women's four trunks. Of the goods seized, the majority belonged to Barton. In two trunks Barton packed:

> One blue cloth costume, one black satin cape, one lace and velvet cape and one figured silk costume by Worth, another figured silk costume, one lace and velvet cape, one pink and white lawn costume, one lace and ribbon cape, one pink silk costume, white lace trimming, one black lace dress, one silk and lace wrap, one figured silk waist, one black silk brocaded waist, one blue lawn skirt and cape, one crepe skirt, with green trimmings, twelve silk underskirts, five ladies' silk undersuits, one sealskin coat, and a collection of silk corsets, silk stockings, parasols, ladies' underwear, crucifixes, and forty-four pairs of ladies' kid gloves.[16]

All three women swore the goods found in their trunks belonged to them and were not inventory for their shops. Family members even provided testimoni-

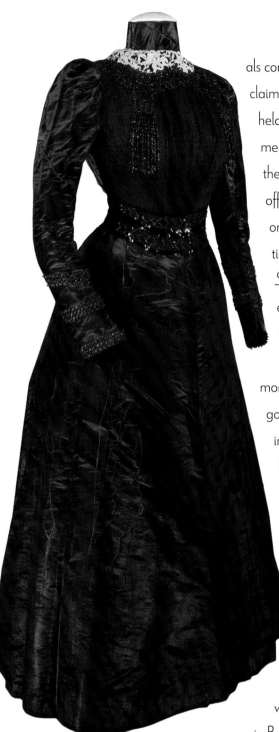

als confirming the dressmakers' good character and echoing the women's claimed innocence. Nevertheless, the United States District Attorney's office held Barton and the other women overnight to await inspection and judgment.[17] Their detainment marked "one of the most eventful afternoons in the New York Customs House in years."[18] While it is unclear whether or not official charges were brought against Barton and her fellow dressmakers, or if the Federal government seized their goods, the dressmakers' sensational story hit newsstands across the country.[19] Although the *Baltimore Sun* reported Barton's detainment, it appears to have had little to no effect on her ever-growing-status as a leading dressmaker and importer in the city.

By the late 1880s, Lottie Barton was known as "Barton of Baltimore" and women of the highest social register in the city purchased her gowns. Although few garments survive today, those that remain reflect the influential clients Barton cultivated. The Fashion Archives of the Maryland Historical Society has two gowns documenting Barton's Baltimore customers: an 1899–1902 dinner dress worn by Mary Anna Jenkins Cromwell Riggs (Figure 2) and a 1900 wedding dress worn by Elizabeth Lee, née O'Donovan. Both gowns embody high fashion designs of their day and are masterfully crafted with fine ornamentation and opulent silks.

Throughout the 1880s and 1890s, Barton of Baltimore expanded her enterprise rapidly. Though Barton did not promote her business in newspapers, she advertised it in Baltimore's coveted *Blue Book*, which published the lineages, addresses, and history of elite families in Baltimore.[20] The *Blue Book* also recorded when young girls made their society debut at debutante balls, with advertisers in the book, like Barton, marketing to their families.

Barton also frequented the opera and contributed to socially important church and community benefits, all of which further cemented her position within her clients' upper-class social circles.[21] A member of the Catholic Archdiocese of Baltimore, Barton donated fine goods to the church and publicly represented herself as a Catholic. Baltimore newspapers even noted her

Figure 2. Silk *Moiré* and Silk Satin Dress, 1899–1902, designed and made by Lottie Barton (1852–1902), worn by Mary "Mollie" Cromwell Riggs (1866–1937). Maryland Historical Society, Gift of Mrs. Richard C. Riggs, 1969.122.7

This dress is exhibited through the generosity of Richard and Sheila Riggs in honor of Eleanor R. Riggs.

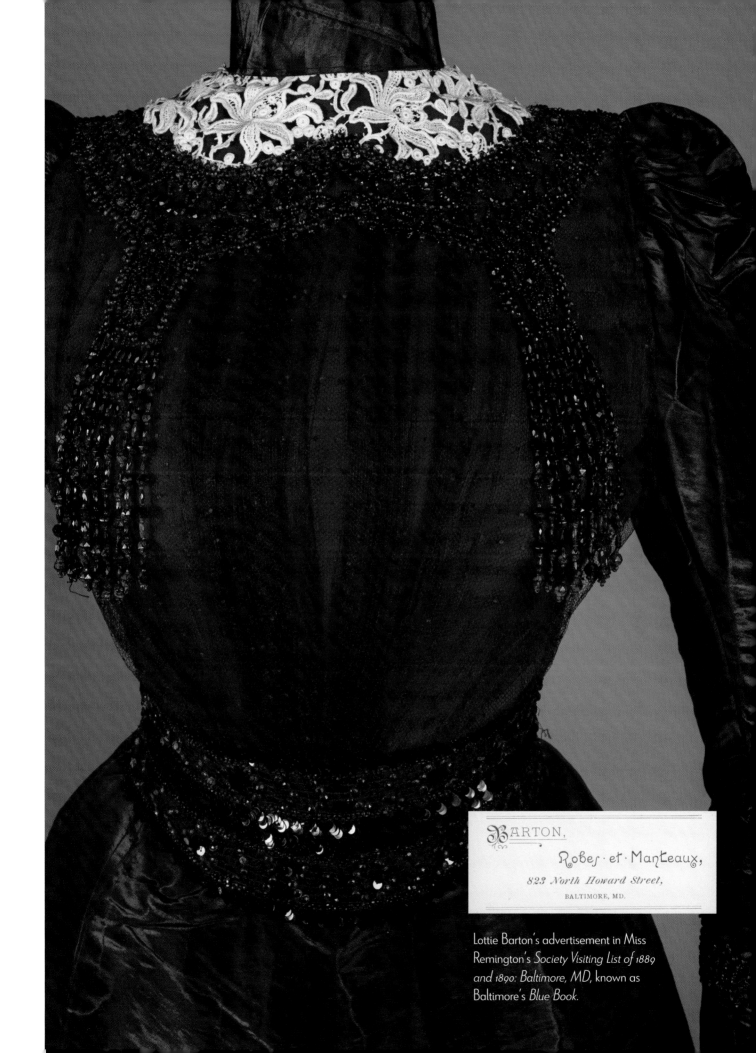

BARTON,

Robes · et · Manteaux,

823 North Howard Street,

BALTIMORE, MD.

Lottie Barton's advertisement in Miss Remington's *Society Visiting List of 1889 and 1890: Baltimore, MD*, known as Baltimore's *Blue Book*.

private meeting with the Pope when she received his blessing during a trip to Italy with friend and fellow smuggler Catharine (Kate) Holland of Chicago in 1897.[22] As a white, southern business woman catering to the most socially prominent members of the white community, Barton showed her cohesion with this group by contributing to the building of Confederate monuments through her participation in bazaars held by the Daughters of the Confederacy.[23]

As her business continued to grow, Barton moved her establishment along North Howard Street. Located at 242 North Howard Street from approximately 1885 to 1889, Barton of Baltimore stood beside the Hutzler Brothers Department Store.[24] Founded in 1858 as a dry-goods store, Hutzler Brothers became a prominent Maryland establishment until its closure in 1990. After the Civil War, like many department stores in the United States, Hutzler's expanded rapidly. In the 1870s and 1880s, the company purchased significant property along North Howard Street. Likely due to this quick expansion, Barton of Baltimore moved to a temporary location at 823 North Howard Street while Barton constructed her final and grandest premises at 405 North Charles Street in 1889.[25]

Not deterred by the 1893 incident with the New York Customs House, only a year later Barton expanded her trade in European imports and refurbished the North Charles Street property. In March 1894, Lottie Barton completed the significant renovations. In an article titled "Improvements on North Charles Street," the *Baltimore Sun* reported the details:

> Miss Lottie M. Barton has purchased the old Deford house, at 405 North Charles street, and has had it rebuilt as a fashion establishment. The building has been extended to the full length of the lot, and now comprises five stories of large rooms, which have been handsomely decorated and furnished. The basement floor will be devoted to the tailor's department of work. It consists of five rooms. The first floor comprises a spacious hall and entrance and a suit of eight large communicating apartments, which will be named as reception, fitting and showrooms. The

color treatment of the suit is in harmonious shades of green in carpet, wall and furniture, with ivory and gold woodwork in the front rooms and polished oak woodwork and fittings in the back rooms. The second floor has been arranged for a private flat to be used by the proprietor, and the third and fourth floors will be used as workrooms for the seventy-five employees and for other business purposes of the establishment. A Spanish tile roof ornaments that new fourth floor. Miss Barton will largely extend her business in importations, and her establishment will be, it is said, one of the largest of the kind in the country. The rebuilding of the house has been completed.[26]

The European goods, along with Barton's creation of a new, grand salon, spoke to her eminent place within the dressmaking trade in the United States, and Baltimore in particular.

Much of Barton's success stemmed from her impressive list of clients, including First Ladies Frances Folsom Cleveland and Caroline Harrison. It is unclear when and how First Lady Frances Cleveland first became a patron of Barton of Baltimore, although Baltimore's proximity to Washington, D.C., and the recommendation of a common friend or patron probably played a part. Before the twenty-one-year-old Frances Folsom married forty-nine-year-old President Grover Cleveland at the White House in 1886, the public knew her as a great beauty, but not as a style icon.[27] To change her public appearance prior to her tenure as First Lady, Frances sailed to Europe to purchase a completely new wardrobe comprised of clothing from the best couture houses.

Once dismissed as a frivolous school girl, Frances's marriage to President Cleveland turned the young woman into a national icon overnight. The First Lady's picture and wedding dress made the front pages of newspapers across the United States. Frances's new European couture wardrobe made a significant impression on the public. From this point onward, the First Lady Cleveland was a style icon for women throughout the nation.[28]

As her biographer Annette Dunlap recounted, although Cleveland procured original pieces from European couture houses, she also possessed

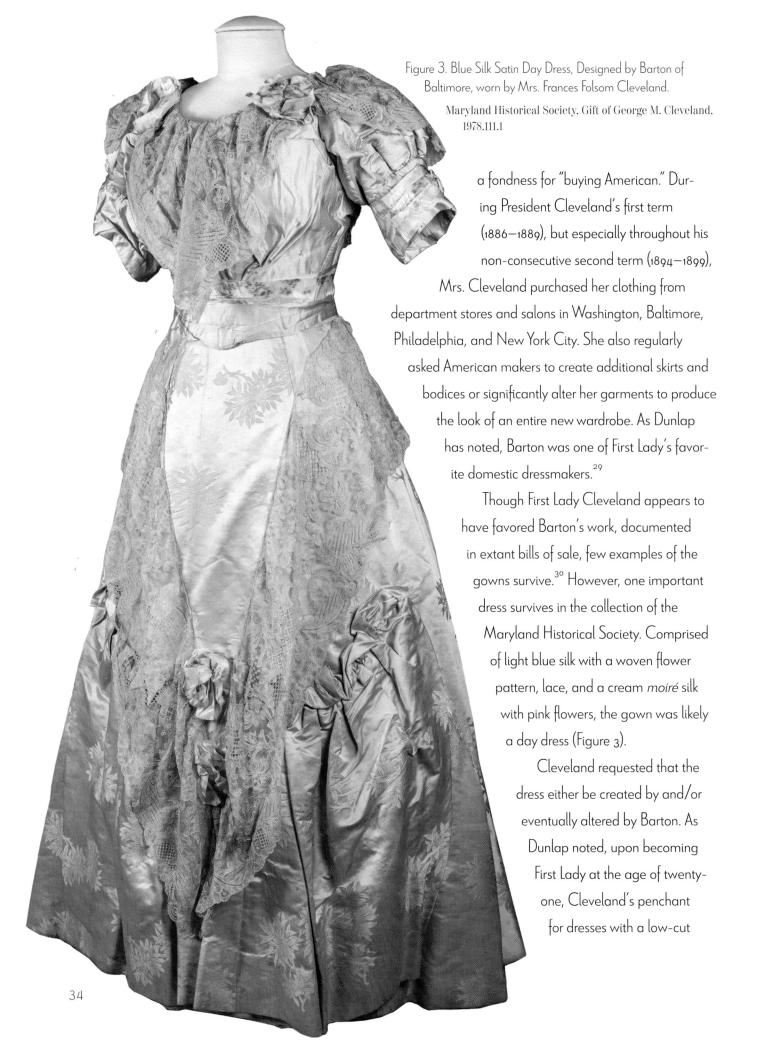

Figure 3. Blue Silk Satin Day Dress, Designed by Barton of Baltimore, worn by Mrs. Frances Folsom Cleveland.

Maryland Historical Society, Gift of George M. Cleveland, 1978.111.1

a fondness for "buying American." During President Cleveland's first term (1886–1889), but especially throughout his non-consecutive second term (1894–1899), Mrs. Cleveland purchased her clothing from department stores and salons in Washington, Baltimore, Philadelphia, and New York City. She also regularly asked American makers to create additional skirts and bodices or significantly alter her garments to produce the look of an entire new wardrobe. As Dunlap has noted, Barton was one of First Lady's favorite domestic dressmakers.[29]

Though First Lady Cleveland appears to have favored Barton's work, documented in extant bills of sale, few examples of the gowns survive.[30] However, one important dress survives in the collection of the Maryland Historical Society. Comprised of light blue silk with a woven flower pattern, lace, and a cream *moiré* silk with pink flowers, the gown was likely a day dress (Figure 3).

Cleveland requested that the dress either be created by and/or eventually altered by Barton. As Dunlap noted, upon becoming First Lady at the age of twenty-one, Cleveland's penchant for dresses with a low-cut

bodice caused a nationwide sensation. A photograph of First Lady Cleveland, taken in 1887, shows a typical *décolletage*-bearing gown from her wardrobe (Figure 4). Examining the photograph in detail, one can make out a very distinct pattern of *japonesque* flowers which echoed the popular taste for Japanese-inspired decorative arts in the late nineteenth century. The flowers on the dress in the photograph perfectly

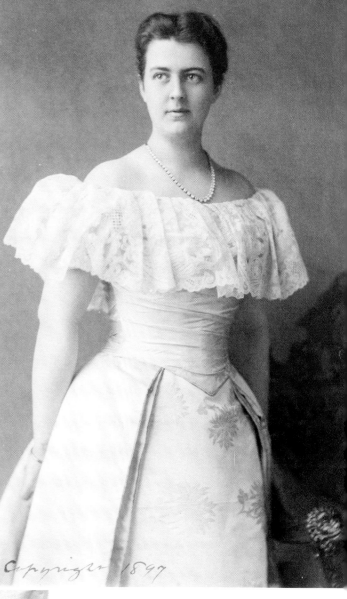

Figure 4. Mrs. Frances Folsom Cleveland, three-quarter-length portrait, standing, facing left, by Frances Benjamin, 1864–1952, photographer, c.1897.

Library of Congress, Prints & Photographs Division, [LC-USZ62-103442]

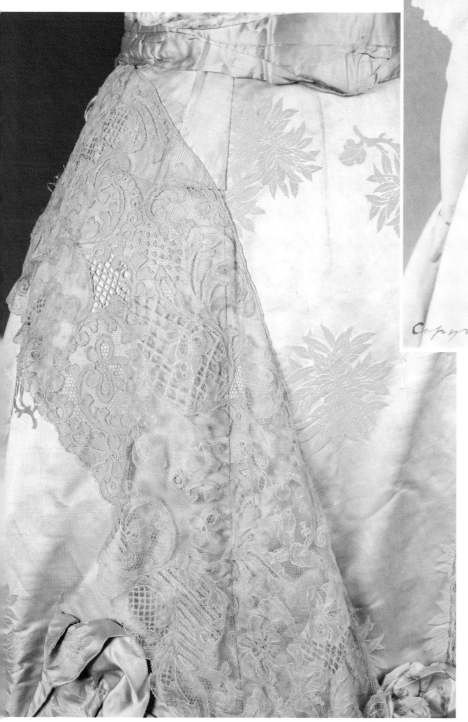

Figure 5. Detail of 1978.111.1, showing blue silk satin fabric matching the *japonesque* design in the 1897 photograph (Figure 4).

Maryland Historical Society, Gift of George M. Cleveland, 1978.111.3

match those on the gown in the collection of the Maryland Historical Society (Figure 5).

Further comparing the MdHS Barton dress that once belonged to First Lady Frances Cleveland and the photograph of Mrs. Cleveland, it becomes clear they are the same dress. Like many of the First Lady's pieces, this dress was significantly altered. In an era when women of her status regularly wore gowns only a handful of times, if that, the First Lady tended to wear gowns for years. She favored separate skirts and bodices that she mixed and matched. The lace along the neckline has changed along with the sleeves, waist, and skirt. In the photograph the *bateau* neckline is covered in a swath of lace. The sleeves, which lay off the shoulder, are hidden by the fall of the lace. Today the dress features a scoop neckline and prominent, round sleeves instead of the *décolletage*-bearing previous iteration. The previous waist originally pointed at the center is now straight and edged in ribbon, and elements of the wrapped silk on the bodice are visible on the dress today. Additionally, the tight fitted bodice from the photograph is now fuller and rounded at the top, in a style called a "pigeon bust."

The skirt is also significantly different. In the photograph, a train and over-skirt are visible above an unadorned silk skirt. However, today the dress lacks both a train and overskirt. Moreover, the simplified A-shaped skirt is adorned with lace ruffles descending from the hips and meeting at the center front with a rosette of cream silk and flower-patterned silk *moiré*.

The voluminous lace-front bust and A-line skirt shape suggest that altera-tions for this piece were made in the mid-1890s. The blue Barton dress in the MdHS collection is an important piece of evidence that demonstrates how the First Lady approached self-fashioning. Today, the Maryland Historical Soci-ety and The Smithsonian Institution's National Museum of American History preserve the majority of Barton's work for First Lady Frances Cleveland.

Another important patron for Barton was First Lady Caroline Harrison, who was, in many ways, Cleveland's counterpoint. In contrast to Cleveland's youthful "school girl" image, First Lady Harrison was a grandmother by the time she entered the White House in 1889. In fact, Harrison, whose husband won the presidency against President Cleveland in the 1888 election, often

commented on First Lady Cleveland's bare arms and low necklines, calling them immodest. Nevertheless, Harrison acknowledged Cleveland's popularity and her successful "buy American" campaign, and she too turned to Barton of Baltimore to fill her wardrobe.[31] The *Baltimore Sun* reported on Barton's work for the First Lady in February of 1890. The lengthy article detailed the women's reactions to all the finery brought before them by Barton:

> Miss Lottie M. Barton, of Baltimore, who also made the gowns worn recently by Mrs. Harrison and Mrs. McKee at one the White House receptions, seemed to know just what pieces from her stock would be likely to please her distinguished customers, who were well satisfied with the result of the morning's shopping. As gown after gown was brought out form the masses of finery in the trunks their exclamations of delight and admiration were truly feminine. . . .[32]

Noting her success in Washington within an exclusive social milieu that included the country's First Ladies, Barton expanded her business beyond Baltimore, opening a branch at 1415 H Street NW, just north of Lafayette Square and the White House in Washington, D.C.[33] Unfortunately, the expansion was ill-fated. While Barton of Baltimore continued to garner attention, shortly after the turn of a new century Barton herself died. In July 1902, Lottie Barton succumbed at the age of fifty to an unknown "long-term illness."[34]

When Barton passed away, she left a burgeoning fashion empire in the greater Baltimore/Washington area without a successor. In an article memorializing the deaths of two prominent citizens of the city, the *Baltimore Sun* named Barton "the minister of aesthetics in the mysterious realm of womanly costume." Speaking to her life's career, the newspaper stated: "Miss Barton's popularity was not based alone on her talent in her profession and her position as a creator of beauty in dress and an arbiter in the matter of elegance and good taste, but on amiable, personal qualities as well, which endeared her to a very large constituency."[35]

As her only heirs, Barton's father and siblings rallied around her business and its legacy. Her sister, Mary J. Barton, Jr., had been a dressmaker under

the name "Mary Barton" prior to her sister's death.[36] The middle Barton child, Clementine Elizabeth Barton Craig, going by "E. Craig," also became an importer of dress goods.[37] With their knowledge of the fashion industry, the family incorporated Barton's business as the L. M. Barton Company, with Clementine Craig overseeing the daily operations in both Baltimore and Washington, D.C.[38] Craig's responsibilities included addressing Lottie's extensive real estate holdings and overseeing the nearly seventy-five employees in the Baltimore salon, as well as the workers employed in Washington.[39] Shortly after her death, Barton's real estate holdings alone, which included Baltimore and D.C. salons, her home at 403 North Charles and over a dozen other properties in Baltimore, totaled in value nearly $52,000 (approximately $1.6 million dollars in 2019).[40] In addition to these financial assets, plus thousands of dollars of inventory, the Barton family inherited stock holdings that Lottie purchased just days before her death from the new Dressmakers' Protective Association, a union created to financially protect American dressmakers.[41]

Despite the company's significant assets, the L. M. Barton Company only lasted a few more years. By the fall of 1907, the legacy of Barton, the company she so brilliantly built, was for sale. With no apparent parties interested in purchasing the company, Lottie's family liquidated $25,000 worth of inventory (nearly $700,000 worth of goods in 2019 dollars). Pattinson & Graham Auctioneers sold Barton's carefully selected supply of laces, furs, garments, ribbon, embroidery and more, along with sewing machines, furniture, dress forms, and fixtures to the highest bidder.[42] With the passing of Barton and her business, so went one of Baltimore's most elite fashion establishments.

Today, scholars overlook the importance of Baltimore as a fashion hub at the turn of the twentieth century. Yet, dressmakers, importers, and department stores of that time dressed the city's elite in high-style, French-influenced fashions that rivaled those for sale in New York and Philadelphia. Among her peers, Lottie Barton was a leading force in shaping the sartorial identity of the city. Importing goods, creating her own designs, and altering fashions, she made wardrobes for debutants, socialites, and First Ladies. Barton's legacy is that of high fashion in Baltimore. Although overlooked by some, Baltimore is and was a fashion city.

NOTES

1 "Tearful Smugglers Plead," *The Sun* (New York City), March 16, 1893, 1.

2 1860 and 1870 United States Federal Censuses, Baltimore City, Maryland, s.v. "Charlotte Barton," accessed February 1, 2019, *Ancestry.com.*

3 Ibid. Rose is also occasionally listed as Rosa.

4 1860, 1870, and 1880 United States Federal Censuses, Baltimore City, Maryland, s.v. "Charlotte Barton," accessed February 1, 2019, *Ancestry.com.*

5 *Woods' Baltimore City Directory* (*WBCD*, Baltimore, MD: John M. Wood, 1867–1868), n.p.; *WBCD* (1870), 795; *WBCD* (1871), 793; *WBCD* (1873), 801; *WBCD* (1883), 1159; *WBCD* (1884), 1272; *WBCD* (1885), 1528; *WBCD* (1886), 1563. Baltimore City Directories list a "Mary J. Barton" as a dressmaker from the 1860s into the 1870s; this would be after the birth of Mary Barton's last child and before her daughter Lottie's career began.

6 Ibid. Ms. Olmier's name and age change dramatically over the course of the 1860, 1870, and 1880 censuses: she is listed as "Clemm Olmin age 46" in 1860, "Clementine Olmire age 60" in 1870, and "Clementine Olmier age 90" in 1880.

7 Ibid.

8 Untitled, *Baltimore Sun*, August 14, 1894, 8; "City News in Brief," *Baltimore Sun*, July 31, 1890, supplement 2; "Personal," *Baltimore Sun*, March 21, 1900, 12; "City News in Brief," *Baltimore Sun*, August 26, 1890, 4; "Personal," *Baltimore Sun*, February 8, 1900, 10.

9 Hind Abdul-Jabbar, "Smuggled in the Bustle," *The Fashion Studies Journal*, accessed February 2, 2019, fashionstudiesjournal.org/4-histories-2/2017/8/1/smuggled-in-the-bustle.

10 Ibid.

11 Ibid.

12 Ibid.

13 Several sources were consulted for currency conversion rates and then averaged for all the amounts listed in this paper. This included officialdata.org and measuringworth.com.

14 "Tearful Smugglers Plead," *The Sun* (New York City), March 16, 1893, 1.

15 Ibid.

16 Ibid.

17 Ibid.

18 Ibid.

19 "Tearful Smugglers Plead," *The Sun* (New York City), March 16, 1893, 1; *The Philadelphia Inquirer*, March 17, 1893, 5; "Seized Chicago Costumes," *The Morning Democrat* (Des Moines, IA), March 17, 1893, 1; "The Seized Trunks," *Baltimore Sun*, March 17, 1893, n.p.

20 Miss Remington, *Society Visiting List of 1889 and 1890: Baltimore, MD* (Baltimore, MD: Thos. E. Lycett & Co., 1889), n.p.

21 "Cleveland Baby Doll," *Baltimore Sun*, November 12, 1897, 7; "Who Were There," *Baltimore Sun*, January 26, 1888, n.p.

22 "Personal," *Baltimore Sun*, March 8, 1897, 10.

23 "Bazar's Time Extended," *Baltimore Sun*, December 7, 1901, 7.

24 "Advertisement," *Baltimore Sun*, March 22, 1881, n.p.; "Advertisement," *Baltimore Sun*, January 5, 1885; "Advertisement," *Baltimore Sun*, August 31, 1896, n.p.; 1860 and 1870 United States Federal Censuses, Baltimore City, Maryland, s.v. "Charlotte Barton," accessed February 1, 2019, *Ancestry.com*; "Improvement on North Charles Street," *Baltimore Sun*, May 29, 1894, 8.

25 "Improvement on North Charles Street," *Baltimore Sun*, May 29, 1894, 8.

26 Ibid.

27 Annette Moritt Dunlap, "Frances Folsom Cleveland's White House Wardrobe," *The White House Historical Association* (*WHHA*), accessed January 5, 2018, whitehousehistory.org/frances-folsom-clevelands-white-house-wardrobe; Nora Ellen Carleson, "Finding First Lady Frances at the MdHS Fashion Archives," *The Fashion Archives*, Maryland Historical Society, accessed August 15, 2018, blog.mdhs.org/costumes/finding-first-lady-frances-at-the-mdhs-fashion-archives.

28 Dunlap, "Frances Folsom Cleveland's White House Wardrobe," *WHHA*, accessed January 5, 2018, whitehousehistory.org/frances-folsom-clevelands-white-house-wardrobe.

29 Ibid.

30 Ibid.

31 Ibid.

32 "White House Gowns," *Baltimore Sun*, February 27, 1890, 1.

33 Ibid.

34 "Notice is Hereby Given," *Washington Evening Star*, August 11, 1902, 5; "Death of Useful Citizens," *Baltimore Sun*, July 31, 1902, 4.

35 "Death of Useful Citizens," *Baltimore Sun*, July 31, 1902, 4.

36 *WBCD* (1867–1868), n.p.; *WBCD* (1870), 795; *WBCD* (1871), 793; *WBCD* (1873), 801; *WBCD* (1883), 1159; *WBCD* (1884), 1272; *WBCD* (1885), 1528; *WBCD* (1886), 1563.

37 "Notice is Hereby Given," *Washington Evening Star*, August 11, 1902, 5; "Art Nouveau Fashion: Giving Dress a Place among Decorative Arts," *The Fashion Archives*, Maryland Historical Society, accessed July 30, 2018, blog.mdhs.org/costumes/art-nouveau-fashion-giving-dress-a-place-among-decorative-arts.

38 "Notice is Hereby Given," *Washington Evening Star*, August 11, 1902, 5.

39 "Improvement on North Charles Street," *Baltimore Sun*, May 29, 1894, 8.

40 "News Article," *Baltimore Sun*, November 18, 1903; "Advertisement," *Baltimore Sun*, July 2, 1907, 1.

41 "Dressmakers' Combine," *Baltimore Sun*, July 26, 1902, 12.

42 "Advertisement," *Baltimore Sun*, September 19, 1907, 13. What happened to Lottie Barton's extensive real estate holdings remains unclear. It is likely that many were sold off and some of them kept to generate revenue, but no records have been found as of yet to prove what happened with those holdings.

Hidden in Plain Sight:
Uncovering the Livery
of Tilghman Davis
and Thomas Brown

By Norah Worthington

THE SPECTRUM OF FASHION in the Maryland Historical Society's Fashion Archives is expansive. Certainly every color imaginable is represented with a time range from the first quarter of the eighteenth century to the first quarter of the twenty-first century. Alongside the designer gowns and finely tailored items for special occasions, there are examples of working wear worn by a large range of Marylanders. Searching out the context for these everyday pieces can bring a small bit of light to lives that were often hidden.

The Maryland Historical Society collection includes a group of nineteenth century livery — the kind of coat-of-arms-decorated uniforms worn by servants of large households, and a rare survival in American collections. These pieces are easily identified because they bear the recognizable Ridgely family crest

Figure 1. Hampton National Historic Site, Towson, Maryland, National Park Service.

Photograph by Tim Ervin

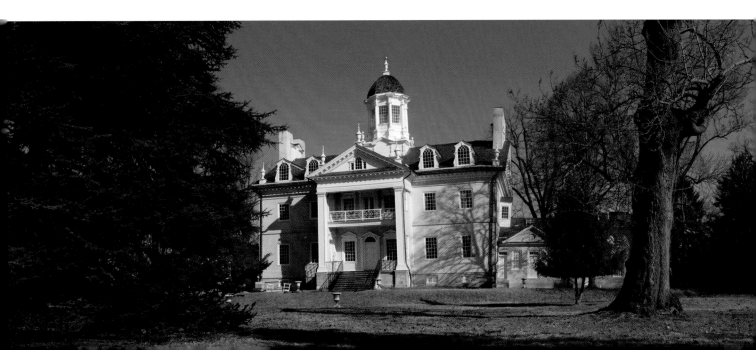

emblem of a stag's head. Hampton, the family's country home in Baltimore County, was likely the largest private residence in the United States when completed in the 1790s (Figure 1). At its height in the early nineteenth century, nearly 350 people worked on its multiple properties, including enslaved, free black, and white laborers. The Ridgely family occupied the mansion until 1948, when the estate became property of the National Park Service. The stag crest of the Ridgely family appears in countless ways when you visit the property; the family seemed to put it on everything from silver holloware to stained glass windows to pier mirrors (Figure 2).

Figure 2. Detail of Ridgely armorial featuring the stag's head, fruit basket, Andrew E. Warner, 1818.

Maryland Historical Society, The Middendorf Purchase Fund, 2018.7

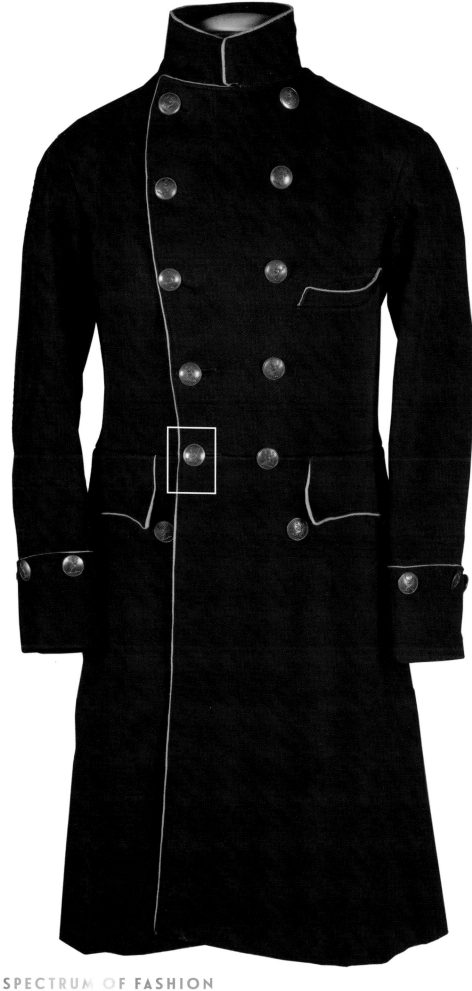

Figure 3. Livery coat, early 1870s.

Maryland Historical Society, Gift of Mr. John Ridgely, 1944.76.27

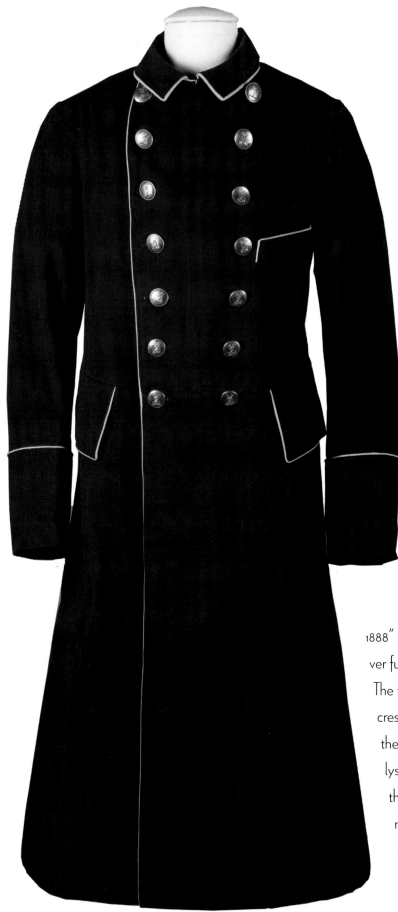

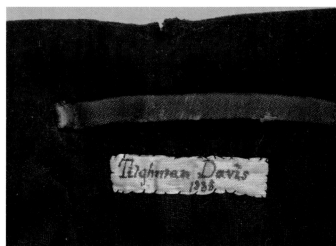

Figure 5: Detail of label in Ridgely family coachman's livery coat, reads "Tilghman Davis / 1888."
Maryland Historical Society, Gift of Mr. John Ridgely, 1944.76.26

The four pieces of Ridgely livery that survive in the Fashion Archives represent a fraction of the large number of livery items that would have been provided to the coachmen of Hampton. There is an unlabeled mid-length double-breasted coat (Figure 3), a long double-breasted coat with the label "Tilghman Davis 1888" (Figures 4 and 5), a detachable four-tiered wool "Carrick" cape with the label "Tom Brown 1888" (Figures 6 and 7), and an elegant London-made beaver fur top hat trimmed with a gold braid band (Figure 8). The two Ridgely coats are trimmed with stag-crested buttons, identifying them as livery (Figure 9). Like the English nobility they aspired to imitate, the Ridgelys saw themselves living a genteel life of manners in the country with well-dressed servants that visually represented the family's wealth and sophistication. Although satirized by nineteenth-century American writers of egalitarian leaning,[1] an article published in the *New York Herald* as late as 1908 confirmed that the wealthy of the United States still dressed

Figure 4. Livery coat, 1888, worn by Tilghman Davis.
Maryland Historical Society, Gift of Mr. John Ridgely, 1944.76.26

This livery is exhibited through the generosity of Historic Hampton, Inc.

Figure 6. Livery cape, 1888, worn by Tom Brown.

Maryland Historical Society, Gift of Mr. John Ridgely, 1944.76.28

This livery is exhibited through the generosity of Historic Hampton, Inc.

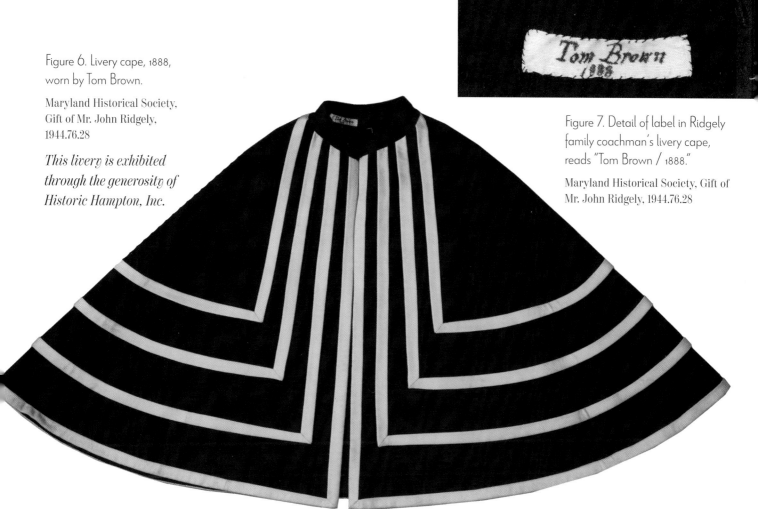

Figure 7. Detail of label in Ridgely family coachman's livery cape, reads "Tom Brown / 1888."

Maryland Historical Society, Gift of Mr. John Ridgely, 1944.76.28

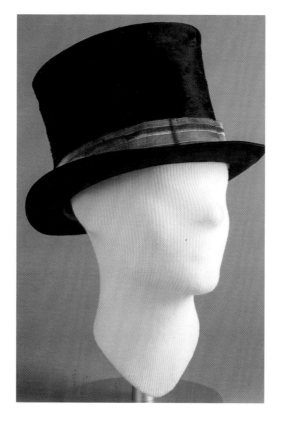

Figure 8. Coachman's hat, late nineteenth century.

Maryland Historical Society, Gift of Mr. John Ridgely, 1944.76.30

This hat is exhibited through the generosity of Mark B. Letzer.

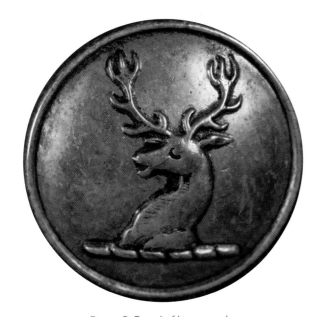

Figure 9. Detail of button on livery coat, early 1870s.

Maryland Historical Society, Gift of Mr. John Ridgely, 1944.76.27

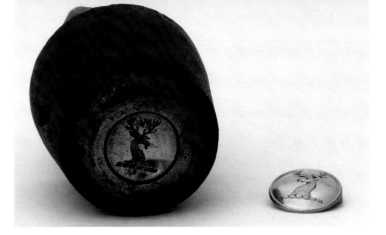

Figure 10. Button Stamp and Button.

Hampton National Historic Site, National Park Service, HAMP 718 and HAMP 38375

Image courtesy of: Hampton National Historic Site Virtual Tour, Museum Management Program, National Park Service

Figure 11. Detail of interior construction of livery coat, early 1870s.

Maryland Historical Society, Gift of Mr. John Ridgely, 1944.76.27

their male servants, especially coachmen, in distinctive uniforms connected to their family crests. The range of colors and trims described in the article was dramatic, but the dark green wool with cream trim of the Ridgely livery seems to fall into the conservative category, comparable to that worn by servants of the Goulds and Astors, some of the wealthiest, most aspirational aristocratic families in the United States.[2]

The unlabeled coat seems to be of an earlier style, cut from finer quality wool, and displays more careful tailoring than the other coat. It is a frock-style coat with a seam at the waist and a knee-length skirt, probably dating to the 1870s (Figure 3). Made of dark green wool, it is trimmed with black wool cuffs and cream wool piping; fading at the cuffs indicates that some kind of additional trim was removed. Twenty of the twenty-two brass buttons all bear a stag's head crest that matches a button stamp in Hampton's collection (Figure 10). The top two buttons (likely replacements) were made by a different manufacturer, but are stamped with the same crest. There are false pocket flaps on the sides of the coat and decorative flaps on the coattails with a functioning exterior welt pocket on the left breast. Tailoring on the jacket includes fine machine-quilting on the collar stand and interior upper body, small darts at the neck and armholes to shape the upper torso, with padding machine-stitched into the front body of the jacket around to the back side seam. The upper body is lined in slightly lighter green wool with a black glazed cotton lining in the tails, and the sleeves are lined in a tan, blue, and red striped cotton sateen

(Figure 11). There are also pockets on the inside of the tails of the coat and an inner right breast pocket with a strip of twill tape is sewn into the center back lining for hanging the coat on a peg or hook.

The other coat is labeled "Tilghman Davis 1888," and the cape is labeled "Tom Brown 1888" (Figures 5 and 7). The coat buttons, marked "Scovill Mfg Co Waterbury,"[3] are similar, but not identical to the buttons on the body of the older, shorter coat. The cape and long coat are made of the same black wool lined in dark green wool, but the cape buttonholes do not exactly match the buttons on the collar stand of the coat, further indicating that the cape and coat were worn by different men. Undoubtedly, there was a matching coat for Thomas Brown's cape and a second cape for Tilghman Davis's coat to complete their uniforms. The cape is characteristic of a coachman's cape, also

Figure 12. Photograph of the beach near the Bruen Villa in Newport, Rhode Island, with Nathan Harris driving Ridgely family members in a carriage.

Hampton National Historic Site, National Park Service, HAMP 16969

Image courtesy of: Hampton National Historic Site, National Park Service

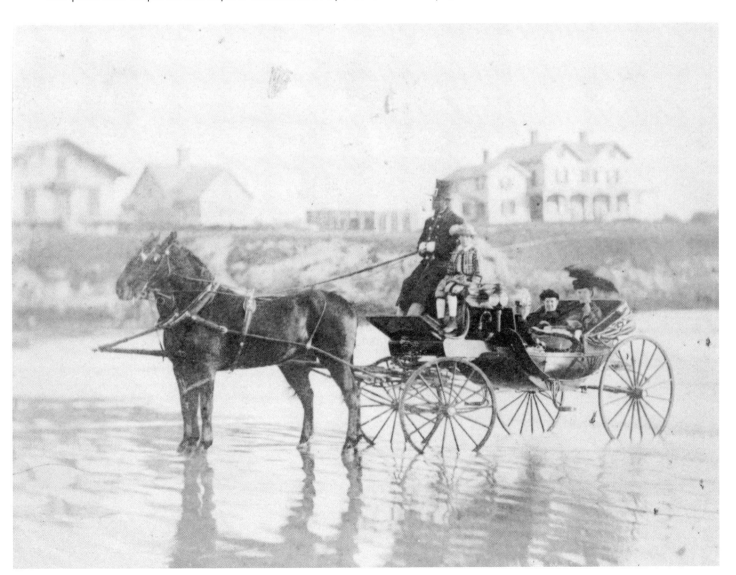

Figure 13. "CHRISTMAS GIFTS of the Colored Children of Hampton, Given by E. Ridgely," 1841–1854, written by Eliza "Didy" Ridgely (1828–1894).

Hampton National Historic Site, National Park Service, Ridgely Family Papers, HAMP 14733, MS 001

Image courtesy of: Hampton National Historic Site, National Park Service

known as a "Carrick" cape. Although it appears to be four layers of wool, the layers are actually false and only extend under each other enough to provide the illusion of layers. Bound in cream wool, the cape has buttonholes around the collar stand to attach it to the coat. The coachman would have looked impressive wearing the imported beaver fur top hat with gold braid driving the Ridgely carriage with the family crest painted on the side (Figure 12).[4]

The Maryland Historical Society houses many items from the Ridgely family. Even before John Ridgely, Jr., sold the core of the grand estate to the National Park Service in the late 1940s, he donated many Ridgely possessions to the MdHS. In subsequent decades, other family members donated clothing, decorative arts, and fine silver to the Maryland Historical Society. The family papers in the MdHS's H. Furlong Baldwin Library are extensive as well: it is there that glimpses of Davis and Brown emerge from the Ridgely family documents. Using the documents in the H. Furlong Baldwin Library, the National Park Service's archival collection at Hampton, and public sources such as census records and city directories, we can piece together a surprising amount of information about these men and the coats they wore.[5]

According to Eliza Ridgely's "Servants Clothing Book,"[6] Tilghman Davis was born at Hampton in March 1843, though later census records list December 1845. He is mentioned in the memoir of a Ridgely family relative, James McHenry Howard, in a section describing several of the formerly enslaved individuals who continued to work for the family in later years.[7] James wrote that Tilghman was the son of enslaved servant Bill Davis, "one of the best

Figure 14.
"Hampton Farm
Account Book," 1854
and 1863.

Maryland Historical
Society, H. Furlong
Baldwin Library,
MS 691

Figure 15. Photograph of Thomas Brown
in Dining Room of Hampton, c.1897.

Hampton National Historic Site, National
Park Service, HAMP 20285

Image courtesy of: Hampton National
Historic Site, National Park Service

negroes ever on the place." Bill Davis, his wife Susan ("Sukey"), and their older children had been purchased by John Ridgely from an estate in Frederick County in 1841. Tilghman's name appears in the 1850s on the list of "Christmas Gifts of the Colored Children of Hampton, given by E. Ridgely" (Figure 13).[8] Throughout the 1850s and 1860s, Tilghman appears in the Hampton Servants Clothing Book and the Farm Account Book as an enslaved boy or man who received clothing twice a year (Figure 14).[9] In 1863, he is listed on a receipt

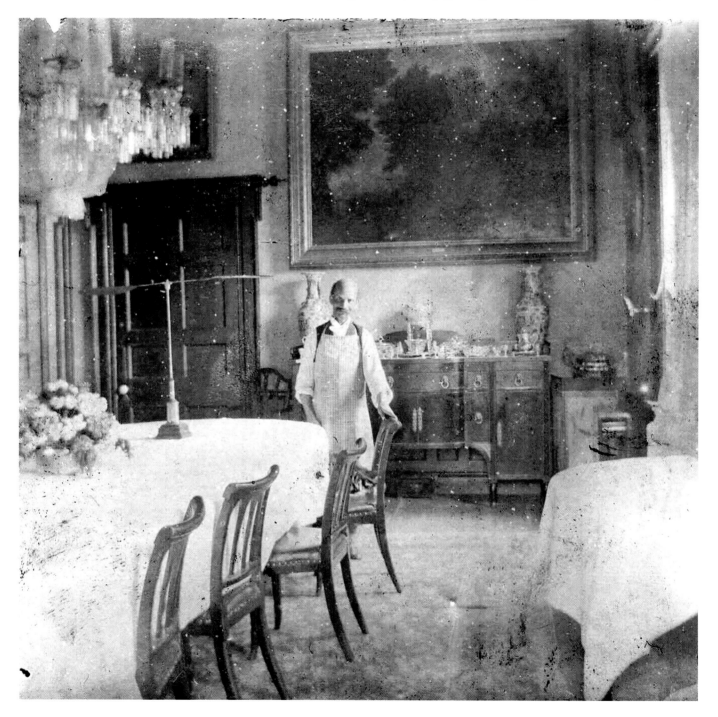

recovering runaways from jail. Interestingly, the group of nine people included two women with children as well as several young men. In 1864, he is listed as having been signed over to a Union captain to enlist although there are no records of his service, so it is possible he worked as a laborer for the army. After emancipation, he continued to work for the Ridgely family as part of the house staff. In 1877, he married a woman named Elizabeth and throughout the 1880s and '90s, he can be found in Baltimore City directories and census records as a coachman. Throughout 1883 and 1884, he resided at 92 Tyson Street, a small alley street just west of Park Avenue in the fashionable Mount Vernon neighborhood of Baltimore, with coach houses and living spaces above them. In the 1890 City Directory (close to the date of his cape), he is recorded at 864 Park Avenue in Baltimore, the townhouse of Margaretta Sophia Howard Ridgely, mistress of Hampton until 1904. One of the last glimpses of him is in the 1900 census, where he is listed at 712 Tyson Street as a coachman with wife Elizabeth (laundress), son Theo (driver), and five other living children (of eight). All of the children and his wife are listed as being able to read and write, but he is recorded as illiterate. He was living at 722 Linden Avenue just south of Madison Avenue between Howard and Eutaw Streets at the time of his death in February 1905.

Born free between 1841 and 1844, Thomas Brown may have been slightly older than Tilghman. James McHenry Howard wrote, "Thomas Brown has been one of the waiters at Hampton nearly ever since the close of the war. His father William Brown used to be my father's coachman when we lived at Cowpens (the Howard family estate adjacent to Hampton). Tom is a good, honest, and industrious man who takes much interest in the welfare of the family" (Figure 15).[10] Tom married Caroline Davis, Tilghman's sister, who worked the dairy at Hampton well into the 1890s. He is counted twice in the 1870 census, working at Hampton as a waiter and living with Caroline in Towsontown, where he is recorded again in 1880. The village of Towsontown began just where the Hampton property ended. The 1900 census lists him as a waiter at Hampton who can read, but not write.

In the MdHS collection of Ridgely papers, there are receipts from 1872 and 1873 referring to green wool livery that include the names Davis and

Figure 16. Receipts for livery to the Ridgely family from Noah Walker & Co, Baltimore, Maryland, Receipts 1872-3.

Maryland Historical Society, H. Furlong Baldwin Library, MS 2891

Figure 17. Receipt of labor at Hampton.

Maryland Historical Society, H. Furlong Baldwin Library, MS 2891

Brown (Figure 16)." These receipts document other parts of the livery uniforms worn by the Hampton staff, even after emancipation. Items ordered include "Green Livery frock (Davis), Beaver [illegible] coat (Brown)," double breasted green livery frock and capes, a green beaver jacket and drab pants, green dark kersey pants and a vest, and yardage of green beaver fabric. The invoices are from Noah Walker & Co., a Baltimore menswear supplier. Each new coat and cape together cost $110. Compared to several Ridgely receipts for labor during the same period, this sum was commensurate with about 207 days' work for one of the hired hands (Figure 17). Thomas's wife Caroline was noted as being paid eight dollars per month.

The presence of these pieces in the Maryland Historical Society's Fashion Archives is a tantalizing reminder of the undiscovered stories waiting to be told by the clothing in the collection. In preparation for the *Spectrum of Fashion* exhibition, there was a concerted effort to assess the menswear in the collection and it was during this "triage" that the livery was discovered. These items, which might have been overlooked in previous eras, are of great interest to us today. Searching for the context of these pieces, we begin to piece together details of lives that could easily be overlooked. By revisiting the historical records armed with names, dates, and a place, we can find context that is sometimes hidden in plain sight. The stories of the coachman and the waiter are just a few of the stories in the collection's boxes waiting to be told.

NOTES

1 "Reverend Cream Cheese and the New Livery," for instance, is a short story by George William Curtis in Mark Twain's *Library of Humor* (Montreal: Dawson Brothers, 1888, online version available at archive.org/details/marktwainslibrarootwaiuoft/page/34).

2 "Liveries of Famous Families," *New York Herald*, June 7, 1908. Reprinted in *The Carriage Journal* 26, no. 3 (Winter 1988): n.p.

3 The Scovill Manufacturing Company of Waterbury, Connecticut, was founded in 1802, and made uniform buttons during the War of 1812 as well as the Civil War. The Hampton museum collection contains about two dozen Scovill buttons with the stag's head crest, probably dating from the last quarter of the nineteenth century.

4 The hat is labeled: "Hatters to the Crown by Special appointment, imported by Marshall, London." The coach is still on display in Stable 1 at Hampton National Historic Site in Towson, Maryland.

5 Many biographical details of Tilghman Davis's and Tom Brown's lives have been uncovered

by the Hampton Ethnographic and Assessment Project 2016–2019, with Dr. Cheryl LaRoche as Principal Investigator for the National Park Service and University of Maryland (information provided by Gregory Weidman, Curator at Hampton National Historic Site).

6 "Servants Clothing Book," MS 691, c.1835–c.1854, H. Furlong Baldwin Library, Maryland Historical Society, Baltimore.

7 J. M. Howard, "Memoirs of the Ridgelys at Hampton," Ridgely Family Papers, HAMP 21686, MS 1001, Hampton National Historic Site, n.p.

8 Contained in Eliza (Didy) Ridgely's diary is a record of her Christmas gifts to the enslaved servants of Hampton 1841–1854 (HAMP 14733, Hampton National Historic Site).

9 According to the "Hampton Farm Account Book," clothing was usually distributed to the enslaved servants by the Ridgelys twice a year, in May and November (MS 691, H. Furlong Baldwin Library, Maryland Historical Society, Baltimore).

10 Howard, "Memoirs," 233–235.

11 Hoyt collection of Ridgely Papers, MS 2891, Box 7, 1866–1876 Hampton Bills – Clothing, H. Furlong Baldwin Library, Maryland Historical Society, Baltimore.

SPECTRUM OF
FASHION

By Allison Tolman
and Emily Bach
with Barbara Meger

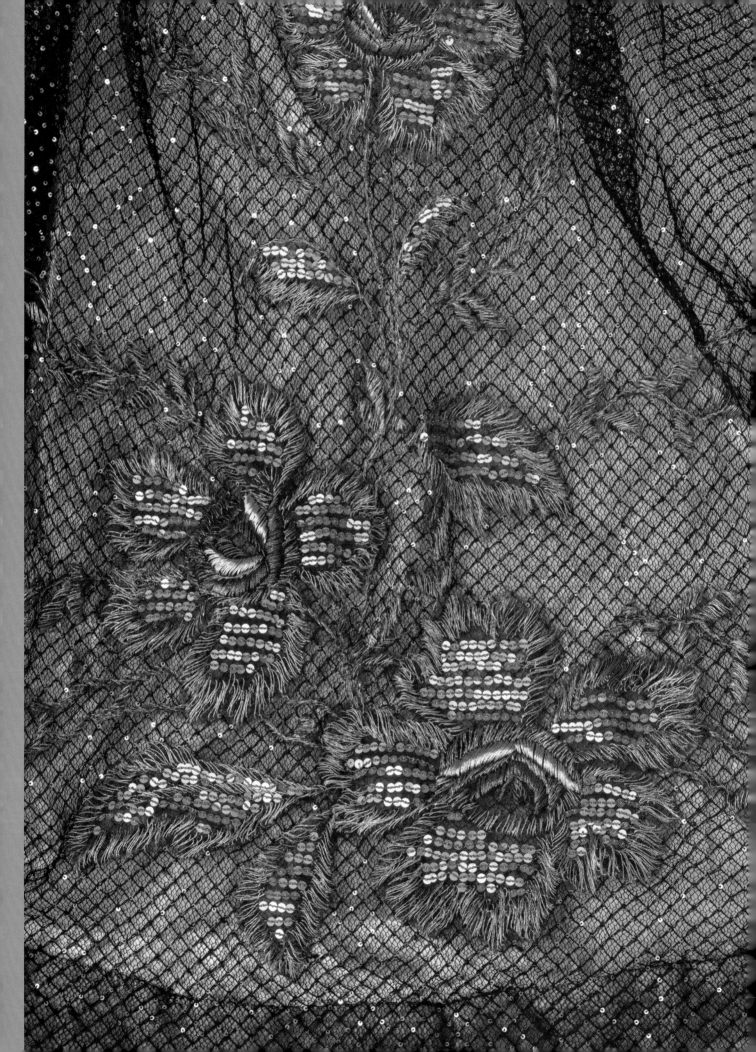

Silk Satin and Net with Metallic Embroidery Evening Dress

1900–1905

Designed by Jacques Doucet (1859–1929)

Worn by Eliza Waller Beale Wilson (1853–1933)

Maryland Historical Society, Gift of Mrs. William S. Hilles, 1974.62.9

Eliza Wilson was a woman of high style. Married to William Thomas Wilson, they were a prominent Maryland couple: she was the president of the Society of Colonial Wars for several years and he a part owner of Grace's Quarter Ducking Club. At their large home at the corner of St. Paul and Biddle Streets in downtown Baltimore, which was designed and built especially for them, the Wilsons hosted elegant dinner parties. They also attended many similar soirées in Baltimore society and abroad. It is likely that Wilson wore this evening dress by Parisian designer Jacques Doucet at one such event. In contrast to his contemporaries, Doucet was known for his use of more delicate fabrics such as the black silk net in this dress. This graceful look is enhanced by scattered sequins and metallic embroidery that decorate the bodice, climbing in floral sprays from the skirt's hemline toward the waist.

This dress is exhibited through the generosity of Hilles Horner Whedbee, Rosalie Jenkins Whedbee, and Claire McKnew Whedbee.

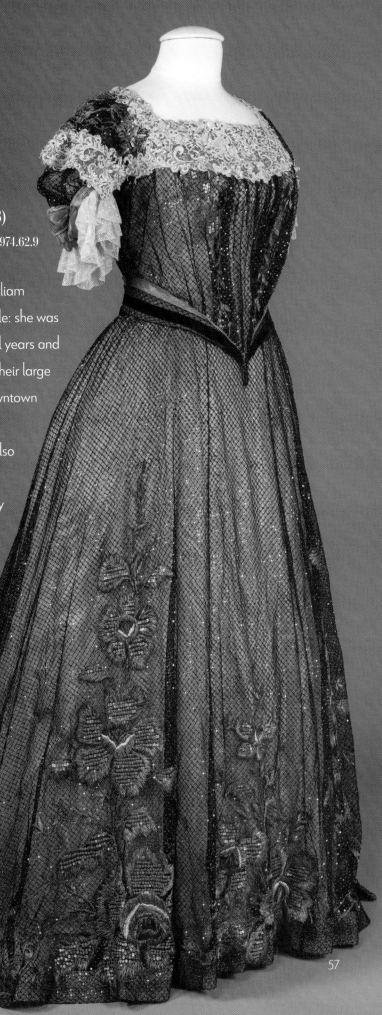

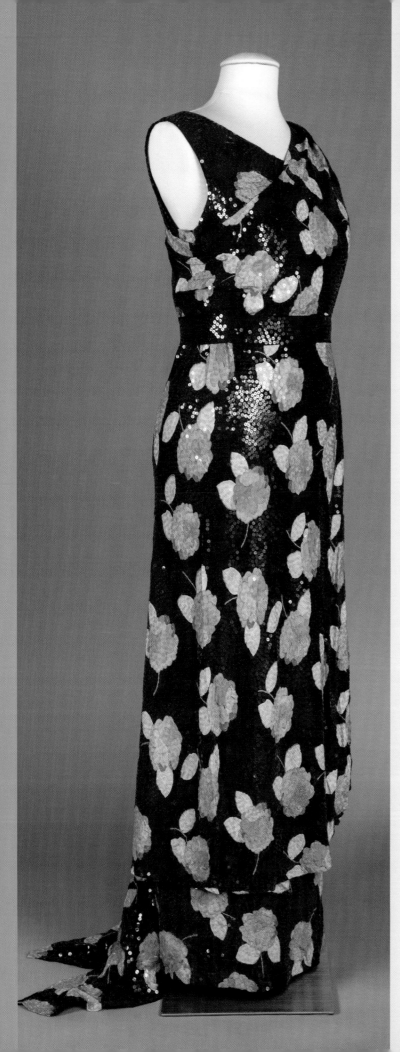

Crêpe Silk and Sequined Evening Dress

1935–1939

Worn by Muriel Wurts-Dundas Boone
(1906–1970)

Maryland Historical Society, Gift of Mr. James R.
Herbert Boone, 1973.48.1 a-c

Evening dresses of the 1930s favored a slender
silhouette, with most gowns cut on the bias, resulting
in the fabric naturally following and accentuating
the wearer's curves. The use of textured fabrics
and trims, such as the silk crêpe and multi-colored
sequins of this dress, produced distinctive fashions.
Hollywood was a particularly important influence
during this period. Previously, women depended
upon fashion magazines for updates on the latest
trends, but films projected, in motion, the flattering
dresses of the era's stars. Thousands of women
flocking to theaters noted which new styles to
emulate and retailers quickly copied the cinematic
fashions to sell in their stores.

*This dress is exhibited through the generosity of
Stephanie Bradshaw.*

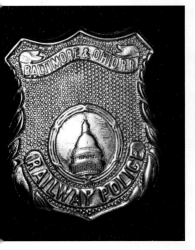

B&O Railroad Uniform

1941–1974

Worn by John L. Heavner (1910–1974)

Maryland Historical Society, Gift of Mrs. John L. Heavner, 1974.94.1

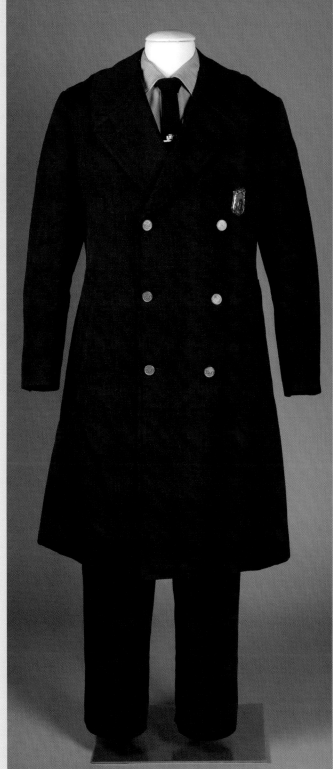

John L. Heavner began working for the B&O Railroad in 1941 as a policeman, but soon left his position to serve in the United States Army during World War II. After the war, John returned and worked at the railroad for the remainder of his life. John saved all paraphernalia connected to his position, including this uniform completed by his nightstick, blackjack, handcuffs, flashlight, and even his pencils, all of which his wife donated to the Maryland Historical Society.

Construction of the Baltimore & Ohio Railroad officially began on July 4, 1828, with Charles Carroll of Carrollton, the last surviving signer of the Declaration of Independence, turning the first shovelful of dirt. During Carroll's keynote speech, he compared the importance of the new railroad, which boasted the title of the first common-carrier railroad chartered specifically for public use, to the importance of the American War of Independence. Operating from 1830 to 1987, the B&O Railroad is considered to be the oldest railway system in the United States.

This uniform is exhibited through the generosity of Mr. Richard L. Berglund.

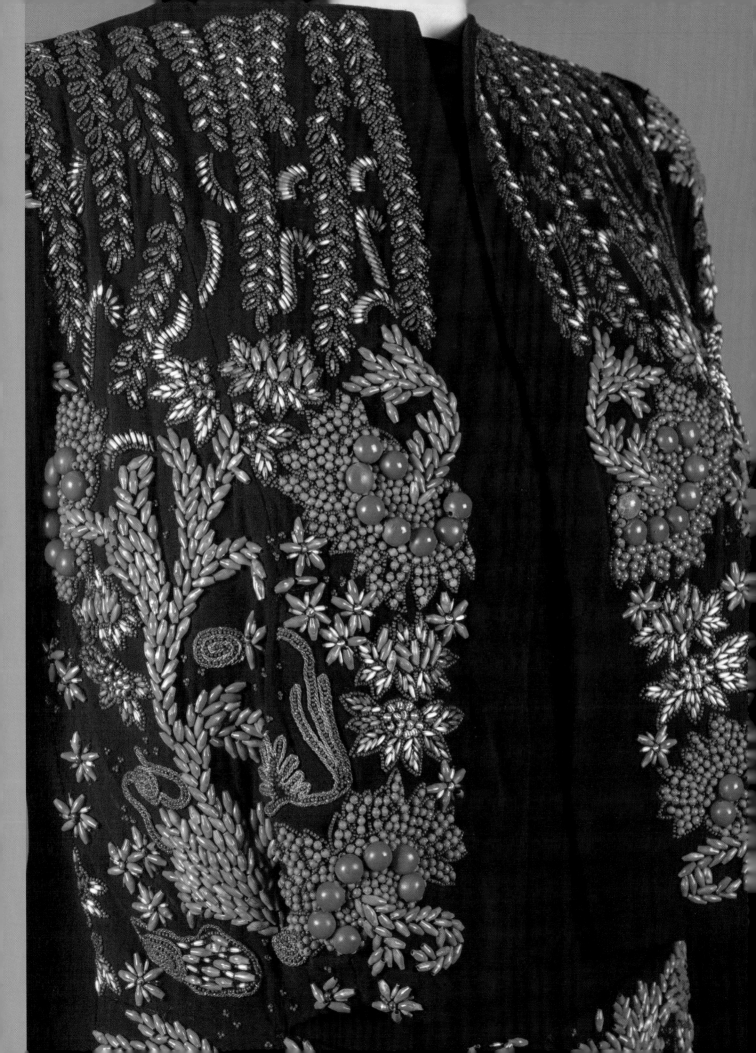

Rayon Crêpe Evening Dress & Jacket Ensemble

1937–1939

Designed by Ventura, Rome

Worn by Muriel Wurts-Dundas Boone

(1906–1970)

Maryland Historical Society, Gift of Mr. James R. Herbert Boone, 1973.48.2

Muriel Dundas Boone and her husband, James Rawlings Herbert Boone, frequently traveled to Europe. During one of their trips to Rome, Muriel purchased this evening dress and jacket ensemble from the Ventura fashion house. With the exception of fan pleating at the skirt, the black crêpe dress is rather plain, until paired with its vividly ornate jacket. Contrasted against the dark fabric, the glass beads, which are painted to imitate precious coral and silver, form exquisite three-dimensional floral patterns.

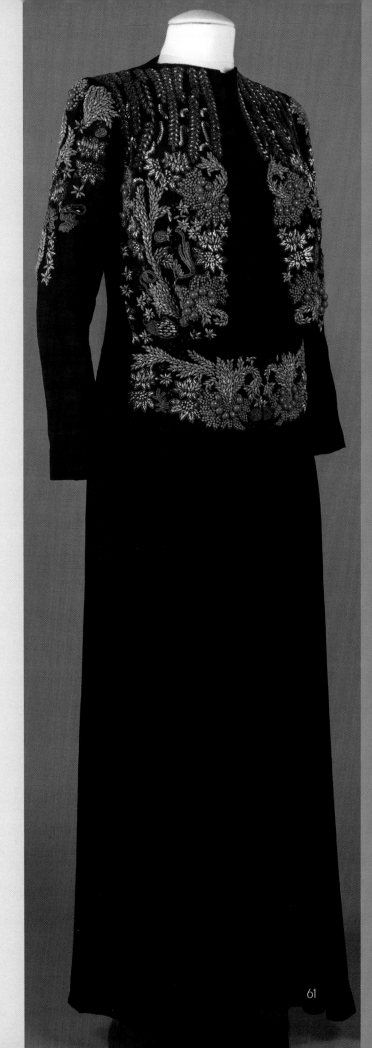

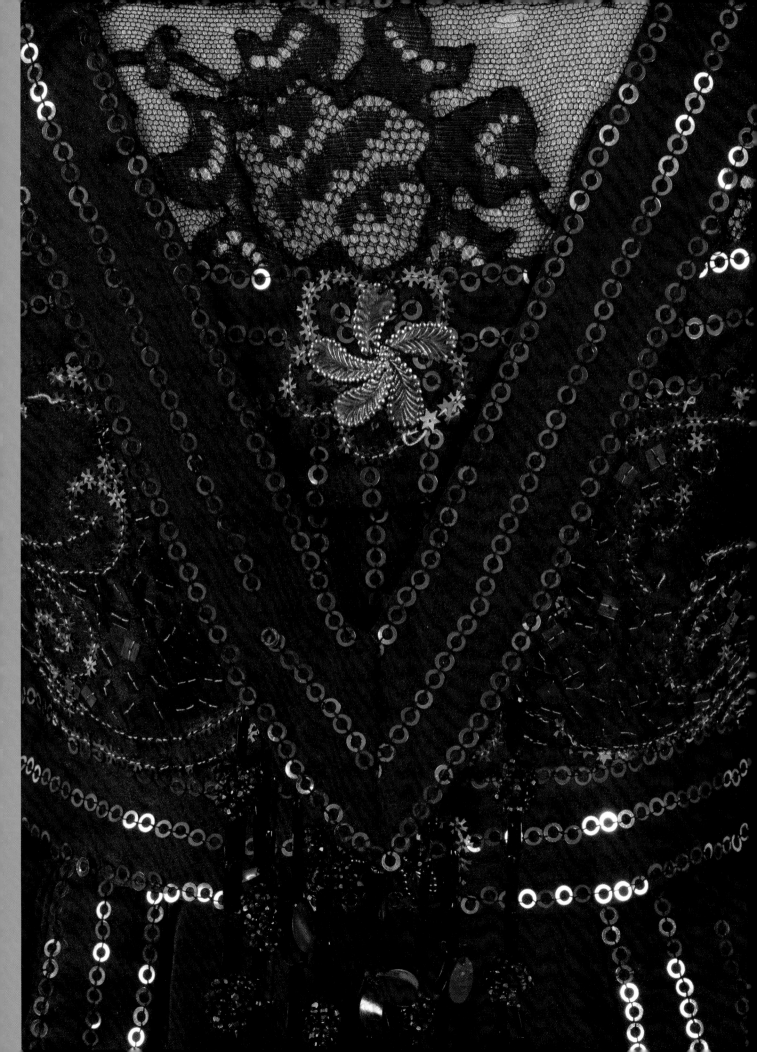

Silk Satin and Tulle Evening Dress

1915–1919
Probably French
Worn by Ethel Cryder Higgins Fowler
(1882–1964)
Maryland Historical Society, Gift of Mrs. Arthur
W. Fowler, 1946.56.11

After their formal introduction to New York society in 1900, when they all wore identical dresses, Ethel Cryder and her sisters, Elsie and Edith, became widely known as the "Cryder Triplets." Each sister famously tied a colored ribbon around her neck to differentiate herself from the others.

After marrying her first husband, Cecil Higgins, in 1908, Ethel spent much of her time abroad. Before and during World War I, the couple lived in England where she likely wore this heavily embellished dress. Sequins on the bodice and train form organic curves that resemble the stems and blossoms of plants, showcasing the Art Nouveau movement's influence on dress design.

This dress is exhibited through the generosity of the Thomas and Carol Obrecht Family Foundation.

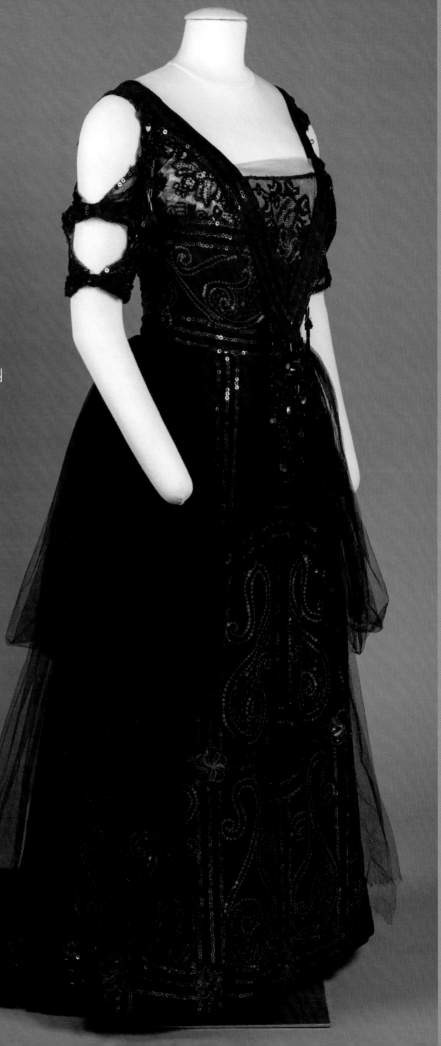

Silk Brocade Waistcoat

1835–1840

Worn by Dr. Charles Jennings Macgill (1806–1881)

Maryland Historical Society, Gift of Miss Louisa M. Gary,
1948.93.1

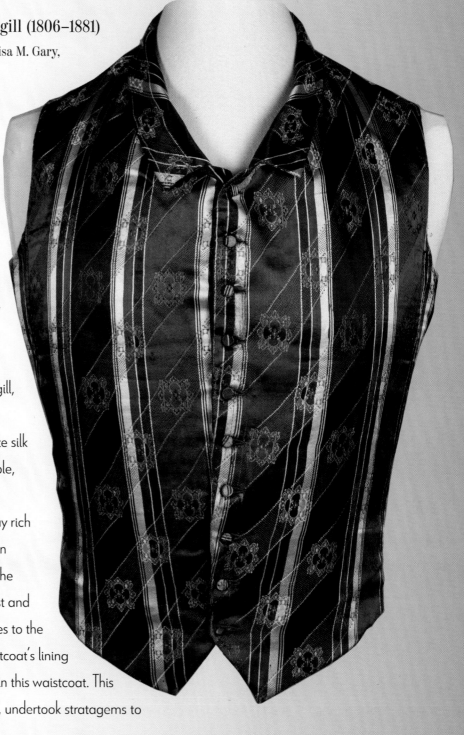

Dr. Charles Jennings Macgill completed his collegiate studies in 1823 at Baltimore College and acquired additional knowledge of medicine and surgery while studying under Dr. Charles G. Worthington. After his apprenticeship, he graduated in 1828 from the College of Medicine of Maryland, now the University of Maryland School of Medicine, with high honors and entered medical practice alongside his brother, Dr. William D. Macgill, in Hagerstown, Maryland.

Macgill would have worn his exquisite silk brocade waistcoat with the era's fashionable, somber-colored woolen suit. Not only did waistcoats provide men a chance to display rich and sumptuous fabrics, they also assisted in attaining the ideal masculine physique of the 1830s, which was defined by a narrow waist and a broad chest. Tailors sculpted men's figures to the preferred silhouette by padding out a waistcoat's lining in the chest with lambswool, as was done in this waistcoat. This demonstrates that men, as well as women, undertook stratagems to create a fashionable silhouette.

This waistcoat is exhibited through the generosity of Julia Browne Sause, the second great granddaughter of Dr. Charles Macgill, in memory of her brothers, Charles Willing Browne III and George Williams Browne.

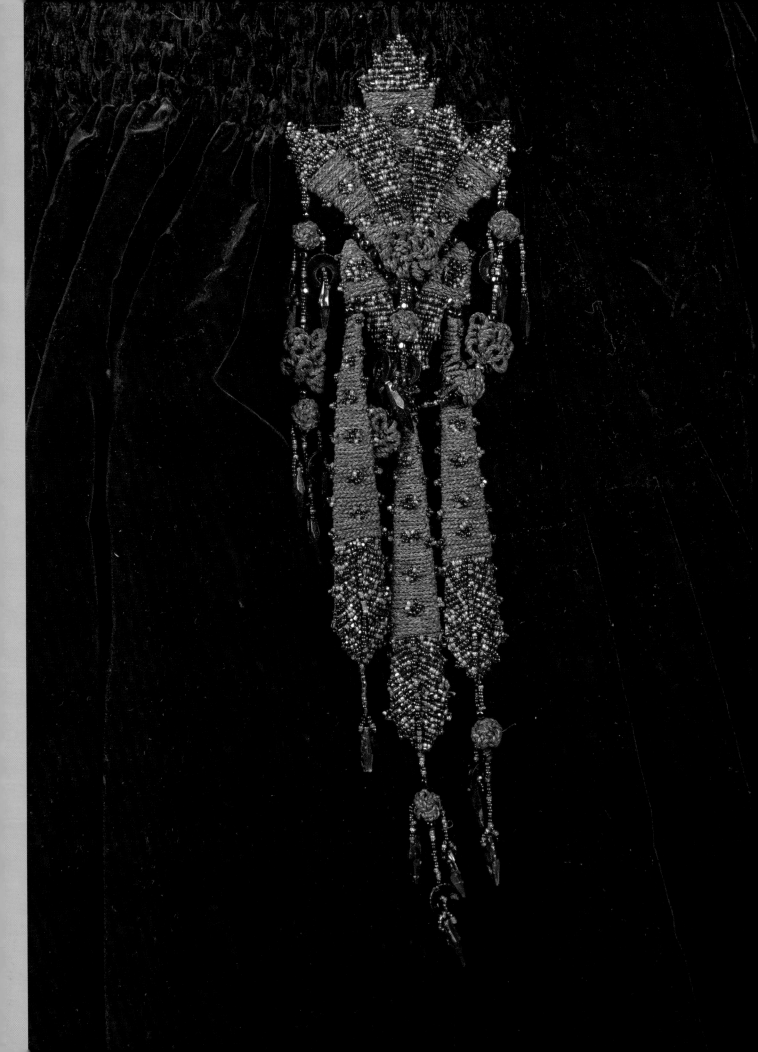

Silk Velvet and Satin Dress

1881

French

Worn by Eliza Ridgely (1858–1954)

Maryland Historical Society, Estate of
Miss Eliza Ridgely 1956.15.27

Eliza Ridgely was born into wealth as
the daughter of Charles (1838–1872) and
Margaretta Howard Ridgely (1824–1904),
and raised at Hampton Mansion in Towson,
one of the largest private estates in America.
This dress, a rich blue velvet that features
a large beaded ornament at the hip and
asymmetric draping, was purchased for
Ridgely by her mother on an 1881 trip to
France.

 Unlike other wealthy, unmarried
women, Ridgely did not appear frequently
in the social pages. Instead, using the
independence granted through her fortune
to help women and children in Baltimore
City, Ridgely founded the United Women
of Maryland in 1897. This large organization
taught young women sewing skills, provided
legal protection for working women,
entertained those confined to hospitals,
instituted kindergarten in Baltimore schools,
and collected clothing to give to those in
need, as well as many other initiatives.

*This dress is exhibited through the generosity
of Nancy E. Smith.*

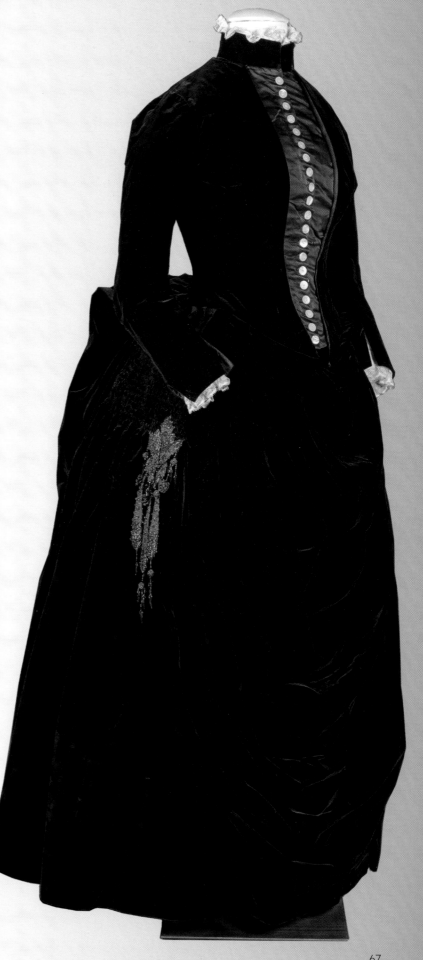

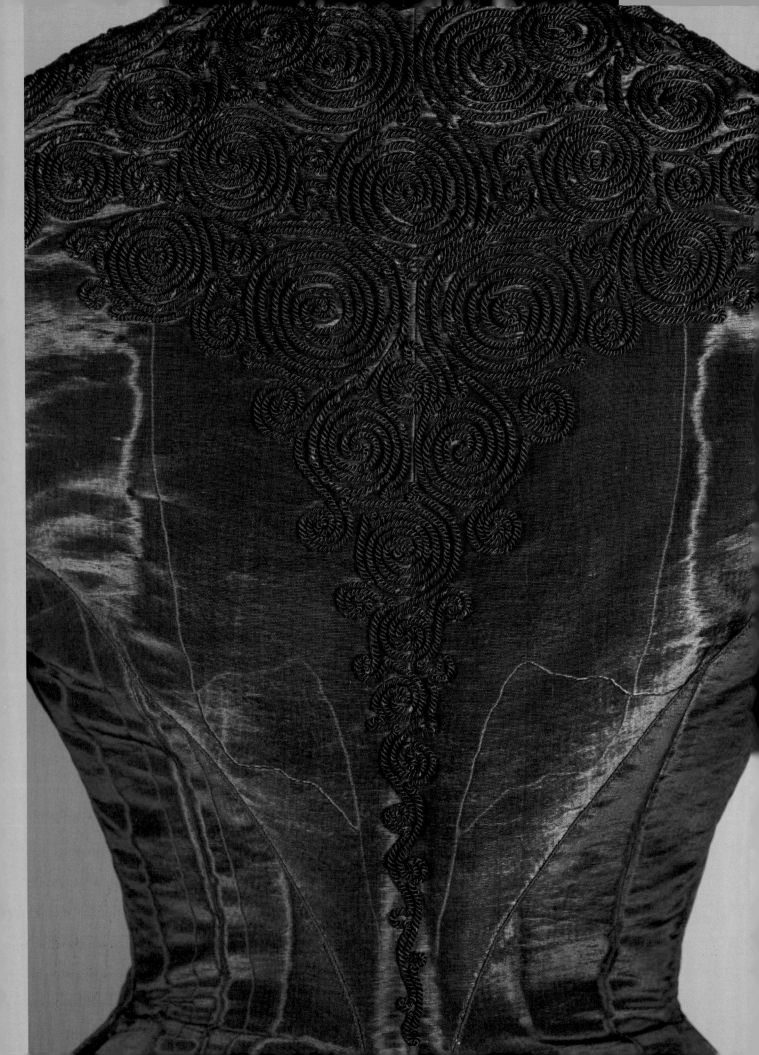

Watered Silk Visiting Dress

1868–1870

Probably French or English

Worn by Margaretta Sophia Howard Ridgely
(1824–1904)

Maryland Historical Society,
Estate of Miss Eliza Ridgely,
1956.15.47

This electric blue, princess line dress with
meticulous hand-sewn decorative cording
has a sad story behind its elegant façade.
The visiting dress appears to have been
barely worn by its owner, Margaretta Howard
Ridgely, and, perhaps, was never worn at all.
It was likely purchased on a family trip in
1870, which started in London and continued
to France. Ridgley's husband Charles
Ridgely (1838–1872) did not survive the
trip and passed away in 1872. After his
death, Ridgely went into mourning,
wearing only blacks, greys, and later
dull purples, until her own death
thirty-two years later. This dress, so
eye-catching and vibrant, would
have been inappropriate to wear
in mourning, and was packed
away, never to be worn again.

*This dress is exhibited through
the generosity of The Women's
Committee of Historic
Hampton, Inc.*

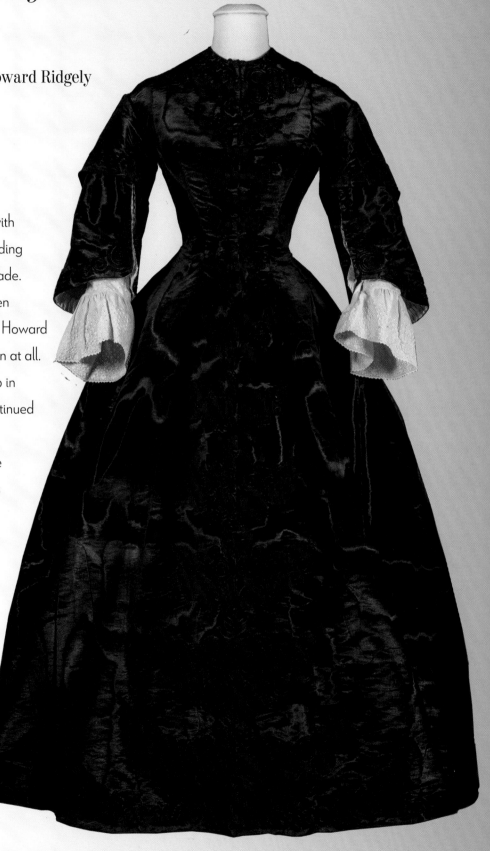

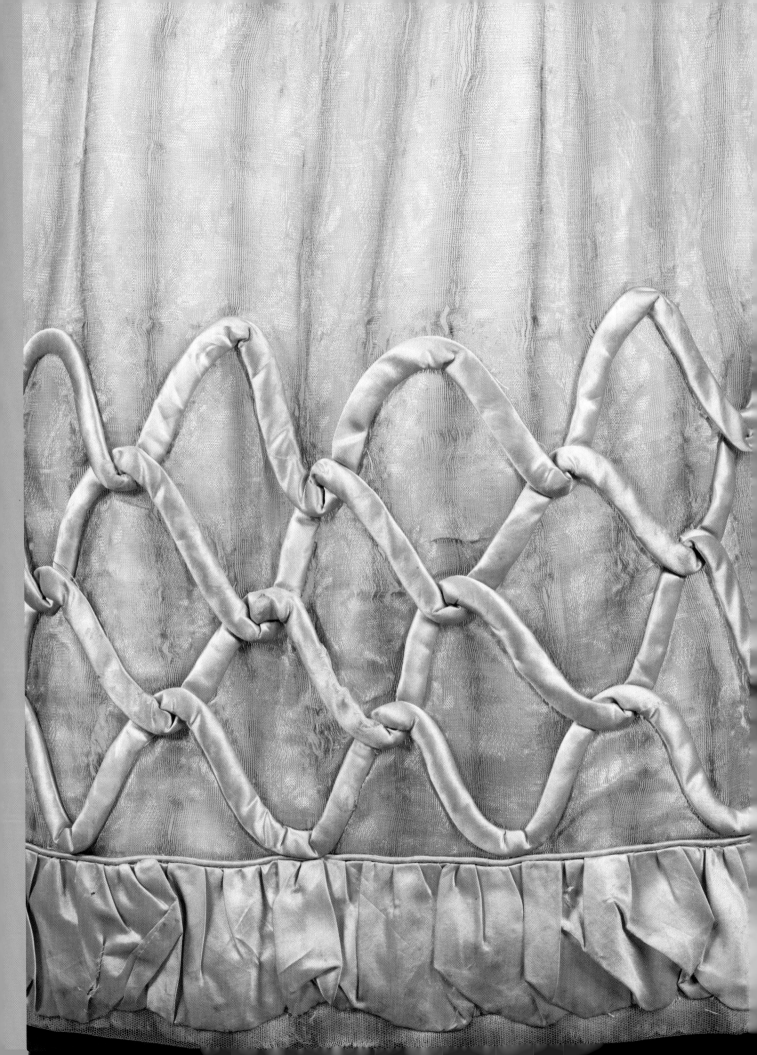

Silk Gauze Evening Dress

1820–1823

Mary Pennington Rutter (1779–1850)

Maryland Historical Society, Gift of Mrs. Olive Rutter Parks and Miss Mary Alice Rutter, 1956.84.6

Rouleaux trim, or tubular lengths of fabric padded out with lambswool, was applied to this dress's bodice, sleeves, and skirt hem. This popular form of ornamentation added dimensional motifs to dresses of the 1820s. Such fancy borders at the skirt's hem flared it out into an A-line silhouette, so different from the earlier narrow, columnar lines popular in Neoclassical styles. This dress, with its delicate *ombré* silk gauze fabric ornamented with lavish trim, embodies the new Romantic-era styles of the period.

This dress is exhibited through the generosity of the Jane Austen Society of North America, Maryland Region.

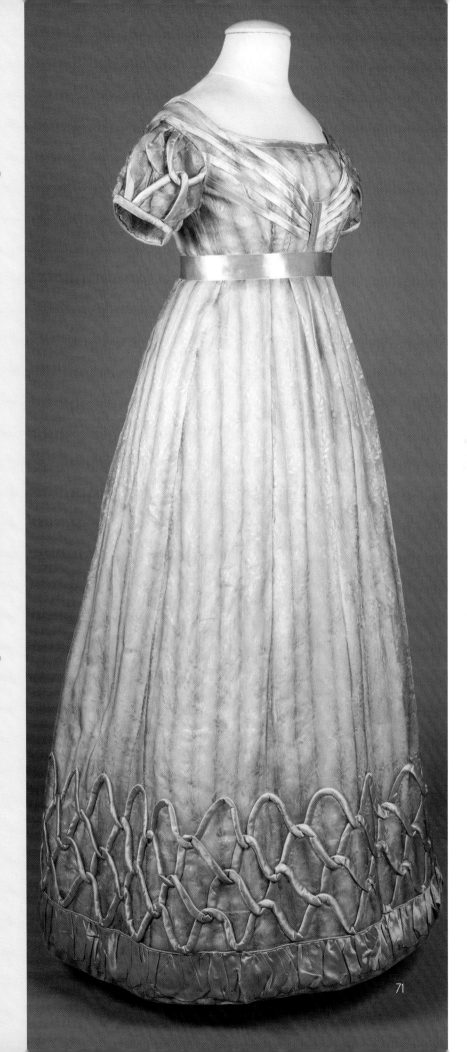

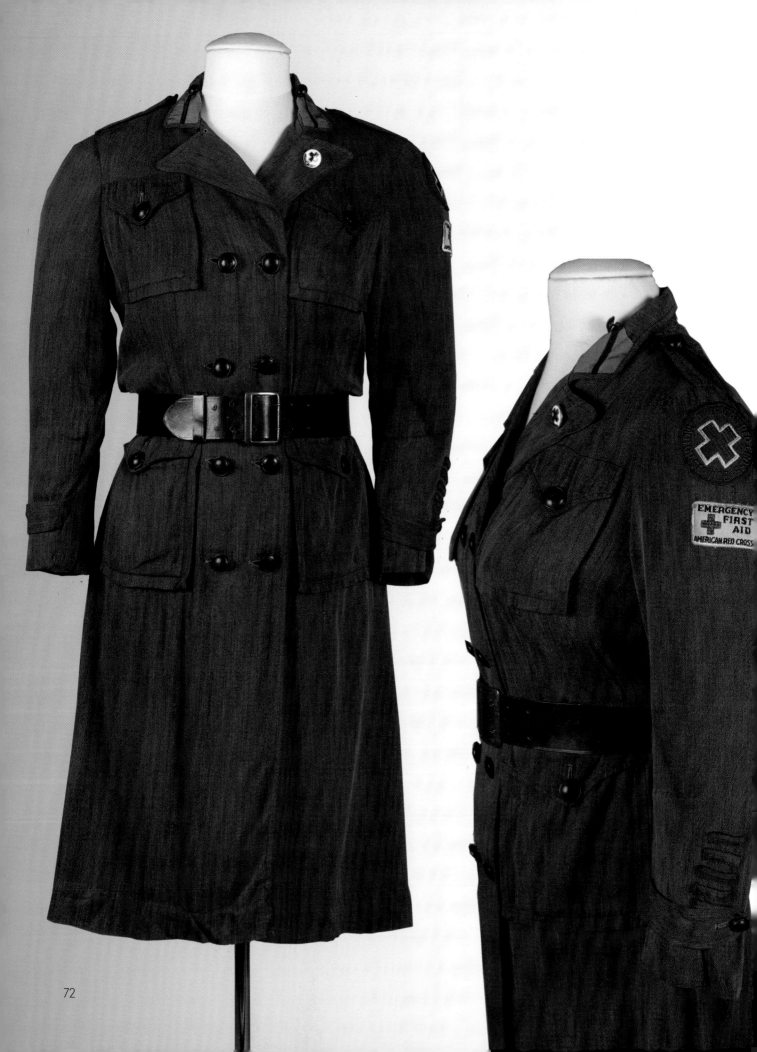

World War II American Red Cross Motor Service Uniform

1942–1944

Worn by Virginia Newcomer (1900–1982)

Maryland Historical Society, Gift of Mrs. Frank Newcomer, 1976.54.1

The American Red Cross Motor Service Corps was developed in World War I, during which over ten thousand women volunteered to deliver supplies and transport the sick and wounded. The Motor Corps continued to serve during the Second World War, this time with over 45,000 women like Virginia Newcomer, who completed rigorous training to volunteer as a transport and supply driver.

While women's uniforms carried some menswear characteristics like a double-breasted closure, patch pockets, and leather belt, their skirts made them distinctively feminine. The fabric of this Motor Corps dress from 1942 may look like wool gabardine, but it is actually a grey-blue spun rayon, a much lighter fabric used in dressmaking. To complete her uniform, Newcomer would have been required to wear a low-heeled black shoe and silk or cotton hose at all times.

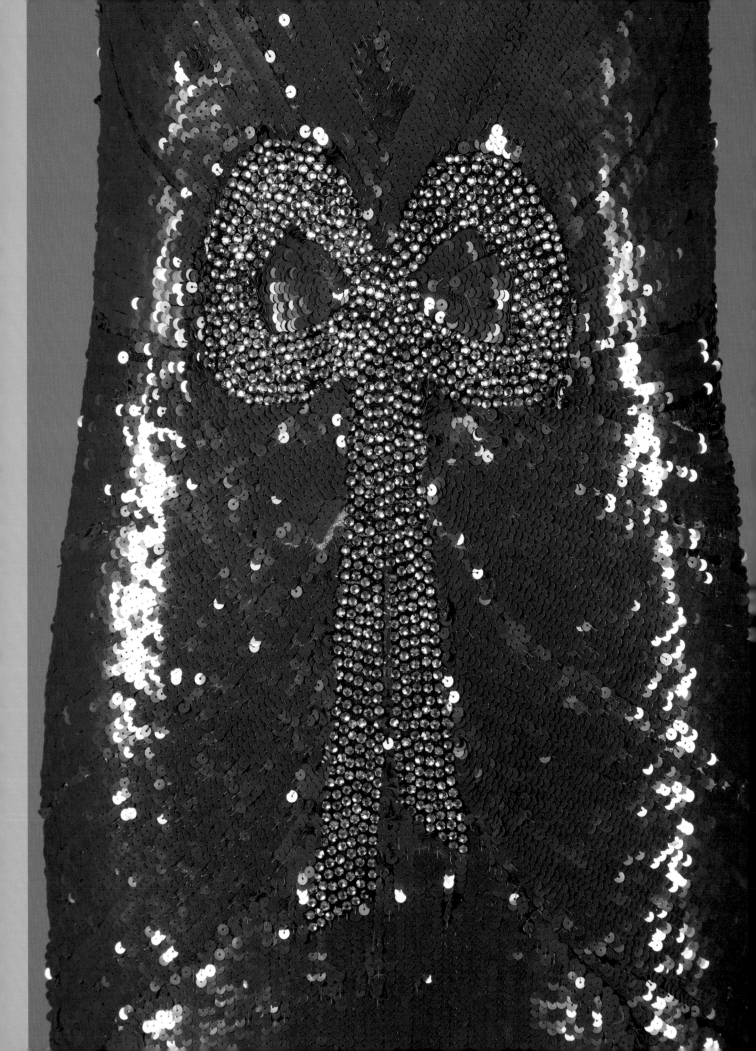

Sequined Evening Dress

1928–1929

Made in France

Worn by Carolyn Fuld Hutzler (1909–1996)

Maryland Historical Society, Gift of Mrs. Joel G. D. Hutzler, 1979.15.1

Carolyn Fuld Hutzler was born into a large family of German Jews involved in the dry-goods business in Baltimore. Her husband Joel Hutzler, along with his brother Albert and cousin Louis, ran the Baltimore-based department store Hutzler Brothers & Company during its later years of operation. Advertisements for the store boasted of the "Hutzler Standard," a guarantee that the store's fine quality goods would impress even those who demanded the absolute best. Carolyn Hutzler purchased this French-made dress from Hutzler's, illustrating the store's practice of retailing luxurious European goods to Baltimore consumers.

This dress is exhibited through the generosity of Rebecca Katz.

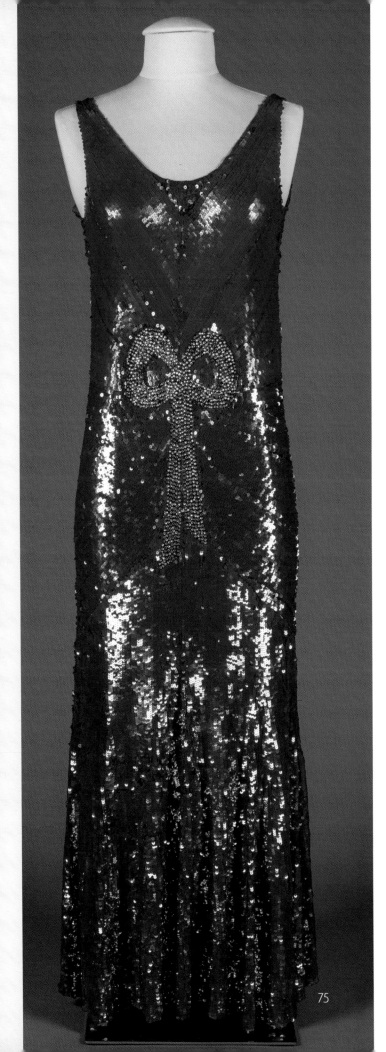

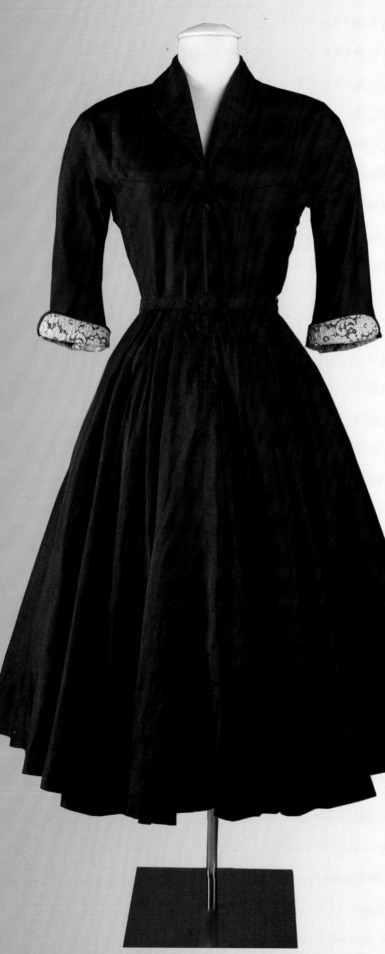

Silk Dress

1950–1952

Hutzler's Dress Salon

Worn by Amelia Prescott Allison Stirling (1899–1989)

Maryland Historical Society, Gift of Mrs. Campbell Lloyd Stirling, 1984.27.3

Amelia Prescott Allison Stirling began working at the Baltimore department store Hutzler Brothers & Company as its magazine editor. Over the years, Stirling accepted various promotions, moving into the positions of advertising copywriter, advertising manager, and finally publicity manager. As Baltimore's first woman to manage the marketing department of a major department store, Stirling handled all advertising, merchandise displays, fashion shows, and store promotions for the Hutzler Brothers Company.

Hutzler's first opened its doors in Baltimore when Moses Hutzler and his son, Abram, founded the company in 1858 as a single storefront. Abram's brothers, Charles and David, joined the retail operation in 1867 and by the early twentieth century the store was known as the Hutzler Brothers Company. Hutzler's was well-known for its importation of fashion goods from Europe, and also sold high-end ready-to-wear women's clothing such as Stirling's navy blue silk dress under its own label, "Hutzler's Dress Salon."

Wool Suit

1942–1945

Made by Metzel, New York and H. Harris, New York

Worn by Edward VIII, the Duke of Windsor (1894–1972)

Maryland Historical Society, Gift from the Stiles Ewing Tuttle Memorial Trust and Stiles Tuttle Colwill in memory of Eugenia Calvert Holland, 1998.04.26

Famously known for abdicating the throne in 1936 and marrying Baltimorean Wallis Simpson, Britain's king, Edward VIII, was also celebrated as an influential style icon. As the Prince of Wales in the 1920s and early 1930s, he influenced the rise of casual menswear by experimenting with clashing patterns and colors and introducing new fashion trends.

The Duke of Windsor preferred comfort and ease of movement in his clothing, as demonstrated by this unlined, loose-fitting suit jacket he wore during the 1940s. Along with the overall relaxed fit, the Duke's suit also features various details he is credited for popularizing, such as cuffed trousers, the tab collar, the welted pockets he preferred over pocket flaps, and a four-button double breast closure rather than the commonly seen six-button closure.

This suit is exhibited through the generosity of Mark B. Letzer.

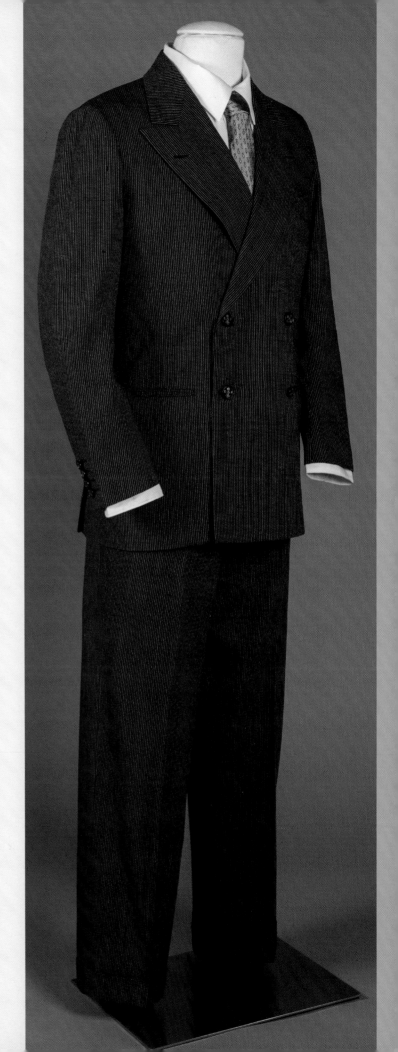

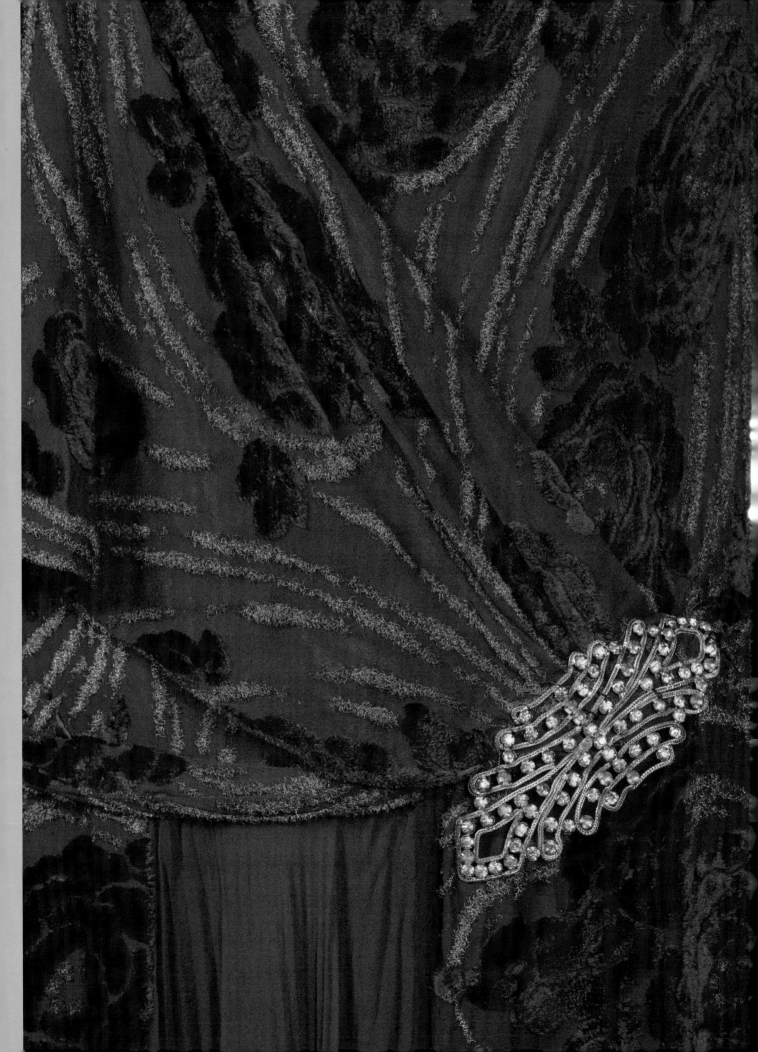

Silk Chiffon and Velvet Dress

1925–1929

Worn by Mary George White Bates

(1885–1963)

Maryland Historical Society, Gift of the Frances B. Wells Estate, 2016.11.2

Known as flappers and "bright young things," the fashionable women of the 1920s shocked their elders by bobbing their hair, using slang, putting on lipstick in public, and wearing short, low-waisted chemise frocks. As women adopted more active lifestyles, such as performing the highly energetic dances that emerged during the decade, designers generated a new and simpler look, particularly noted by vertical lines and rising hemlines. With androgynous silhouettes that rejected accentuating the natural curves, women of the 1920s visually transformed themselves into feminized versions of men, symbolizing the general liberalism that prevailed throughout the decade.

This dress is exhibited through the generosity of Mrs. Sarah Wells Macias, Mrs. Katherine W. Power, Mrs. Nancy Wells Warder, and Ms. Marianne D. Wells.

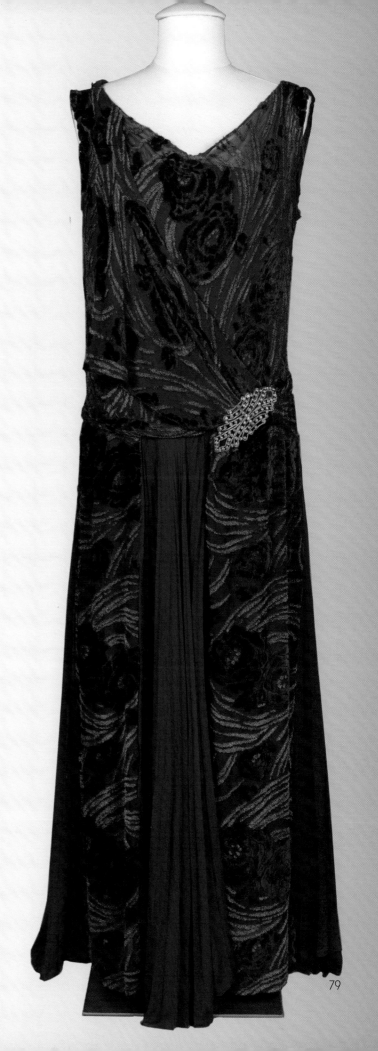

Silk Skirt and Jacket Ensemble

c.1980
Made by Hermès
Worn by Gertrude Louise Poe
(1915–2017)
Maryland Historical Society, Gift from
the Estate of Gertrude L. Poe, 2018.2.26

Gertrude Louise Poe, a pioneer in her field, is known as "Maryland's First Lady of Journalism." In 1980, Poe retired from her forty-one-year career as editor of *The News Leader*. After her retirement, Poe remained a fixture in Maryland, endowing a scholarship fund at the University of Maryland's College of Journalism, staying active in her community in Laurel, and traveling to Europe.

During her European travels, Poe purchased high-end ready-to-wear pieces by top designers. This stunning ensemble by Hermès exemplifies her love of timeless styles, fine fabrics, and striking patterns. This skirt and jacket both have the same mosaic pavement pattern that is featured on one of Hermès's signature scarves. The skirt in fact appears to be made from a series of the scarves, pleated and attached together, with slits on either side.

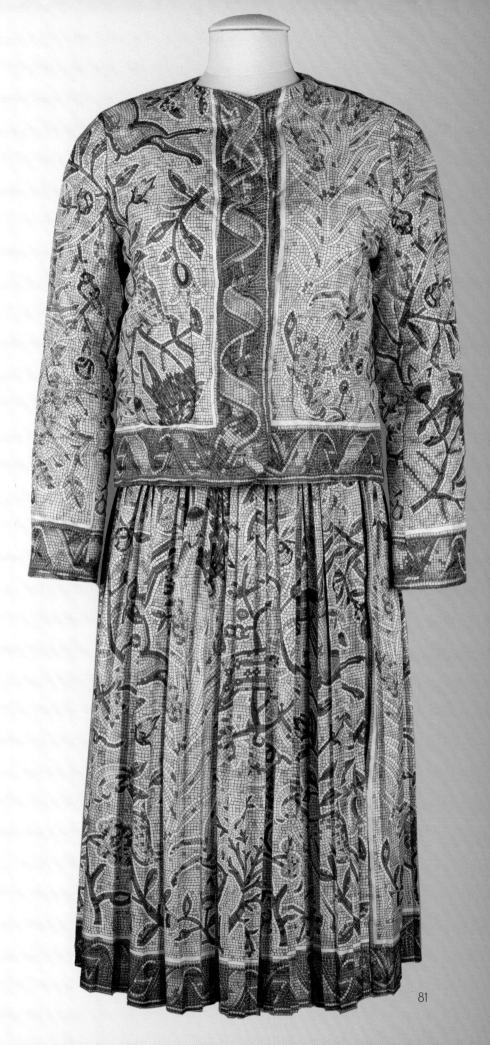

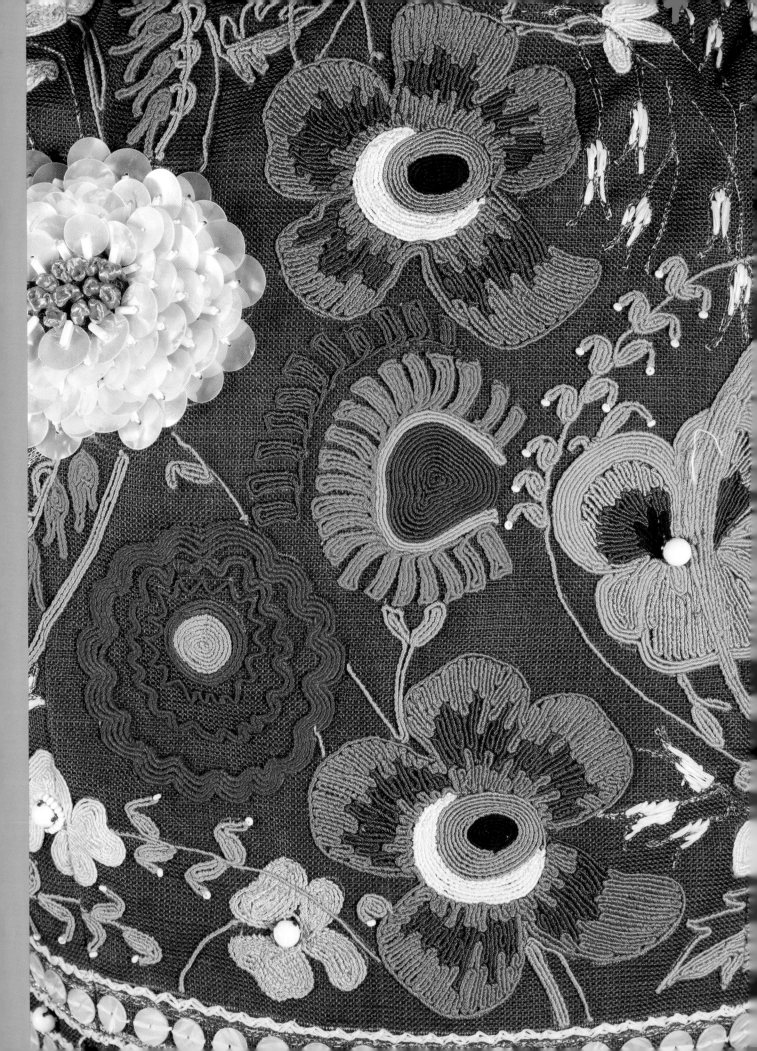

Silk and Linen Crop Top, Skirt, and Shorts

1969–1970

Designed by Madame Grés (1903–1993)

Worn by Wallis Warfield Simpson, the Duchess of Windsor (1896–1986)

Maryland Historical Society, Gift from the Stiles Ewing Tuttle Memorial Trust and Stiles T. Colwill in memory of Eugenia Calvert Holland, 1998.4.24

This striking ensemble was worn by the Duchess of Windsor when she was seventy-three years old and was supposedly created for a visit to Thailand. Despite the notion that she wore the shorts as "hot pants," it was, in fact, the style to wear shorts of this type under maxi or long skirts with slits and the shorts were never intended to be worn alone. It is uncertain whether or not she allowed her midriff to show when wearing this, but the top is decidedly cropped.

Madame Grés's extraordinary career as a couturière and costume designer spanned more than six decades. Known for the drapery of her earlier designs, by 1970 she had reinvented her aesthetic, creating gowns that allowed midriffs and backs to show in provocative ways. With its elaborate beadwork and embroidery, this ensemble marked a significant departure from her typical styles and must have been a custom piece for one of her best and longest-standing clients, the Duchess of Windsor.

This ensemble is exhibited through the generosity of Claire Miller.

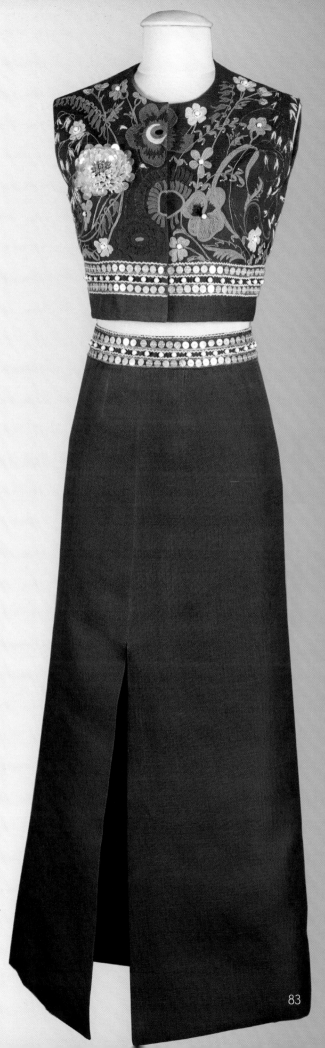

83

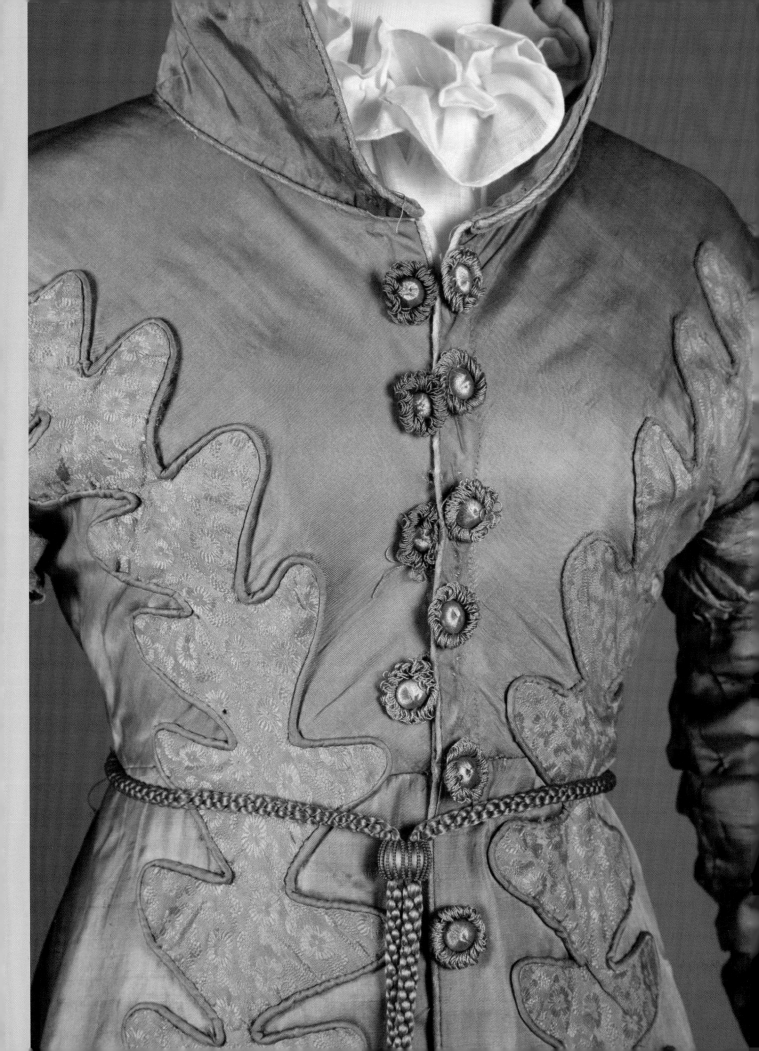

Silk Pelisse

1815–1820

Possibly worn by Eliza
Eichelberger Ridgely
(1803–1867)

Maryland Historical Society, Gift of
John Ridgely, 1944.76.24

A pelisse was a type of fitted outer
coat characterized by decorative
trims and ornamentation. During
the 1810s, a revival in Renaissance
and medieval motifs manifested
themselves in clothing. This
electric green silk pelisse features
silk appliquéd "Vandyke"-style
decoration, which takes its name
from trim with large points seen
in seventeenth-century Dutch
paintings by Sir Anthony van Dyck.
Alongside this detail, the pelisse's
silk braid cord with metal tassels
and double-puffed sleeves perfectly
reflect the era's fashionable Gothic
aesthetic.

*This piece is exhibited through the
generosity of Renée Wilson of Bijoux.*

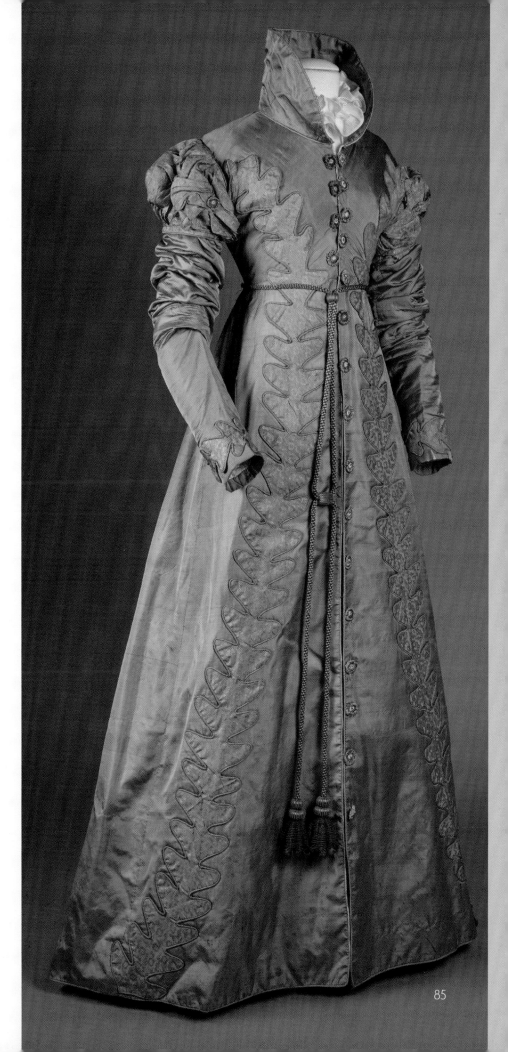

Silk Brocade Evening Dress

1913

Designed by Cauët Sœurs, Paris

Worn by Laura Patterson Swan Robeson (1881–1973)

Maryland Historical Society, Gift of Mrs. Andrew Robeson, 1948.58.2

During her 1913 European honeymoon with her husband Andrew Robeson, Laura Patterson Swan Robeson purchased this Cauët Sœurs gown on the Rue de la Paix in Paris, a boulevard renowned for the numerous couture houses based there. Reflecting the new slender silhouette that revealed a woman's figure, this gown's asymmetrical drapery billows at the hips while tapering tightly down to the hem, creating a "hobble skirt," so called because its narrowness forced women to "hobble" when walking.

This dress is exhibited through the generosity of Mark B. Letzer in honor of Louise Lake Hayman.

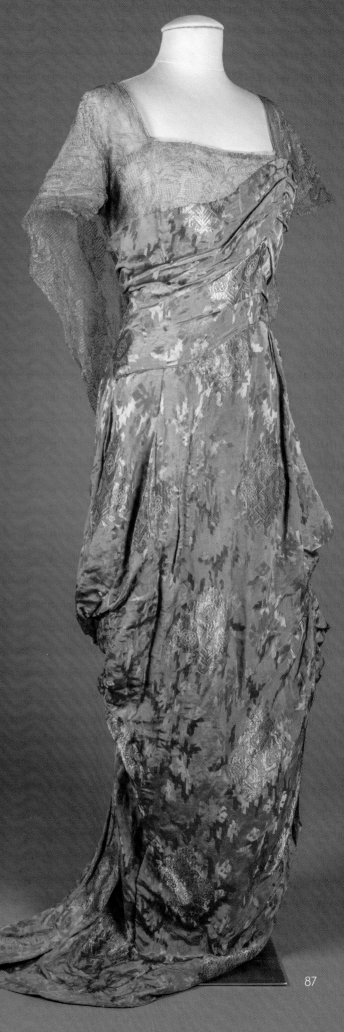

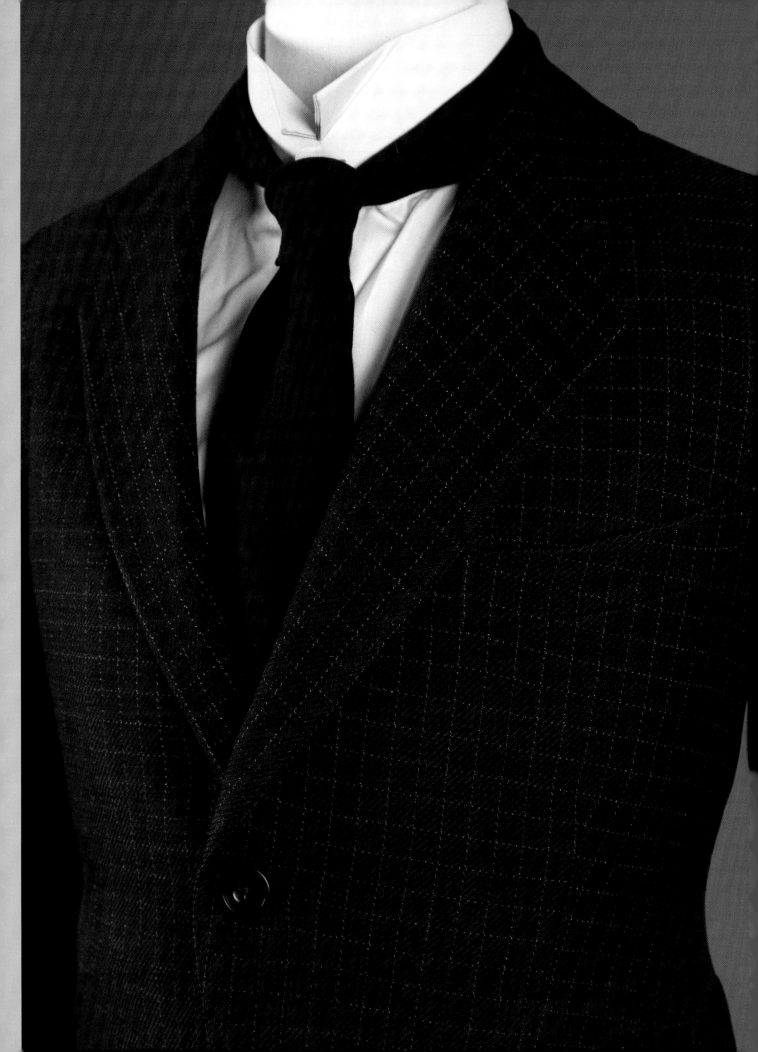

Wool Suit

1890–1899

Maryland Historical Society, Gift of Mr. Paul Edel, 1962.105.1

Although no information survives regarding the original wearer of this dark green plaid suit, stamped on the jacket's inside pocket is "Paul Edel, Costumer, Baltimore, Md." Edel owned a shop on 204 West Monument Street, directly across from the Maryland Historical Society, where he rented out the historic clothing he collected, such as this 1890s suit, as "costumes for all occasions."

In addition to being a costumer, he directed and acted in various theatricals. Edel was particularly involved with Baltimore's Vagabond Theater, the country's oldest continuously operating "Little Theater," a movement that emphasized experimental works produced by amateurs.

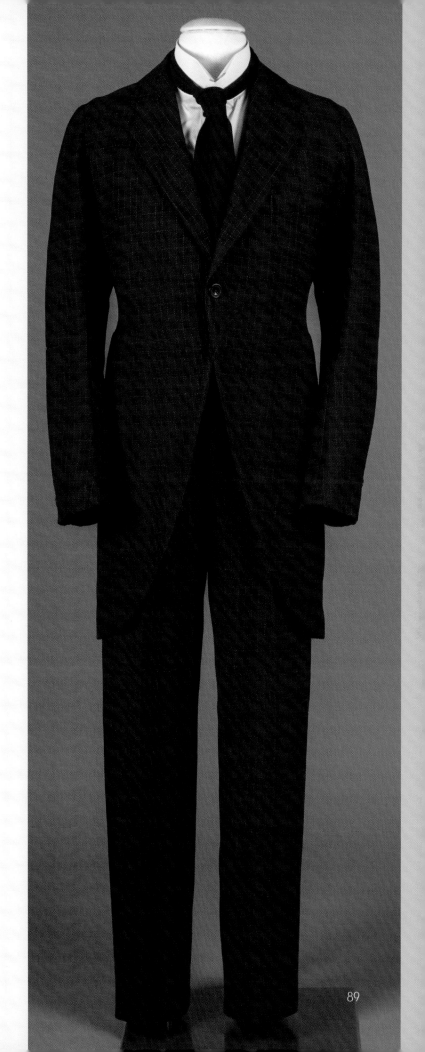

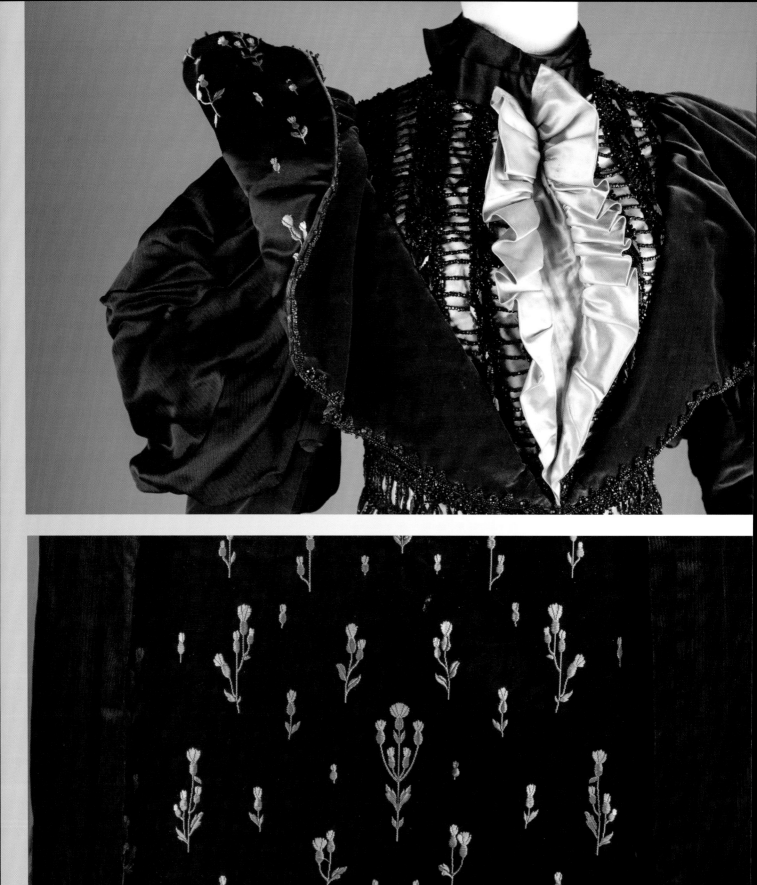

Silk and Velvet Dress

1895
E. Craig, Importer
Worn by Mrs. Elizabeth
Vickers Anderson (1868–1930)
Maryland Historical Society, Gift of
Mrs. Kent Groff, 1978.95.63 a, b

Dated to 1895, Elizabeth Vickers
Anderson's dress presents the
cyclical nature of fashion with its
voluminous leg-of-mutton sleeves, a
style previously popular in 1830s. To
counterbalance the broad shoulder
line, horsehair lining stiffens the skirt
and widens the hemline to match
the shoulders' width. Following
popular fashion trends of the 1890s,
Anderson's dress with its dark green
silk velvet, chartreuse silk satin, and
black silk brocade utilizes contrasting
fabrics, colors, and textures to create
a visually striking look.

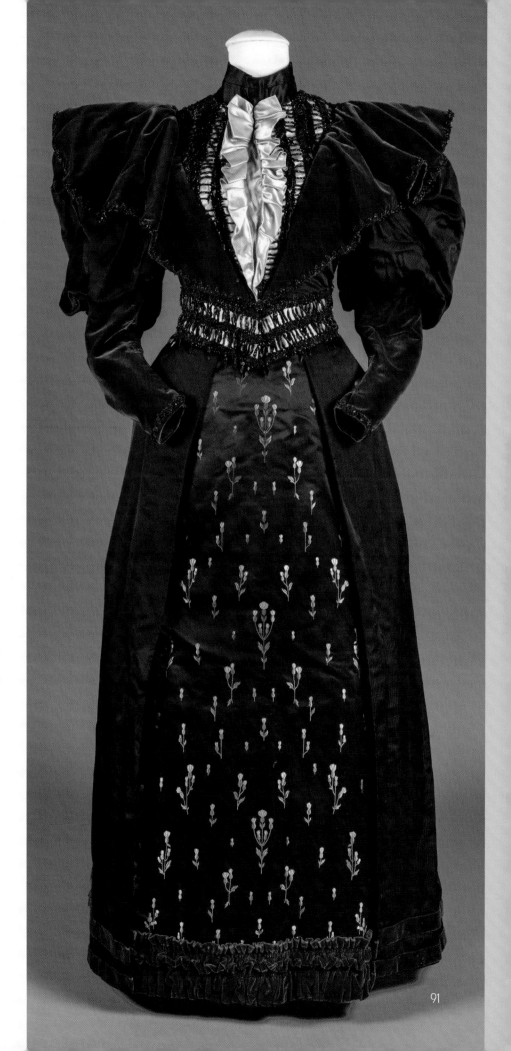

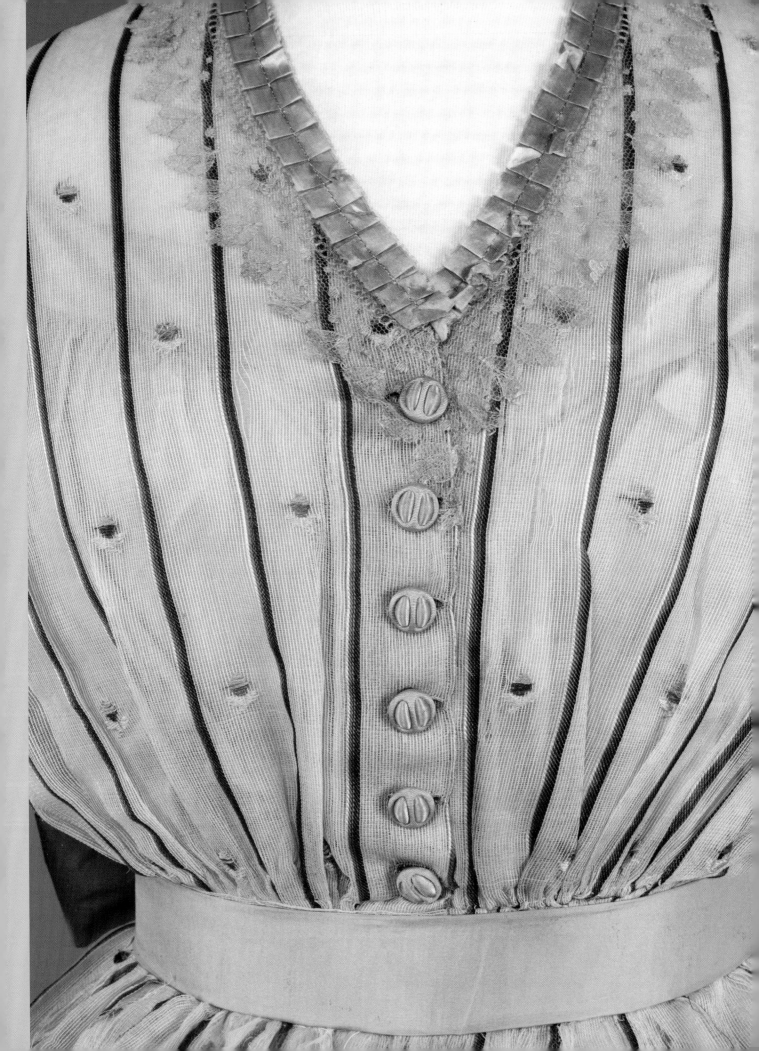

Silk Gauze Embroidered Dress

1868–1870

Possibly worn by Mary Garrettson Evans (1841–1918)

Maryland Historical Society, Gift of the Scott Family of Western
Run Valley, Baltimore County, 1984.57.1-2

"There is nothing so graceful and pretty for a young person
as a thin dress"

> — *Godey's Lady's Book*, March, 1865

Sheer, gauzy dresses such as this one became
popular in the 1860s, especially with younger
women. Open weaves, rather than closely-
woven silk gowns, were particularly
desirable in the summer months. Despite
the prettiness of these sheer, light dresses,
they lacked the vibrant colors of their silk
taffeta contemporaries. To add color,
the dresses were trimmed with bright
ribbons and lace, or punctuated
with vibrant embroidery. This
dress, from the Scott family
of Western Run Valley,
features red stripes and
blue, red, and violet
flowers embroidered
throughout, as
well as acid
green ribbon
and lace
trim.

Printed Cotton and Wool Knit Dress

1955

Designed by Claire McCardell (1905–1958)

Worn by Natalie Mendeloff

Maryland Historical Society,
Gift of Natalie Mendeloff, 1998.19 a-b

By the mid-1950s, award-winning designer Claire McCardell had made a name for herself in the world of contemporary fashion. In November 1955, *Life Magazine* published the article "New Fabrics Put Modern Art in Fashion," which featured the design collaboration between artist Marc Chagall and McCardell. Chagall designed this dress's floral cotton print and McCardell cleverly pleated the fabric to best highlight his artwork, particularly the abstract human figures. The yellow wool sash draws attention to the wearer's cinched waist and emphasizes the hourglass silhouette of the 1950s.

This dress is exhibited through the generosity of Mrs. Barbara L. Hecht.

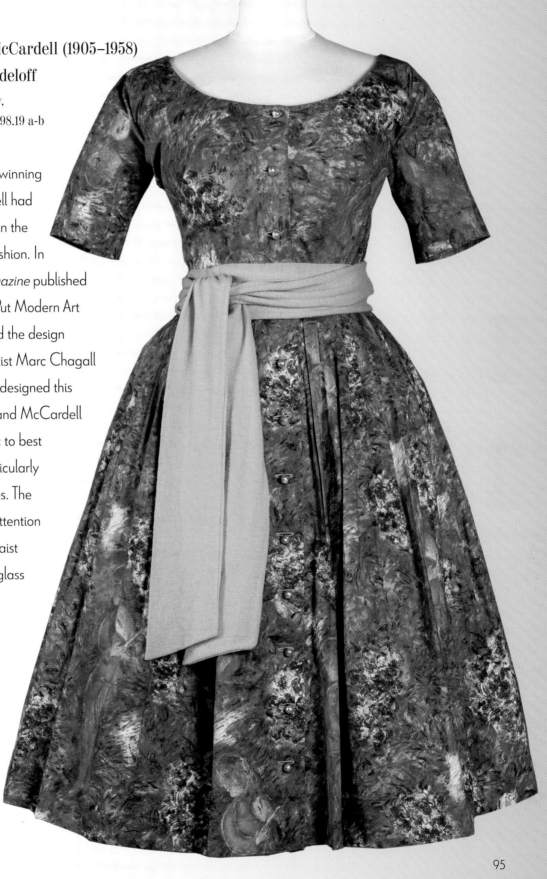

Wool United States Army Hospital Corps Uniform

1942–1945

Made by Carey, Baltimore

Worn by William Donald Schaefer (1921–2011)

Maryland Historical Society, Gift of the Estate of William Donald Schaefer, 2012.35.1

After receiving his Bachelor of Laws degree from the University of Baltimore in 1942, William Donald Schaefer put his legal career on hold and enlisted as a private in the United States Army Hospital Corps on October 17, 1942. Stationed at the 2nd General Hospital in England, Schaefer served in a supervisory position at military hospitals in Western Europe, specifically Britain. In the later years of the war he was transferred to the 802nd Hospital Center. Rising through the ranks, Schaefer left active duty after World War II with the rank of major and remained in the U.S. Army Reserves until he retired in 1979 with the rank of colonel, indicated by the silver eagles pinned to the jacket's shoulders.

Returning to Baltimore after the war, Schaefer completed a Master of Laws degree in 1951 and then began a celebrated career in public service. He won a seat on Baltimore's City Council in 1955, working his way up to the council presidency. After sixteen years as a councilman, he won four terms as Baltimore's 44th mayor, from 1971 to 1987. Schaefer then served as Maryland's 58th governor, from 1987 to 1995, and later the 32nd Comptroller of Maryland, from 1999 to 2007. During his extensive political career, he received several honorary degrees and awards, including the Jefferson Award for Public Service by an elected official.

This uniform is exhibited through the generosity of Louise Lake Hayman.

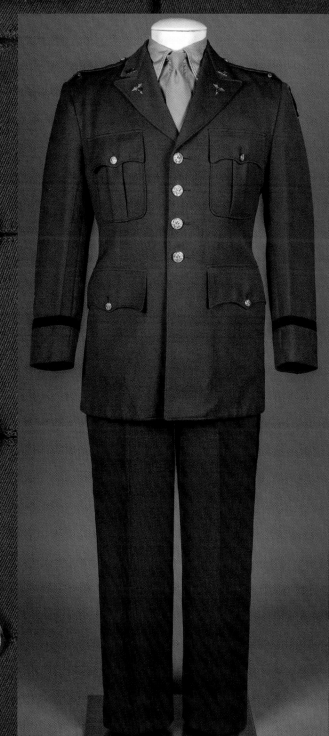

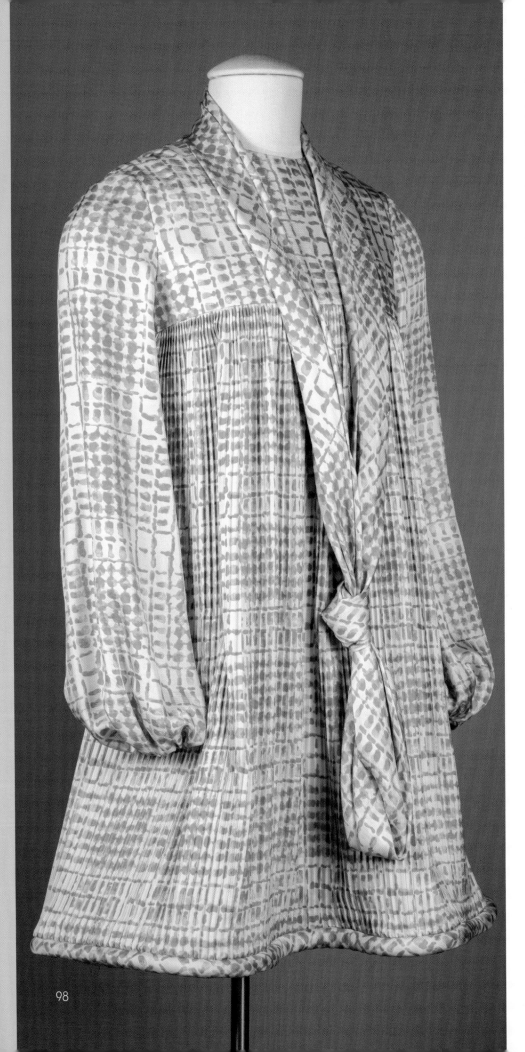

Silk Minidress

1965–1969
Designed by Pierre Cardin, Paris
Worn by Barbara P. Katz
Maryland Historical Society, Gift of Mrs. Barbara P. Katz, 2017.5.6

When the miniskirt styles of the 1960s grew in popularity, long-time Baltimorean Barbara Katz declared she would never wear one. Despite this, Katz eventually gave into the trend and purchased this, her first minidress, designed by Pierre Cardin. From that moment on, Katz embraced higher hemlines.

The green and white printed silk minidress features an abstract watercolor design that mimics a plaid. The style is playful, with a baby-doll cut, pleated circular skirt and rolled band at the hem.

This ensemble is exhibited through the generosity of G. Brian Comes and Raymond Mitchener of Ruth Shaw.

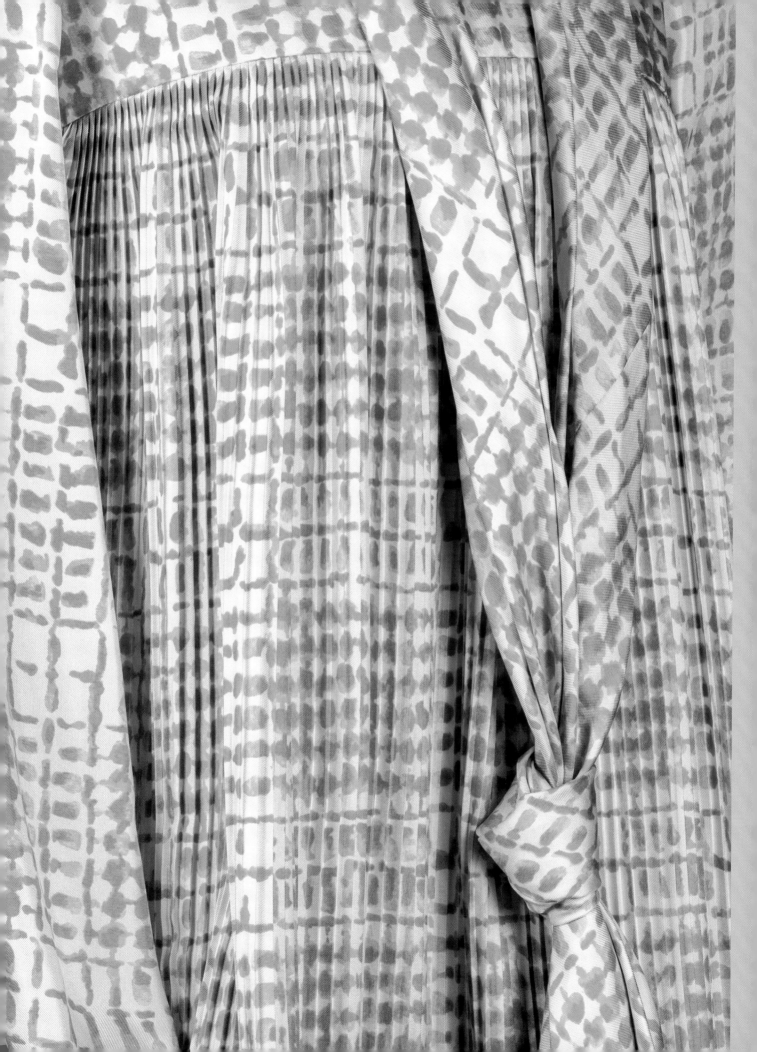

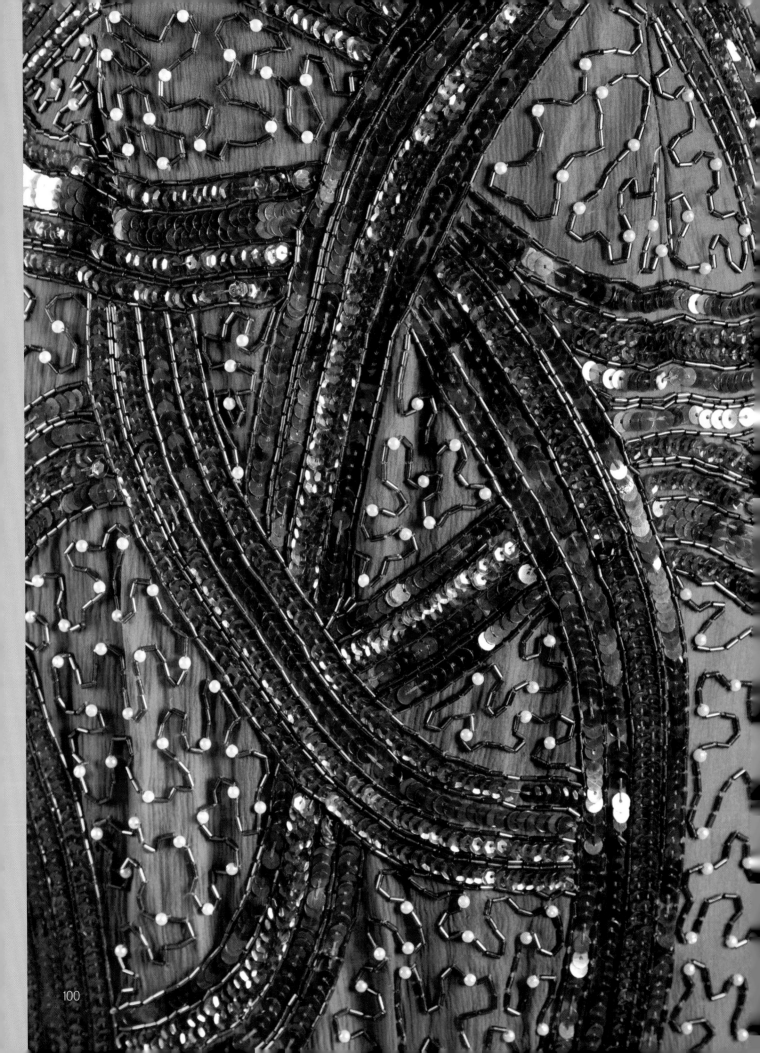

Silk Beaded Evening Dress

1980s

Designed by Judith Ann Creations

Worn by Gertrude Louise Poe

(1915–2017)

Maryland Historical Society, Gift from the Estate of
Gertrude L. Poe, 2018.2.34

Gertrude Poe was used to standing out in a crowd.
Throughout her long journalistic career, she was often
not just the only woman in a room, but the first woman
permitted in the room, as when Poe became the first
woman inducted into the now Maryland-Delaware-DC
Press Association's Hall of Fame in 1987.

This beaded silk net evening dress certainly would
have made Poe stand out when she first wore it in the
1980s at the Olney Theatre's premiere of *The Wizard
of Oz*. Covered entirely in two-tone green beads and
sequins, the boldly-colored gown evokes Oz's Emerald
City. With its heavily padded shoulders, clingy drape, and
beaded fishtail train that glimmered with every movement,
this dress was a favorite of Poe's and she wore it numerous
times over the years, including in 2004 to the Laurel
Historical Society Gala. Poe's support of the Olney Theater
continues today and, each year, one production a season is
supported by her generosity.

*This gown is exhibited through the generosity of Edie
Hostetter Hess in memory of her father, E. Ralph Hostetter.*

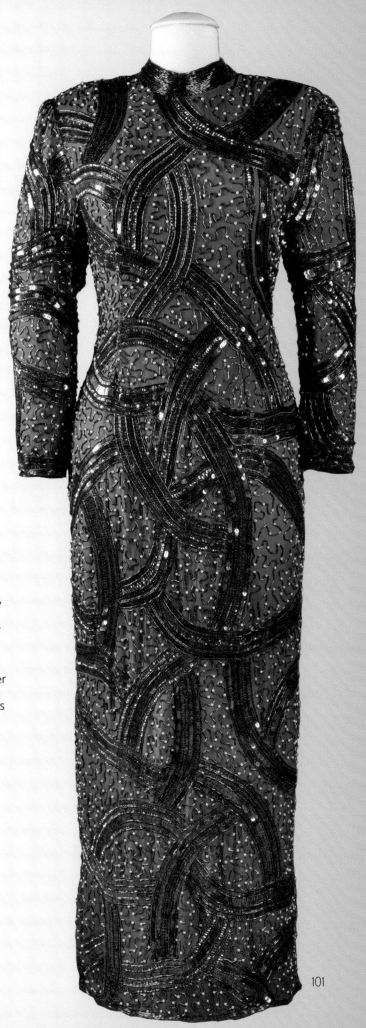

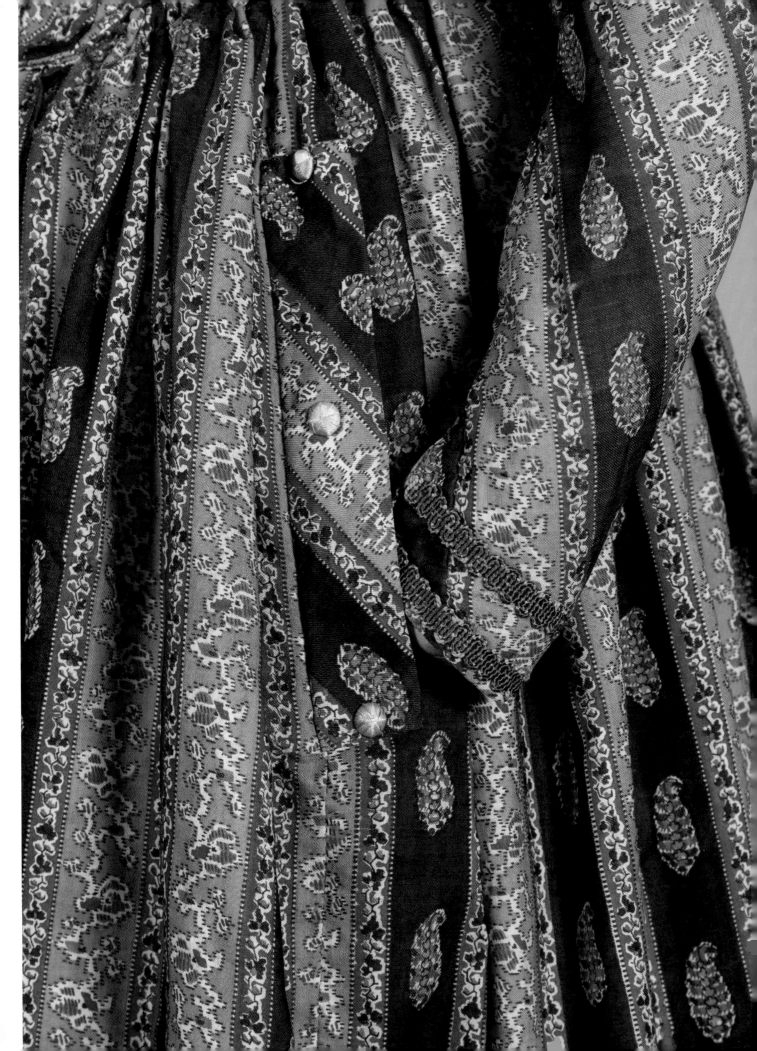

Wool Printed Challis Dress

1845–1850

Worn by Mary Elizabeth Dorsey Farnandis (1795–1888)

Maryland Historical Society, Gift of Mrs. H. Irvine Keyser, 1969.26.1

Fashionable paisley prints first gained popularity in the Western world during the late eighteenth century with the importation of fine goat-haired shawls from the Kashmir region of India. *Buta* motifs — the teardrop shape now synonymous with the term "paisley" — embellished the borders of these shawls and designers later adapted these shapes for Western consumers' tastes. Nearing the mid-nineteenth century, textile manufacturers succeeded in producing paisley fabrics cheaper than those made in India, allowing entire dresses to be constructed from it.

Mary Elizabeth Dorsey Farnandis spent much of her life on the "Homestead," a large tract of land in Bel Air, Maryland, that she inherited. Around 1815, she married Walter Farnandis and together they raised six children.

This dress is exhibited through the generosity of Corinne Dorsey Onnen (Mrs. Ferdinand H. Onnen, Jr.).

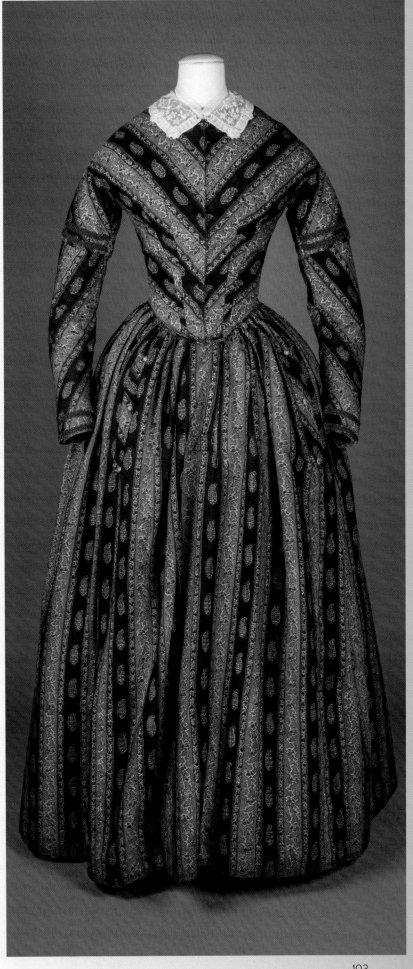

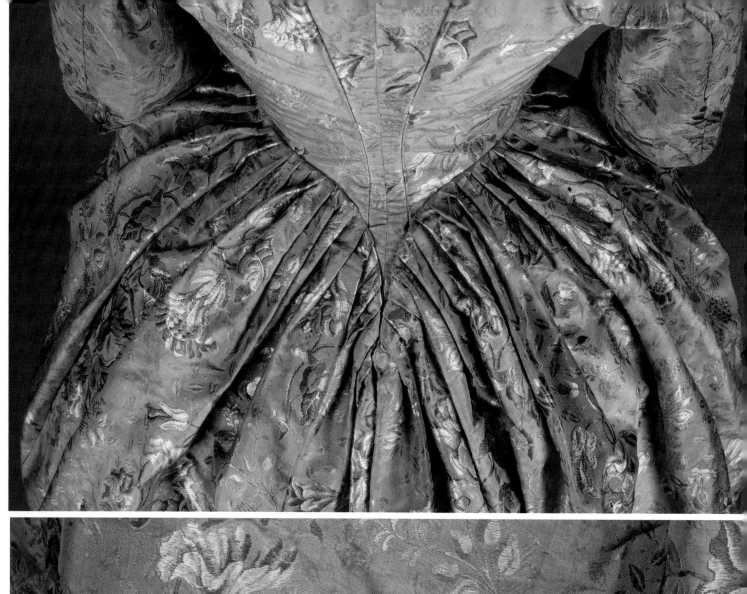
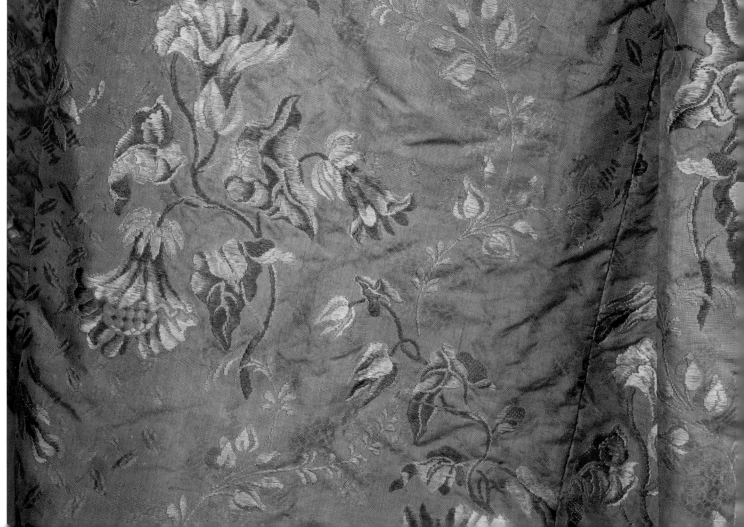

Silk Brocade Dress

1780–1789

First worn by Elizabeth Woodrop
Davey (1726–1782) and later worn
by Catherine Davey McKim
(1766–1860)

Maryland Historical Society, Gift of
Miss Katherine S. Montell, 1943.48.1

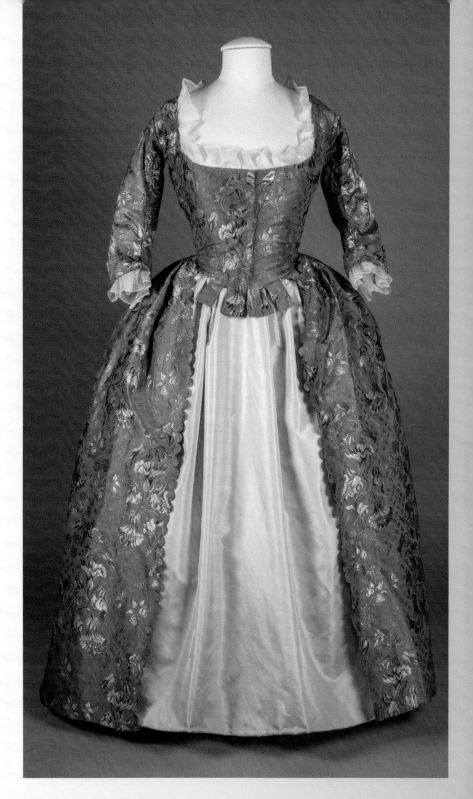

In the eighteenth century, women routinely
restyled outmoded dresses, largely
because textiles at that time cost more
than the dressmaking labor. Although
this silk brocade, with its bronze ground
and large-scale, multi-colored botanical
pattern, dates to the Rococo period of the
1740s, alterations in the 1780s demonstrate
how old-fashioned garments were
redesigned.

Catherine Davey McKim, who owned this
dress during its last configuration, most
noticeably updated the dress by converting
its bodice. In the 1740s when McKim's
mother, Elizabeth Woodrop Davey, wore
this dress, bodices did not fully close in
the center front. This void was filled by a
stomacher, or a removable decorative
panel. By the 1780s, stomachers were no
longer fashionable and McKim sewed together fabric pieces of varying sizes to transform the bodice into one
that completely closed.

In 1785, probably about the time Catherine Davey altered this dress, she married Alexander McKim, who served
in the American Revolution and fought under General Lafayette during the Yorktown campaign.

*This dress is exhibited through the generosity of the Colonel John Streett Chapter, National Society Daughters of the
American Revolution.*

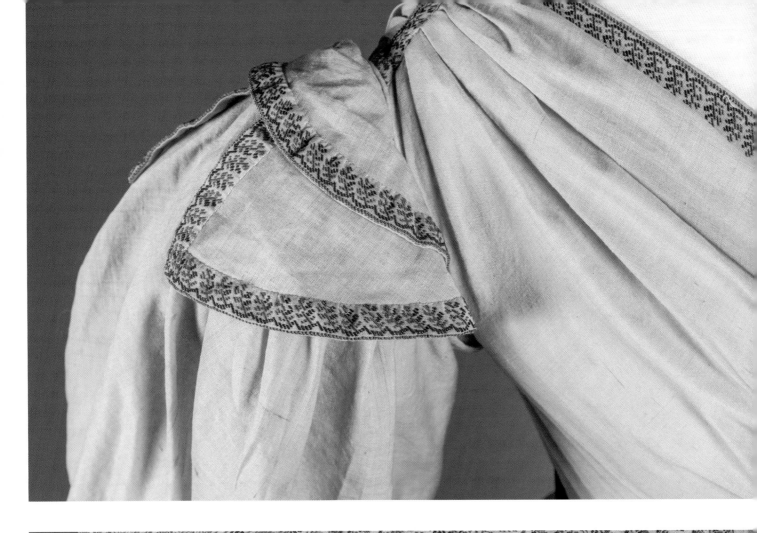
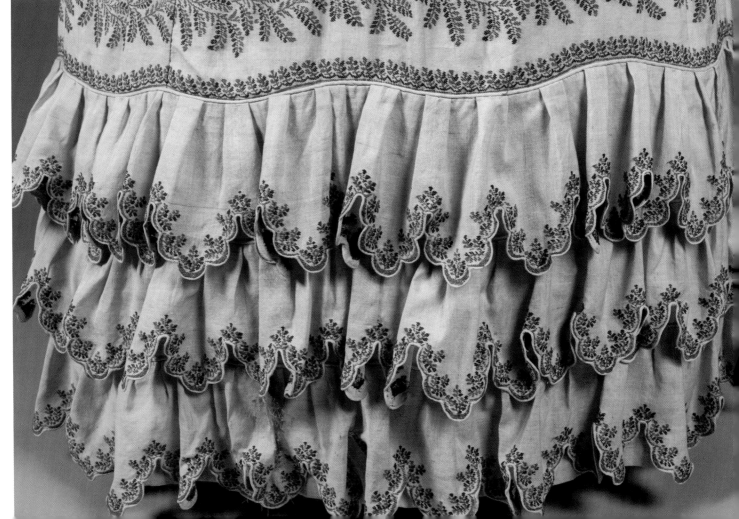

Cotton and Wool Challis Dress

1831–1834

Worn by Eliza Eichelberger Ridgely (1803–1867)

Maryland Historical Society, Gift of Mr. John Ridgely, 1944.76.1

The exuberant and artistic styles of 1830s fashion captured the Romantic era's revival of motifs from the Middle Ages and the Renaissance. Such historic influences can be seen in this dress's vivid navy blue and apricot color contrast, multi-tiered scalloped hem, and dramatic gigot, or "leg-of-mutton," sleeves. Because of the exaggerated proportions of such sleeves, women wore special sleeve supports to create the desired volume. At the end of the decade, sleeve fullness collapsed into the fitted styles of the 1840s.

Famously known as the "Lady with a Harp" after her portrait painted by Thomas Sully in 1818, Eliza Eichelberger Ridgely grew up in Baltimore and participated in its lively social life. During the Marquis de Lafayette's tour of the United States in 1824, Ridgely befriended the Revolutionary War hero and the two corresponded until his death in 1834.

This dress is exhibited through the generosity of Suzanne and Stuart Amos, Ann and John Boyce, Margaret and William Meyers II, Kathy and Edmund Novak, Jr., and Carol and David Whitman.

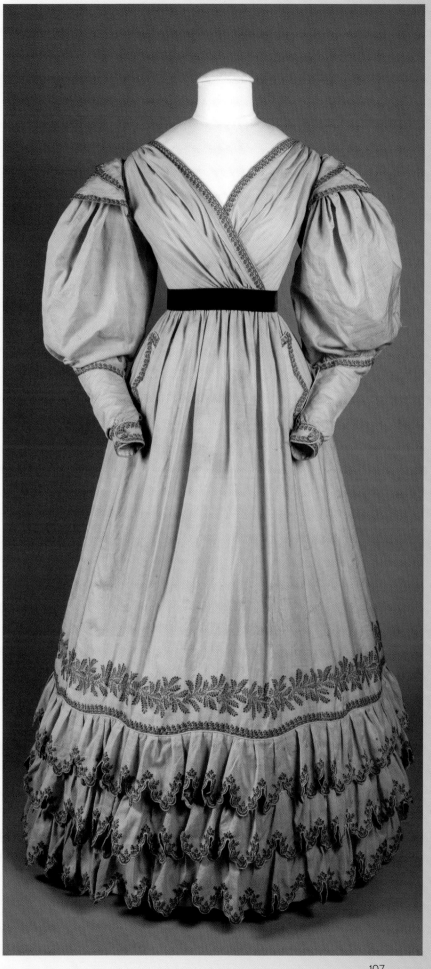

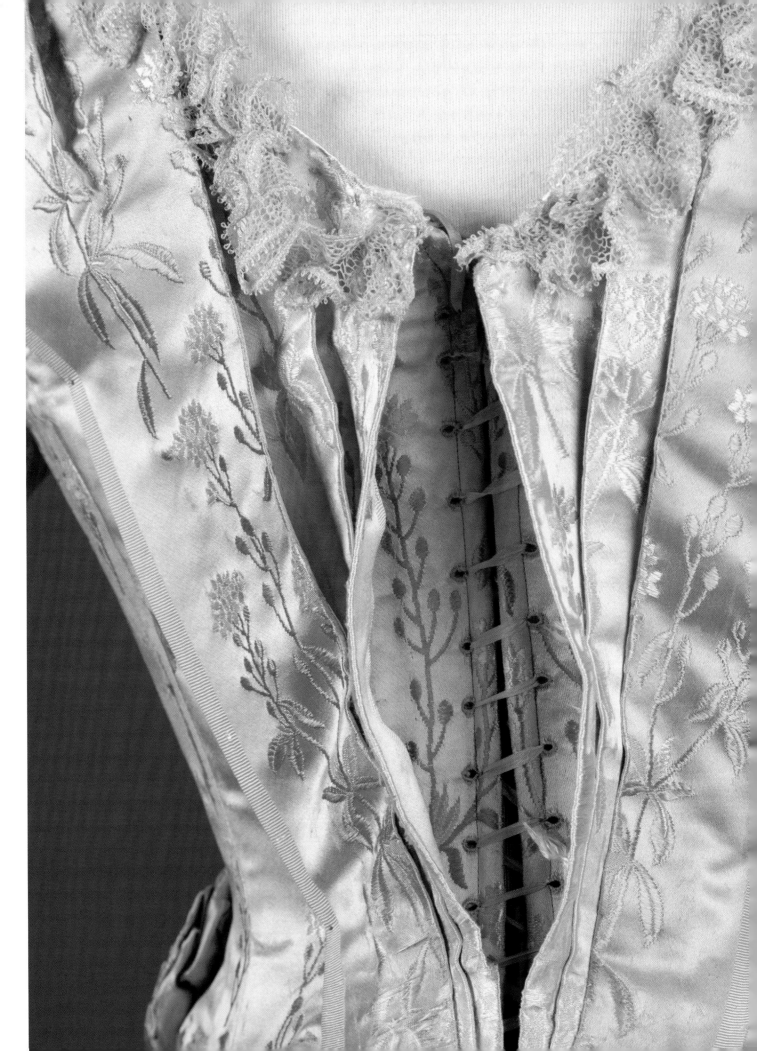

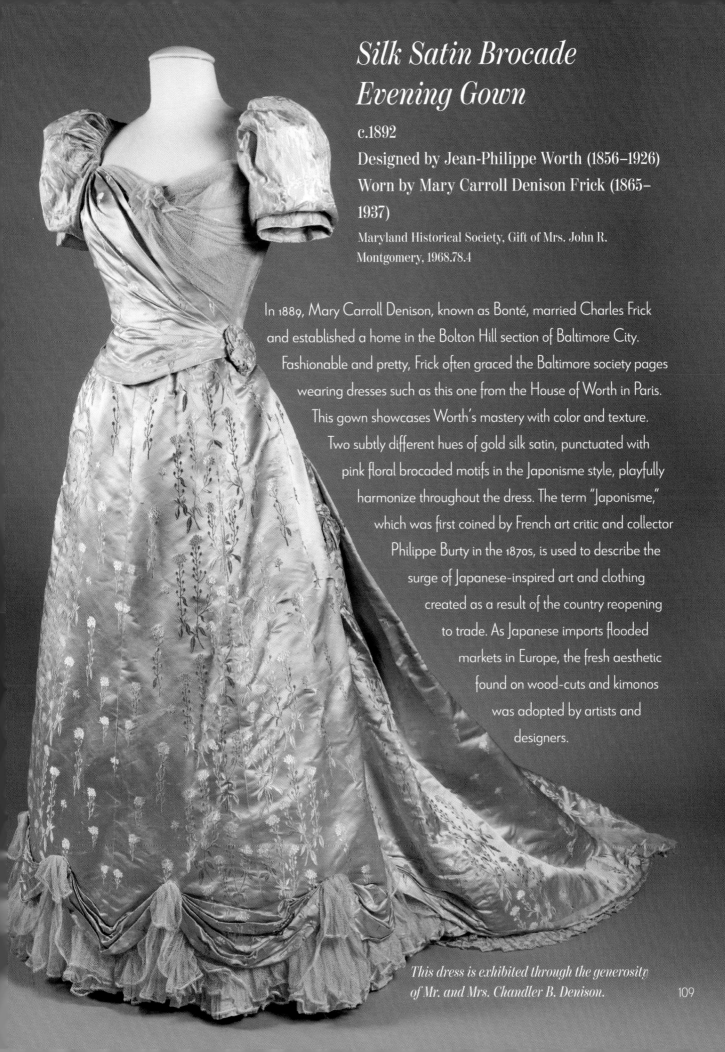

Silk Satin Brocade Evening Gown

c.1892

Designed by Jean-Philippe Worth (1856–1926)

Worn by Mary Carroll Denison Frick (1865–1937)

Maryland Historical Society, Gift of Mrs. John R. Montgomery, 1968.78.4

In 1889, Mary Carroll Denison, known as Bonté, married Charles Frick and established a home in the Bolton Hill section of Baltimore City. Fashionable and pretty, Frick often graced the Baltimore society pages wearing dresses such as this one from the House of Worth in Paris. This gown showcases Worth's mastery with color and texture. Two subtly different hues of gold silk satin, punctuated with pink floral brocaded motifs in the Japonisme style, playfully harmonize throughout the dress. The term "Japonisme," which was first coined by French art critic and collector Philippe Burty in the 1870s, is used to describe the surge of Japanese-inspired art and clothing created as a result of the country reopening to trade. As Japanese imports flooded markets in Europe, the fresh aesthetic found on wood-cuts and kimonos was adopted by artists and designers.

This dress is exhibited through the generosity of Mr. and Mrs. Chandler B. Denison.

Printed Velvet and Fur-Trimmed Cocoon Coat

1925–1929

Probably French

Worn by Gretchen Hochschild Hutzler (1888–1977)

Maryland Historical Society, Gift of Mrs. Albert D. Hutzler, 1977.12.1

Displayed with silk velvet, satin, and net evening gown, 1925–1928, designed by Max Cohen, Inc., worn by Doris Cohn.

Maryland Historical Society, Gift of Mrs. Herman E. Cohn, 1946.52.21

Daughter of Max Hochschild and Lina Hamburger, Gretchen Hochschild grew up as part of Baltimore's department store royalty. Albert Hutzler, the son of the founders of the Hutzler's Department Store, was also member of this elite group. The Hochschild-Kohn store and its rival Hutzler's were located just across Howard Street from each other. When Gretchen Hochschild and Albert Hutzler married in 1911, they united the competitors, bonding three German Jewish immigrant families that had all found success in the dry-goods business in Baltimore.

The couple often traveled the country and Europe together, surveying other department stores and seeking designs and goods for their own store. This cocoon coat, likely purchased on one such trip, is fit for a leading Baltimorean like Hutzler. It features a trendy *chinoiserie* print on velvet with a large fur collar, cuffs, and hem. The coat's gold silk lining was sold in Hutzler Brothers Department Stores at forty dollars a yard (approximately $500 a yard 2019) and is said to have been displayed in a silk museum in Lyon, France.

This dress and coat are exhibited through the generosity of Marguerite Mullan Greenman.

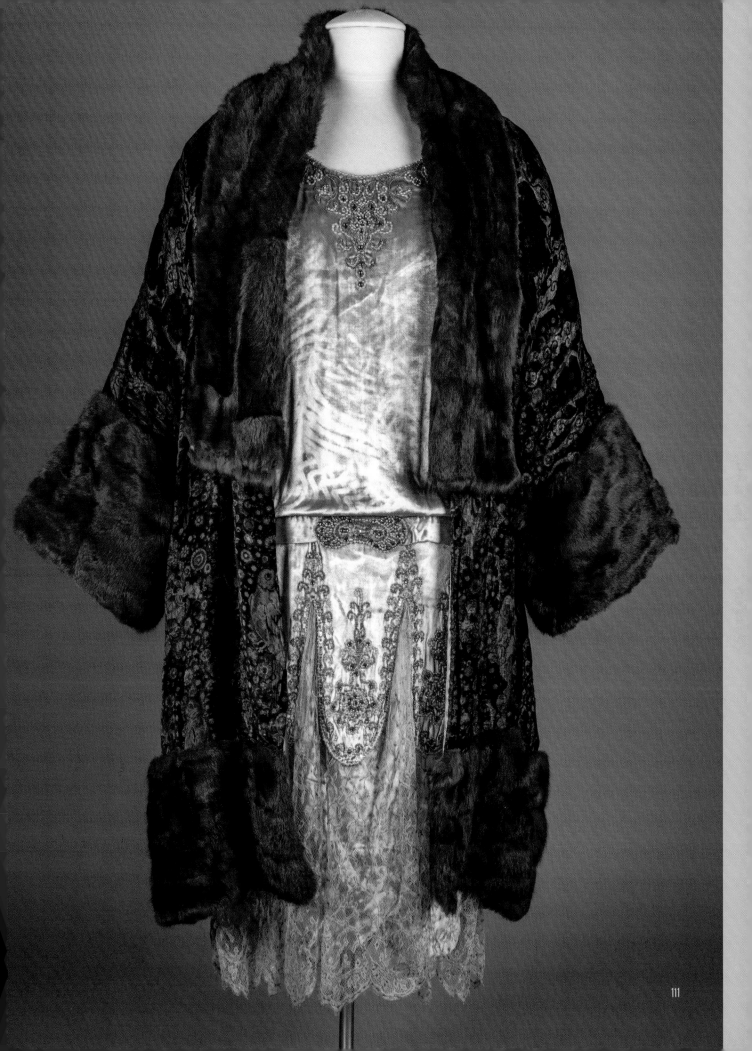

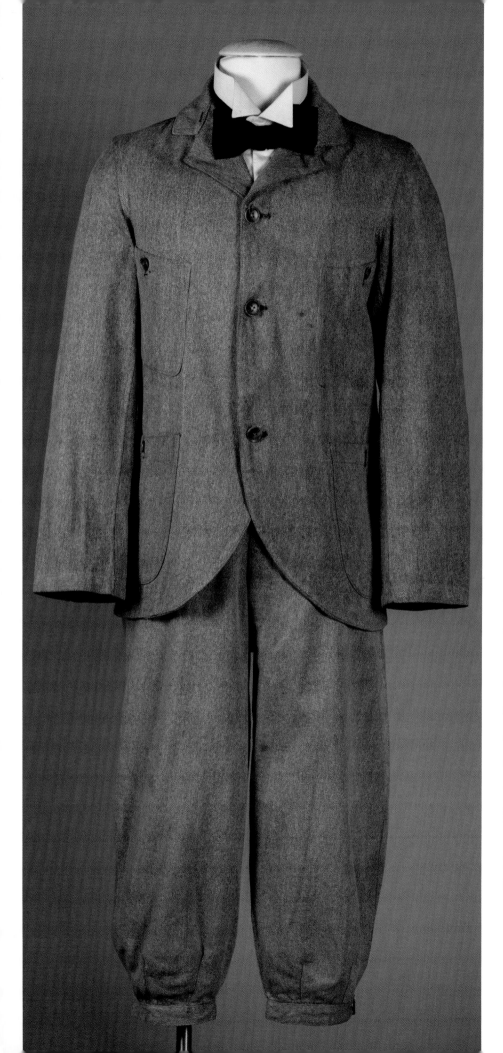

Twilled Cotton Cycling Suit

1890–1899
Worn by George Franklin Frock

Maryland Historical Society, Gift of Mrs. Albert W. Rhine, 1980.26.1 a-b

During the late nineteenth century's Gilded Age, the growing popularity of sports contributed to the emergence of wardrobes dedicated to athletic activities. Cycling, in particular, became widespread in the 1890s as mass production and improved technology made bicycles more accessible, regardless of social class or location. Twill cottons and wools were prevalently used for cycling attire due their natural durability and water resistance. Because this activity required more ease of movement, men wore loose, shortened trousers and women donned split skirts or, if especially daring, knee-length bloomer-style trousers, not unlike what was worn by their male counterparts.

This suit is exhibited through the generosity of Mr. John J. Neubauer.

Wool Suit

1960s

Worn by Helen Delich Bentley
(1923–2016)

Maryland Historical Society, Gift of Mrs.
Helen D. Bentley, 2015.20.1

Helen Delich Bentley's career as a
journalist began in 1948 as a young
reporter for the *Baltimore Sun*. Unlike
most women reporters who were
restricted to the society pages, Bentley's
beat was the waterfront. She created
the nation's most respected maritime
news section, breaking important local
and national stories. In the 1950s, she
branched into television with the series
The Port That Built a City. For this
program, Bentley acted as producer,
director, editor, writer, and interviewer,
all the while still editing and reporting
for the *Sun*. Along with her penchant for
journalism, Bentley also ran a successful
political career and served as the Federal
Maritime Commission's chair from 1969 to
1975 and as a Maryland congresswoman
from 1985 to 1995. A well-known face in
Baltimore news, she was also known for
her personal style, including her hats,
which were featured in a profile on Mrs.
Bentley in the 1950s.

*This suit is exhibited through the generosity
of Executive Alliance – A Catalyst for Women
Leaders.*

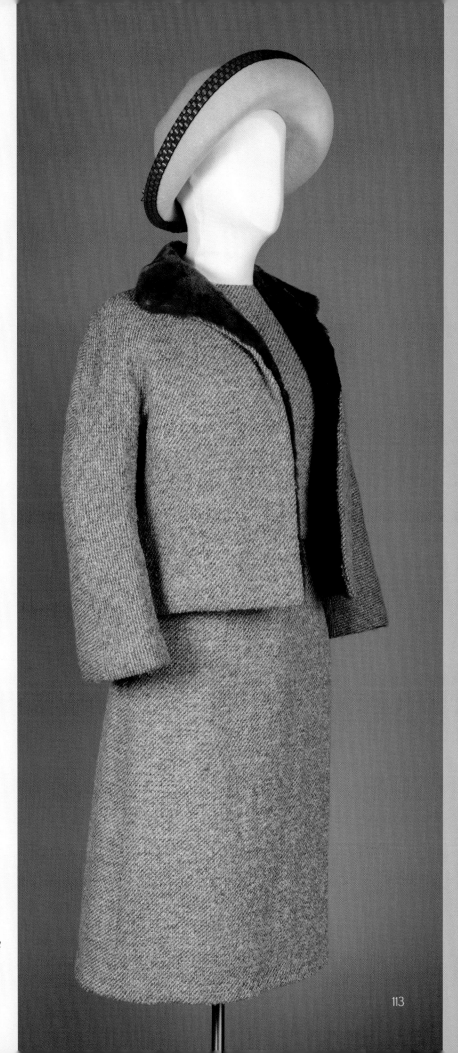

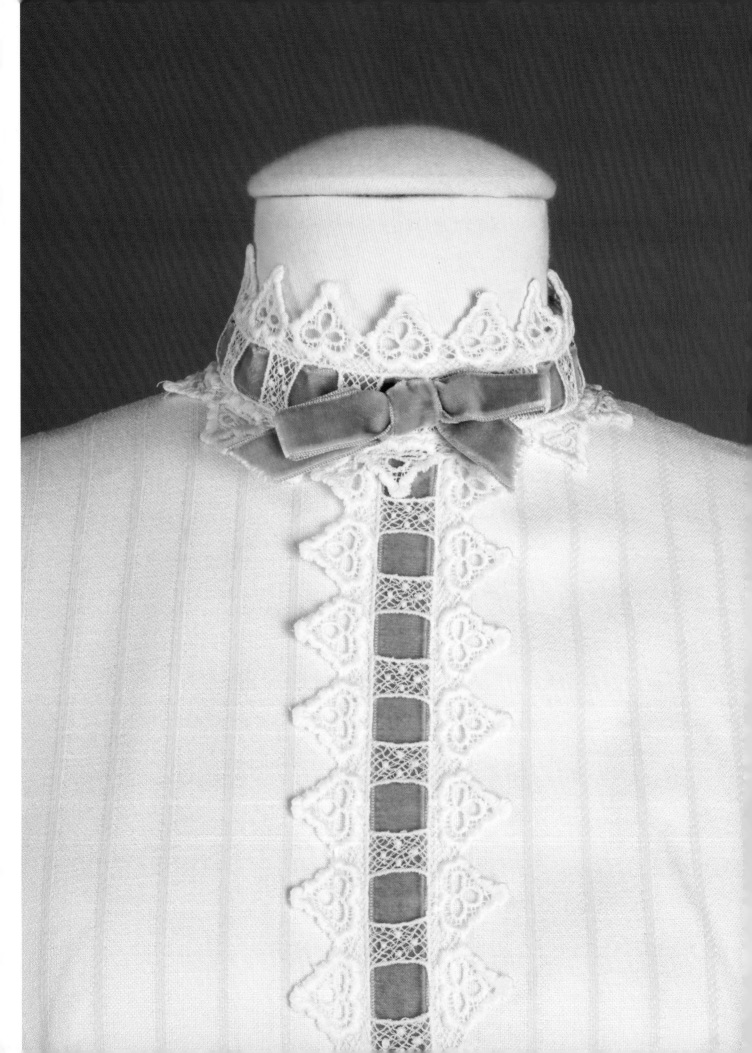

Cotton Dress

1970

Worn by Nancy Lee Kimmel (1948–1976)

Maryland Historical Society, Gift of Mr. Ross Kimmel
2016.6.3

Nancy Kimmel made herself this dress when she was the maid-of-honor for her friend, Linda Windel, who married Clinton Brown in August of 1970. Its style typifies the high-waisted empire style of the late 1960s and early 1970s. The bold yellow and gold combination was popular one at the time, appearing not only in fashion but in household decoration as well. Kimmel began sewing as a teenager after taking home economics classes at Bethesda-Chevy Chase Senior High School. She later attended the University of Maryland where she majored in home economics with a focus in interior design, a field she pursued after graduation.

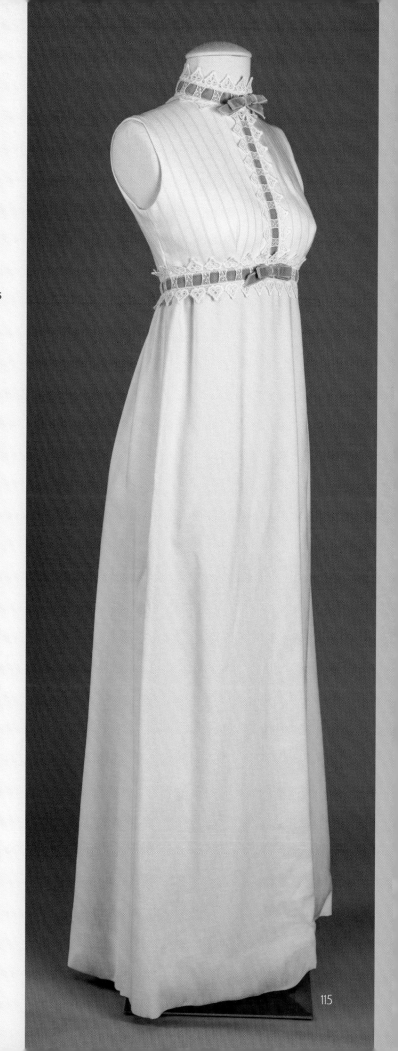

115

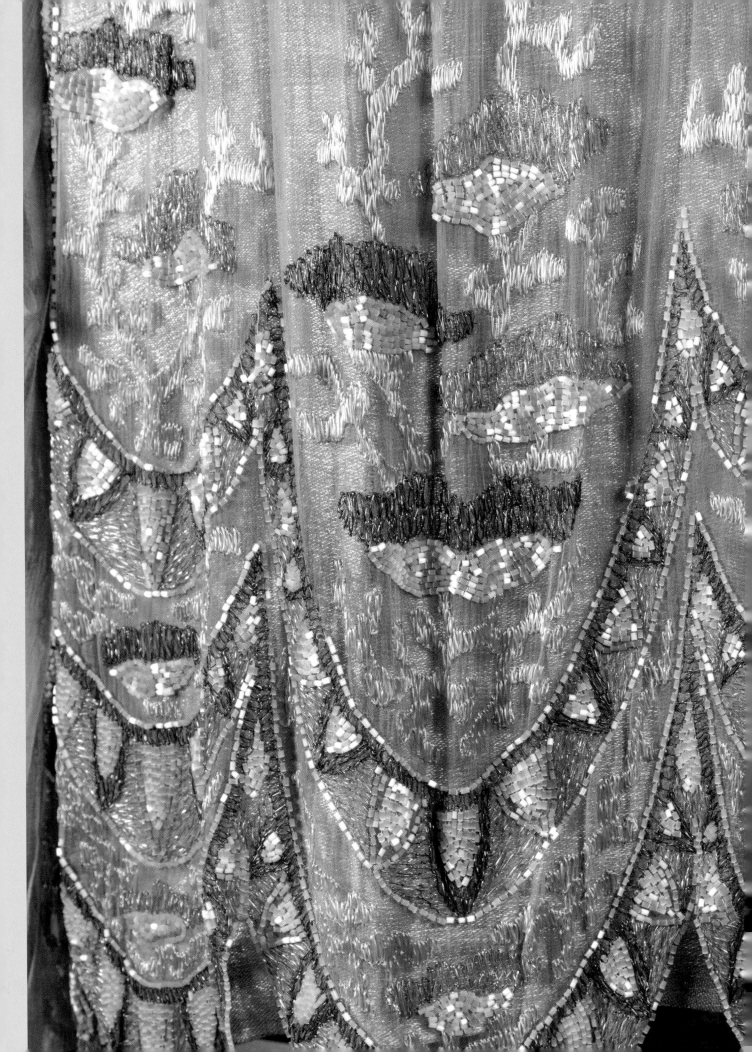

Silk Chiffon and Lamé Evening Dress

1922–1926

Worn by Mrs. Marion Booz Galleher (1898–1992)

Maryland Historical Society,
Gift of Dr. Earl P. Galleher, Jr., 2017.23.1

In 1922, the tomb of the Egyptian pharaoh Tutankhamun was discovered, inspiring a worldwide interest in ancient cultures. Egyptian-inspired beadwork and motifs quickly started appearing in jewelry and clothing, like the scalloped tiers of geometric beadwork in this dress. Its colors, especially the gold *lamé* that shines through the ethereal peach chiffon, evoke Egyptian jewelry and crowns. Marion Booz Galleher, a descendant of the Booz Brothers shipbuilders of Baltimore, wore this quintessential flapper dress in the mid-1920s. In 1849, her grandfather, Thomas Booz, began a shipbuilding enterprise with his brother in Baltimore, constructing wooden clipper ships at their yard in Fells Point. The next generation continued this legacy, manufacturing "monitor" type ships for the Union Army during the Civil War.

This dress is exhibited through the generosity of Terry H. Morgenthaler.

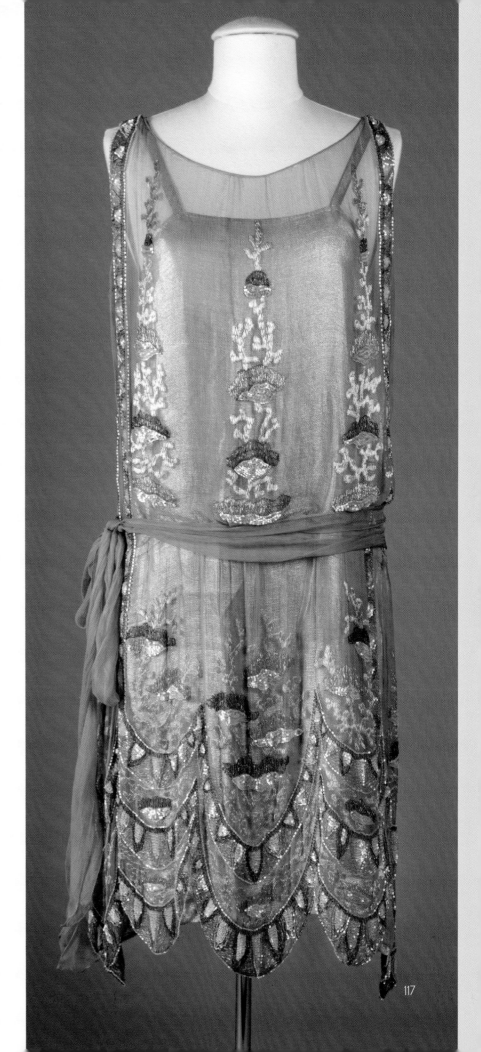

117

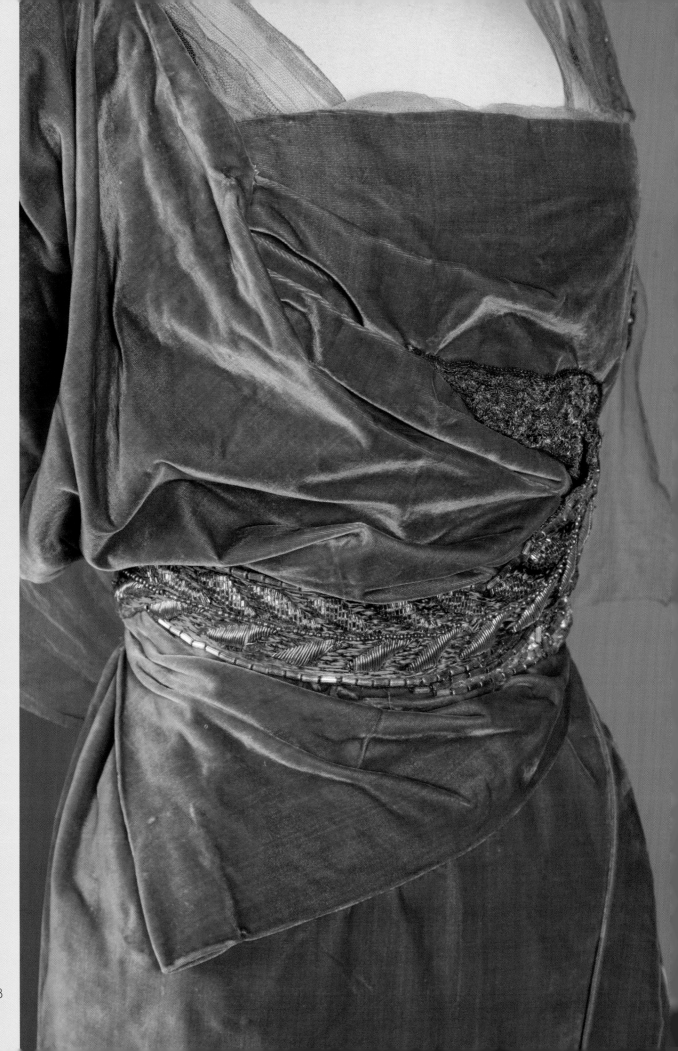

Velvet Evening Dress

Winter 1911
Designed by Jeanne Paquin (1869–1936)
Worn by Mrs. Alice Lee Thomas Stevenson (1884–1972)

Maryland Historical Society, The Estate of
Mrs. Alice Lee Thomas Stevenson 1972.81.10

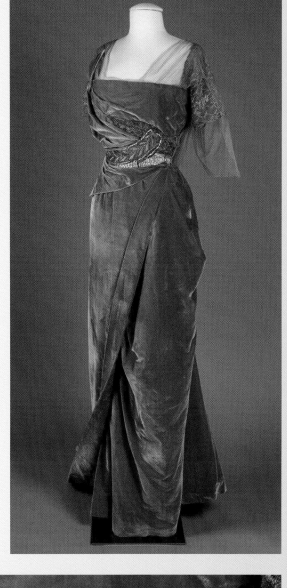

This stunning coral velvet evening dress was likely bought by Alice
Lee Whitridge upon her marriage to Robert Hooper Stevenson, Jr., in
1911. No stranger to French couture, Alice owned dresses from several
designers with shops along the Rue de la Paix, one of Paris's fashion
avenues. This Jeanne Paquin dress features some of the designer's
signature elements, including bright colors, playful textures, and
an ode to Neoclassicism. Paquin modified contemporary fashion
through her own innovations to accommodate active, modern
women like herself. The narrow hobble skirt of this dress, for example,
features a hidden pleat so the wearer could wear the trendy style but
walk with more ease.

*This dress is exhibited
through the generosity
of Mrs. Sylvia Lee Parker.*

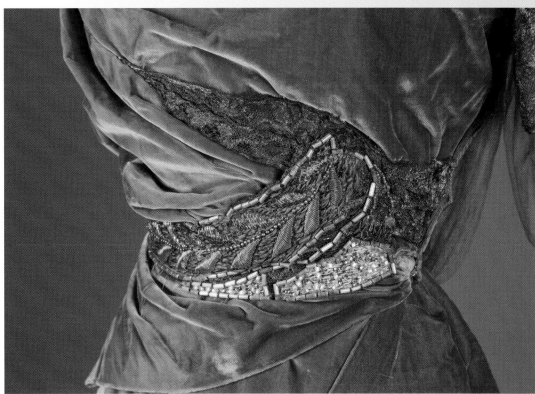

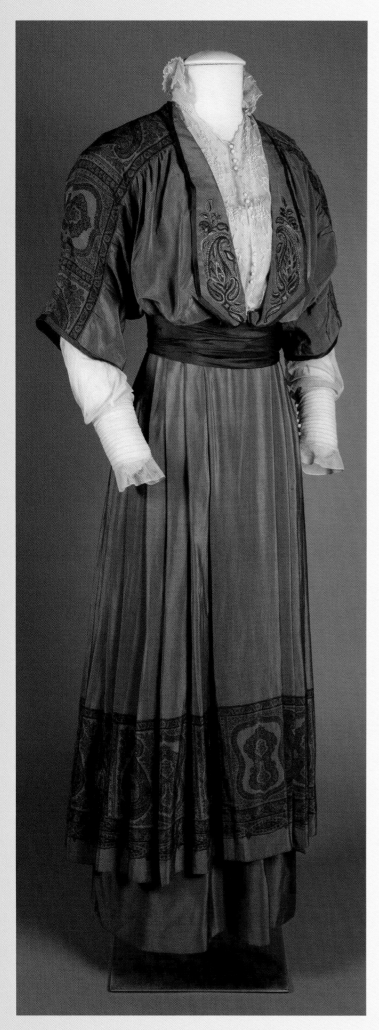

Silk Chiffon and Silk Faille Dress

1910–1919

Worn by Mary George White Bates (1885–1963)

Designed by Liberty & Co of London

Maryland Historical Society, Gift of the Frances B. Wells
Estate, 2016.11.4

Mary George White accomplished various milestones
when pursuing her higher education. After graduating in
1907 from the Woman's College of Baltimore City, today
known as Goucher College, she enrolled at Johns Hopkins
University and graduated in 1913 as the institution's first
woman to earn a higher degree in philosophy. In 1910, she
briefly left Hopkins to study abroad in Germany at the
University of Breslau (now Wrocław in Poland), where
she was the first American woman ever admitted.

In October 1917, six months after the United States
officially entered World War I, White joined the war
effort as the secretary for the Young Women's Christian
Association. She managed the housing and recreational
needs of the "Hello Girls," the telephone operators
connected with the Army Signal Corps. Of these
women, White was the only one allowed to travel freely
throughout Europe with the Army; she remained in France
until the conflict concluded.

Upon returning to the United States, Mary married
Charles F. Bates in June 1919, with her close friend
Margaret Wilson, the daughter of President Wilson,
standing beside her as bridesmaid.

*This dress is exhibited through the generosity of
Mrs. Sarah Wells Macias, Mrs. Katherine W. Power,
Mrs. Nancy Wells Warder, and Ms. Marianne D. Wells.*

Silk Chiffon and Silk Satin Dress

1915–1919

Worn by Mary George White Bates (1885–1963)

Maryland Historical Society, Gift of the Frances B. Wells Estate, 2016.11.11

Two-tiered skirts were popular during the 1910s, with the bottom layer appearing tailored in contrast to the gauzy, diaphanous overlay. Pumpkin-orange silk satin peeks through the silk chiffon. Following the decade's adoration for decorated fabrics, Mary George White Bates's dress is embellished with jet beading arranged in geometric patterns that echo the Art Nouveau movement's use of stylized motifs and shapes.

This dress is exhibited through the generosity of Nancy E. Smith.

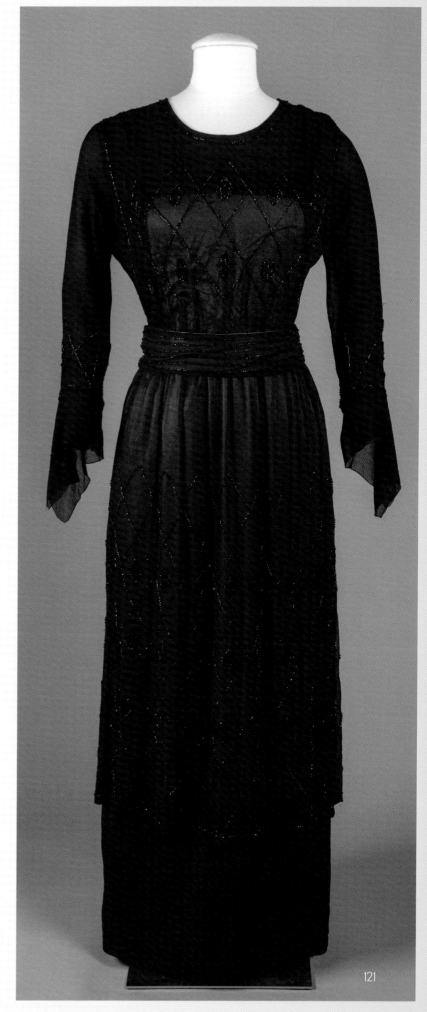

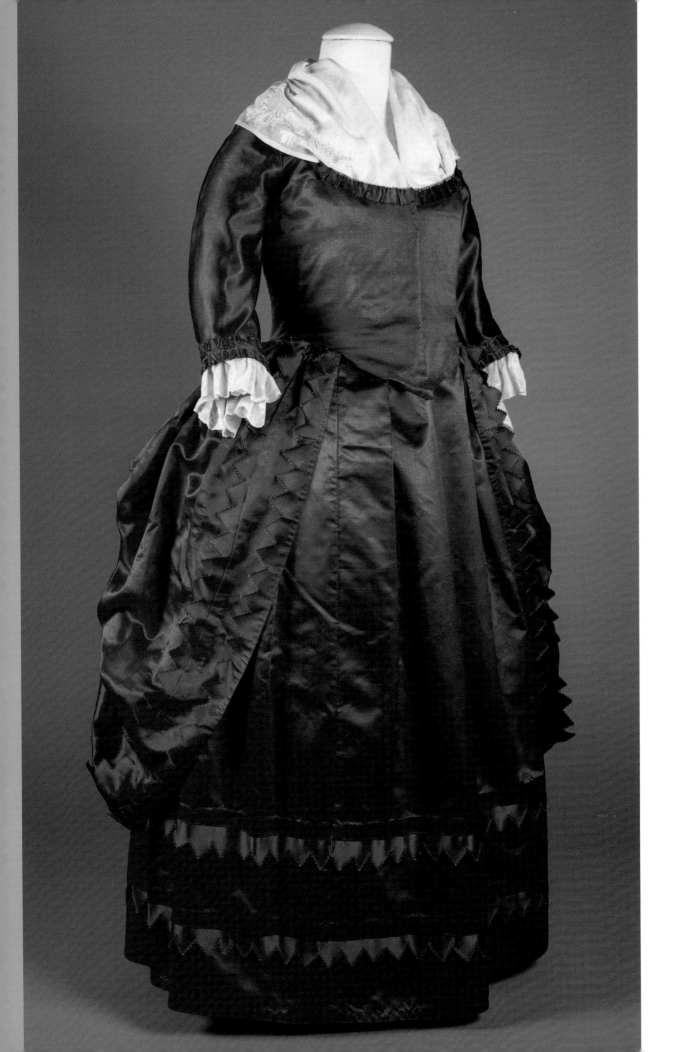

Silk Satin Robe à la Polonaise

1780–1785

Unknown wearer

Maryland Historical Society, The Anne Cheston Murray Collection
from Ivy Neck, Cumberstone, Maryland, 2004.39.30

Eighteenth-century dresses fashioned in the *Robe à la Polonaise*
style likely originated with working women drawing sections of
their skirts through their pocket slits to make manual labor easier
and avoid the natural soiling from a dusty road. Romantic,
pastoral representations of these women eventually led to a
fashionable interpretation of their "common" dress. Hidden
or displayed drawstrings looped the overskirt into decorative
swags that added captivating textural dimensions and revealed
a decorative petticoat. Because of the dress's bold fuchsia color
and larger bust and waist size, it is likely that an older woman
past her child-bearing years wore this dress. Typically, a settled
woman wore more luxurious fabrics that displayed her family's
established wealth.

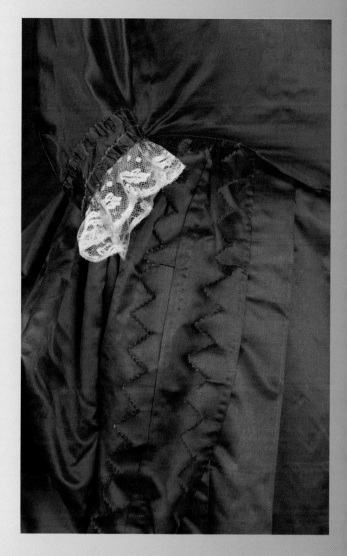

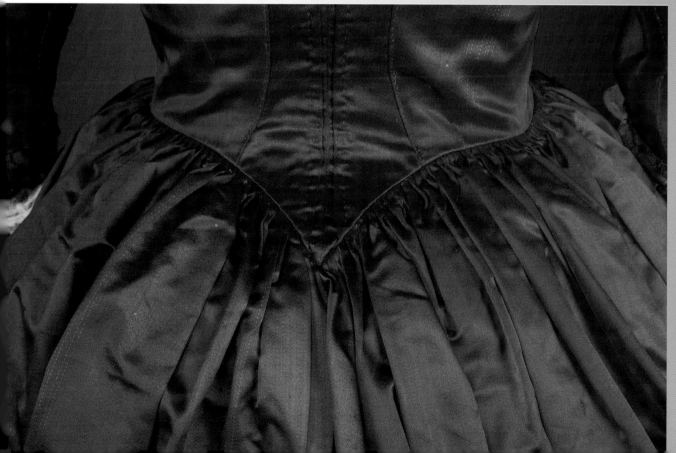

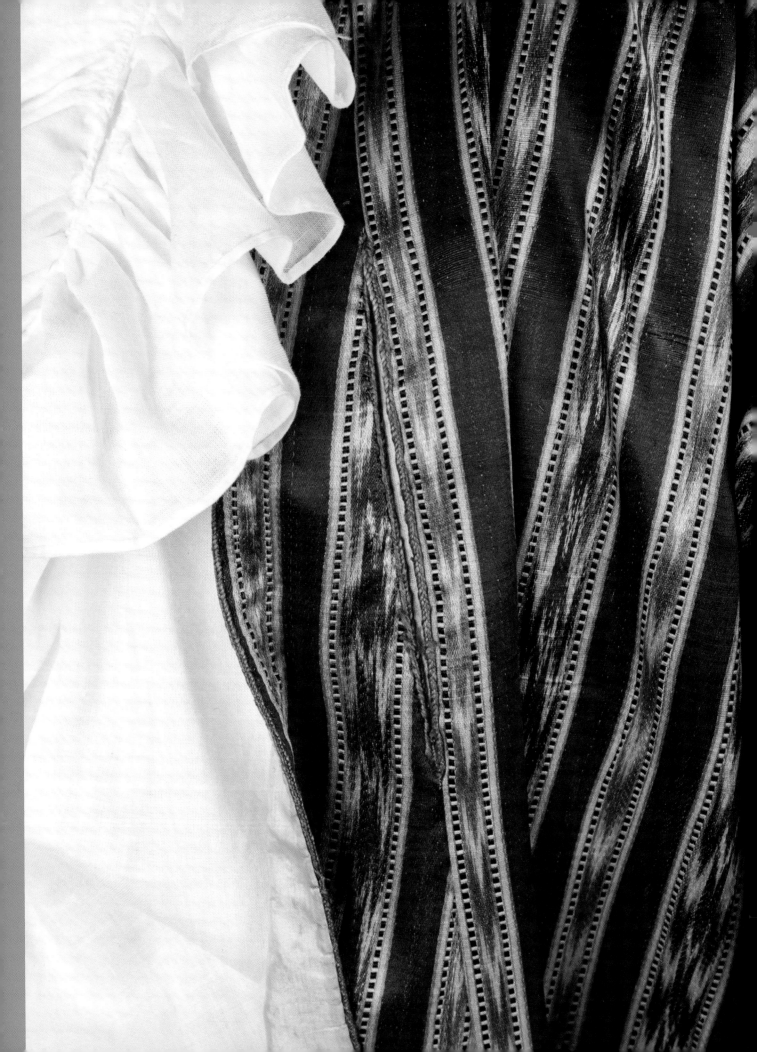

Silk Banyan

1780–1789

Worn by Solomon Etting
(1764–1847)

Maryland Historical Society, Eleanor S. Cohen
Collection, 1918.06.58

Banyans, the loose robes or dressing
gowns men wore informally in their homes,
reveal the influences from the Middle
East and Far East in the Western World.
Constructed from luxurious imported
fabrics, such as hand-painted India
chintzes and Chinese silks, these robes
symbolized a man's worldliness and
connections to foreign lands. Such a visual
proclamation from Solomon Etting's own
banyan coincides with his career as a
merchant involved in the Baltimore East
India Trading Company.

He is often remembered for his
championing of Jewish civil rights. Etting
fervently fought for the "Jew Bill," an act
passed in 1826 that overturned Maryland
legislation responsible for prohibiting
Jewish men from holding public office.
Shortly after the bill's ratification, Etting
successfully ran for the Baltimore City
Council and became one of Maryland's
first Jewish men to hold an elected office.

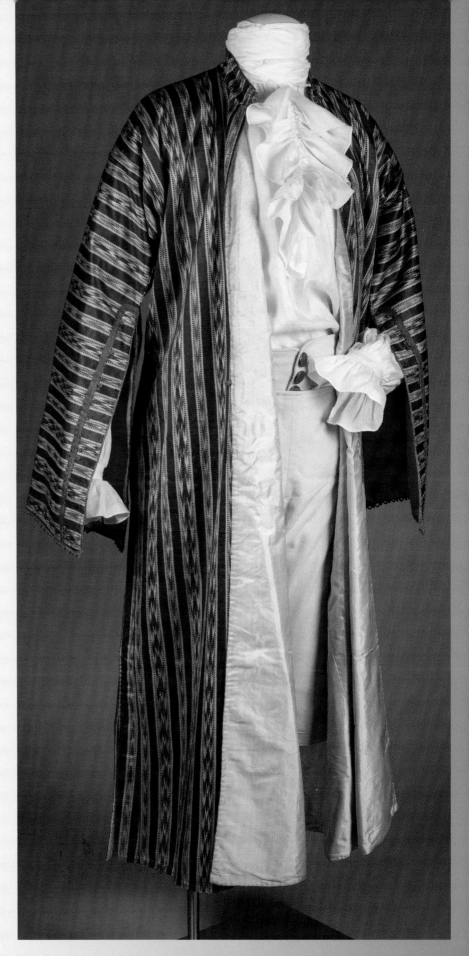

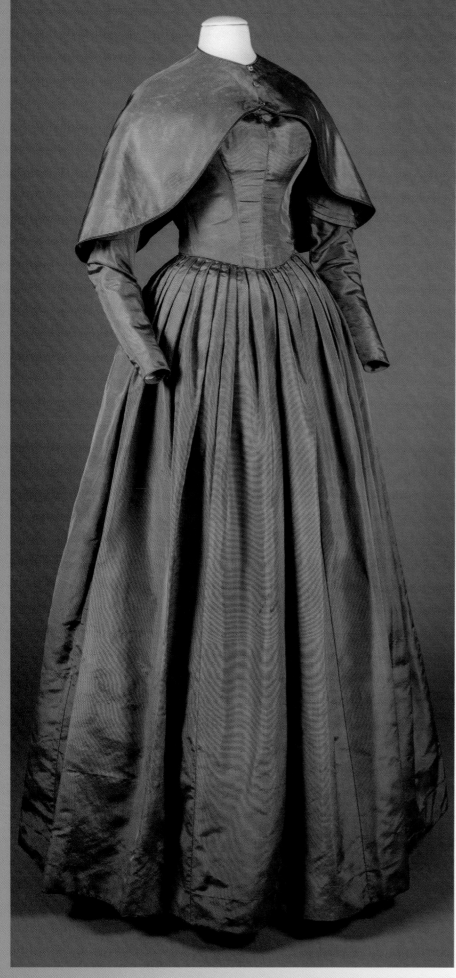

Silk Faille Evening Dress

1840s

Probably French

Unknown wearer

Maryland Historical Society, Estate of Miss Eliza Ridgely, 1956.15.30

This rose silk *faille* evening dress, which came to the Maryland Historical Society through the estate of Miss Eliza Ridgely, is a mystery. While most garments from the Hampton Mansion estate in Towson are easily attributed to a wearer in the Ridgely family, the woman who wore this particular dress was much taller than any of the other known Ridgely women. It is possible it was worn by the donor's aunt and namesake, Eliza Ridgely Buckler (1828–1894), known as "Didy," though this cannot be certain. Adding to the mystery, the dress appears to have been altered, with the hem let down, plus extra pieces of fabric were included with the gift. Finally, one side of the back of the bodice is padded, suggesting the wearer may have had scoliosis.

This dress is exhibited through the generosity of The Women's Committee of Historic Hampton, Inc.

Silk Dress

1883–1885

Worn by Anna Elizabeth Creckenberger
(1861–1931)

Maryland Historical Society, Gift of Mrs. David F. Rife, 1960.78.9

During the 1880s, bustles, an undergarment structure, projected the backs of skirts outwards, sometimes in exaggerated angles. With volume drawn to the back, skirts became narrower, which drew focus to the waist and hips. Such a curvaceous silhouette was further accentuated by elongated corsets reinforced with whalebone and steel busks.

Drapery, pleating, and puffed fabrics further emphasized the decade's notable lines while creating interesting effects. Some key characteristics of 1880s fashion included combining rich textures, such as the sheen of this dress's plain burgundy silk contrasted with the gold silk brocade stripes, and the relatively plain sleeve cuffs.

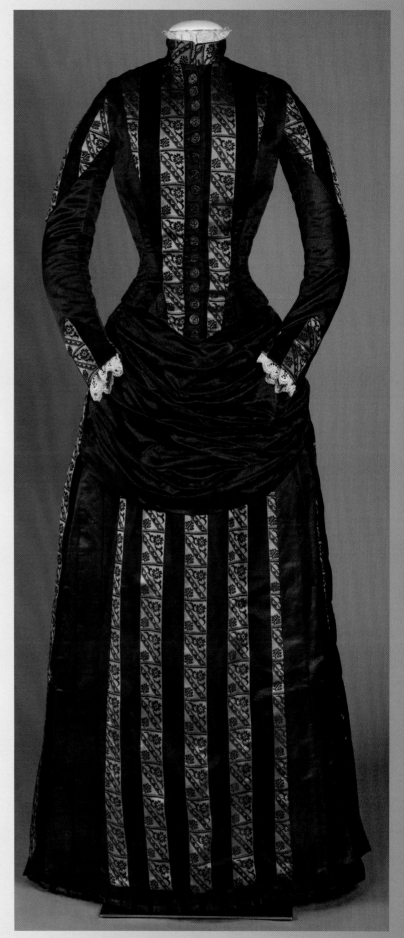

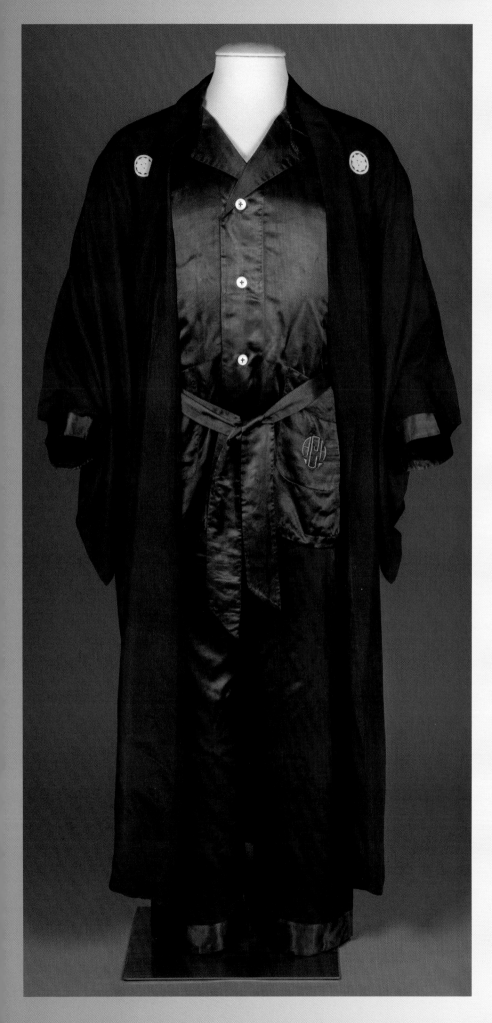

Silk Kimono and Silk Pajama Set

1934–1936
Worn by Albert H. Cousins, Jr.
(1907–1998)

Maryland Historical Society, Gift of Mr. Albert Cousins, 1979.85.2-3

This red silk kimono illustrates the Western world's continuing obsession with Eastern culture in the early twentieth century. Kimonos like this were worn as lounge-wear by men and women, both idealizing and misinterpreting the Japanese garment. This kimono was particularly important to its wearer, Albert H. Cousins, Jr., as it was gifted to him by Marta Carias, the daughter of the President of Honduras. Cousins spent over a decade during the early years of his career in the United States Foreign Service in South America, serving as a diplomat in Argentina and Honduras as well as Venezuela. Upon his return to the United States, he brought home many decorative arts and clothing representing his time abroad.

This kimono is exhibited through the generosity of the Wieler Family Foundation.

Silk Brocade Evening Dress

1940–1945

Worn by Jeannette Eareckson Straus (1898–1969)

Maryland Historical Society, Bequest of Mrs. Henry L. Straus through her sister Mrs. C. Herbert Baxley (Leila Eareckson), 1969.78.1

Women's fashion of the 1940s was characterized by streamlined silhouettes with slim skirts and boxy shoulders broadened by shoulder pads. World War II influenced the emergence of this look once governments began rationing clothing materials. In 1942, the United States War Production Board issued Regulation L-85, a policy that regulated various dress construction details, such as hem lengths and dyes. Despite an overall shortening of skirts, evening dresses, such as Jeannette Eareckson Straus's, remained an exception to rationing policies with the War Production Board wishing to keep homecoming events for soldiers special.

Representative of not only early 1940s' fashion trends, Jeanette Straus's luxurious brocade dress reflects the wealth she and her husband, Henry L. Straus, enjoyed after he invented the "totalisator," a machine that quickly calculated the odds on a horse race as spectators placed their bets. An equestrian herself, Jeannette successfully trained her favorite horse, Pilaster, who was placed in the Hall of Fame for Maryland-bred horses in 1967.

This dress is exhibited through the generosity of the Wieler Family Foundation.

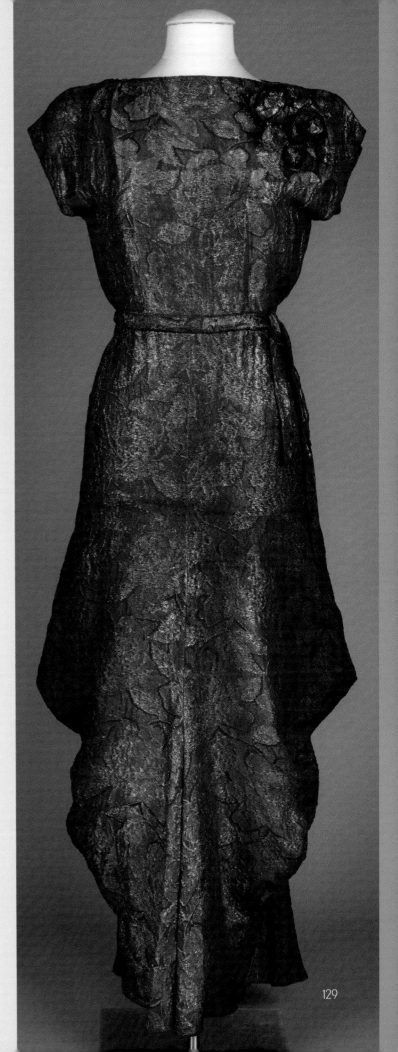

129

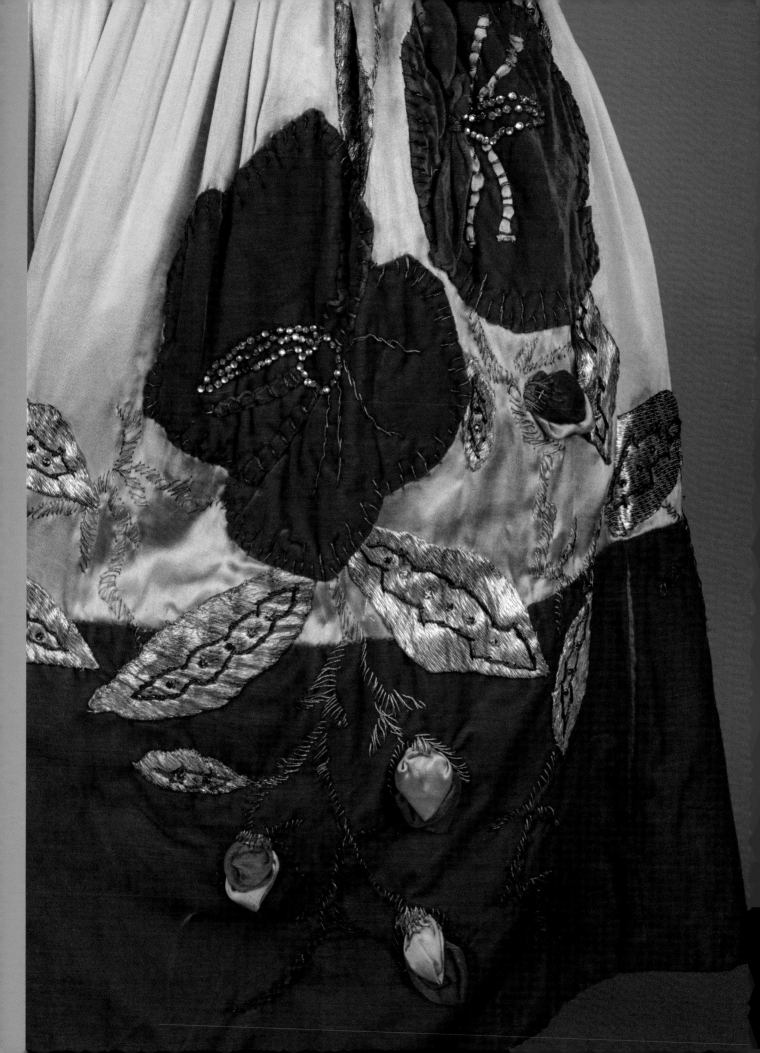

Silk Satin and Silk Velvet Evening Dress

1922–1925
Likely made in France
Worn by Amelia Prescott
Allison (1899–1989)

Maryland Historical Society, Gift of
Mrs. Campbell Lloyd Stirling, 1974.14.2

In the early 1920s, the emergence of a curvaceous evening dress called the *robe de style* offered women an alternative to the boyish, straight-lined silhouette most associated with this decade. Also known as the "picture dress," this style harked back to an idealized past with its retention of a Romantic silhouette reminiscent of eighteenth century fashions. Jeanne Lanvin, the French couture designer often credited for introducing this style, reinterpreted *panniers*, the skirt supports women wore in the previous centuries, to exaggerate the hips. With such a full skirt, the *robe de style* presented designers a canvas for vibrant colors, embroidery, and ornamentation.

This dress is exhibited through the generosity of Walt and Debbie Farthing.

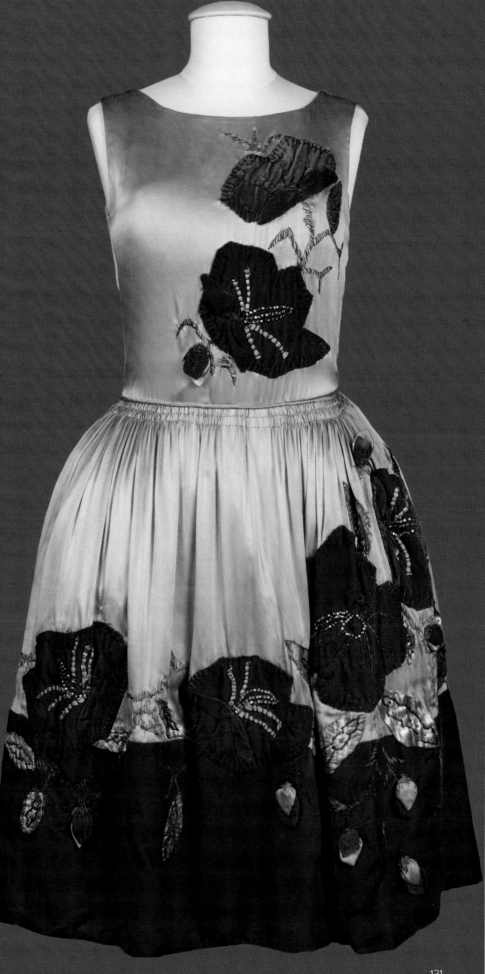

131

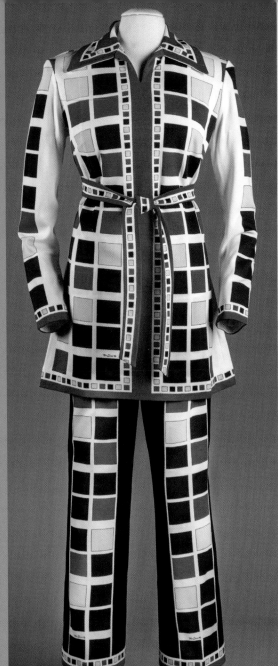

Polyester Knit Pantsuit

1969–1970
Designed by Max "Mr. Dino" Cohen
(active in the 1960s and 1970s)
Worn by Mary Curtin Sadtler (1930–1989)
Maryland Historical Society, Gift of Mrs. William C. Sadtler, 1978.48.13 a-c

By the end of the 1960s, pantsuits with matching trousers and tunics for women became fashionable. Designers favored bright colors and experimented with new types of fabrics during this period, which this Mr. Dino suit demonstrates with its bold color blocking on polyester knit fabric. Max Cohen, known professionally as Mr. Dino, designed every print for his garments and proudly signed each piece of an ensemble. His signature prominently appears three times on Mary's pantsuit, once on the tunic and twice on the trousers.

Mary's husband, William Sadtler, purchased this pantsuit for her from the Village of Cross Keys shopping center in Baltimore as a Christmas gift.

This suit is exhibited through the generosity of lori k.

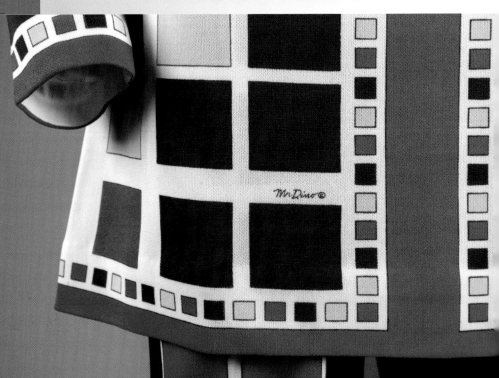

Velvet and Silk Embroidered Evening Coat

Possibly 1891–1892, altered
1909–1911

**Worn by First Lady Frances
Folsom Cleveland (1864–1947)**

Maryland Historical Society, Gift of
George M. Cleveland, 1978.111.3

Frances Folsom Cleveland was far
from the typical First Lady. Married
to President Grover Cleveland in
1886 during his first term, her youth,
beauty, and fashion kept the First
Lady in the spotlight throughout
Cleveland's non-concurrent terms.
Shown here from the back, this
evening coat may originally date to
the early 1890s, the period between
Cleveland's two presidential terms.
During this period, Mrs. Cleveland
was pregnant with their daughter
Ruth. While the high waistline of
the coat gives credence to this
date, this early dating is uncertain
when considering the additional
alterations to the neckline and
sleeves done in the early 1910s,
possibly by the First Lady herself.

*This coat is exhibited through the
generosity of Mr. and Mrs. Jack Donald
Letzer and Allison E. Letzer.*

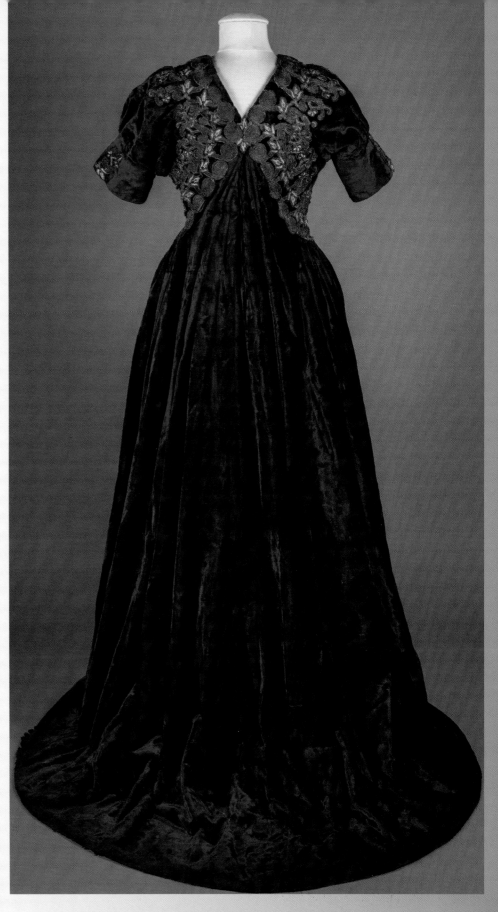

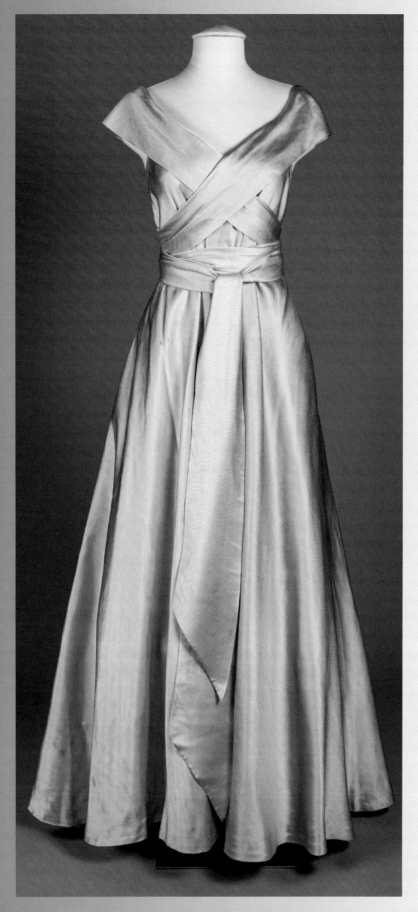

This dress is exhibited through the generosity of Suzanne Love Merryman.

Silk Faille Evening Dress

1940
Designed by Claire McCardell
Worn by Claire McCardell (1905–1958)
Maryland Historical Society, Gift of Robert McCardell, 1998.43.27

Maryland-born fashion designer Claire McCardell was introduced to the designs of Madeleine Vionnet (1876–1975) when she traveled to Paris in 1926 as part of her course of instruction at Parsons School of Design. Vionnet's attention to the harmony between a garment and its wearer made a lasting impact on McCardell and she translated that philosophy to the design of this columnar evening gown. The attached collar/sash crosses from the shoulders over the chest to wrap twice around the waist and end in a tie at the front. McCardell firmly believed, "Sashes must not only tie, but be generous enough to wind round and round again, to be tied wherever the wearer wishes."* She recognized that to be comfortable, it was the wearer who should dictate the placement and girth of her own waist. Ever practical, McCardell inserted deep pockets into the side seams of all her garments, including evening gowns. The current state of this gown with its multiple repairs suggests that it must have been one of McCardell's favorites and that she wore it time and again. According to family archives, it was never reproduced.

*Discarded manuscript notes for McCardell's 1956 book *What Shall I Wear*, the Claire McCardell collection, MS 3066, Box 4, Folder 11, H. Furlong Baldwin Library, Maryland Historical Society, Baltimore

Wool Crêpe Maxidress

1969–1970

Designed by Geoffrey Beene (1927–2004)
Worn by Barbara P. Katz (1933–)

Maryland Historical Society, Gift of
Mrs. Barbara P. Katz, 2017.5.6

This maxidress from the Geoffrey Beene ready-
to-wear line was purchased in Baltimore by
Barbara P. Katz, the first female chair of the
Maryland Historical Society's Board of Trustees.
Katz grew up surrounded by fashion: dressing up
in hats and playing in closets filled with high-end
fashion, she learned about style very early.

Katz recalls Beene as a favorite designer,
with his bold colors and innovative designs.
Beene is credited as the first American designer
to use wool crêpe in his designs for evening
wear. In the collections of the late 1960s, Geoffrey
Beene favored strong geometric lines and bold
color combinations like the black and red seen
in this dress. When worn, the red skirt "petals" of
this dress move to expose the black underneath,
creating dynamism in this seemingly simple dress.

*This dress is exhibited through the generosity of
Alexandra Deutsch in honor of Barbara P. Katz
who has done so much for this collection.*

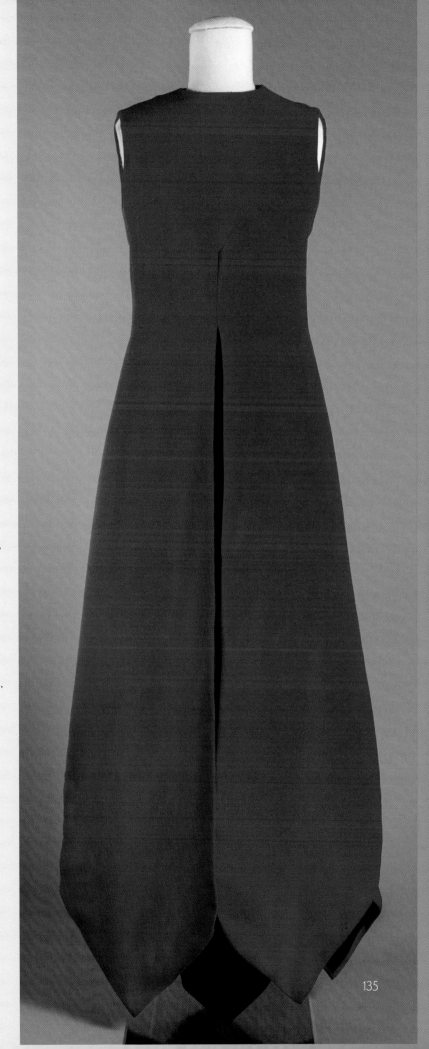

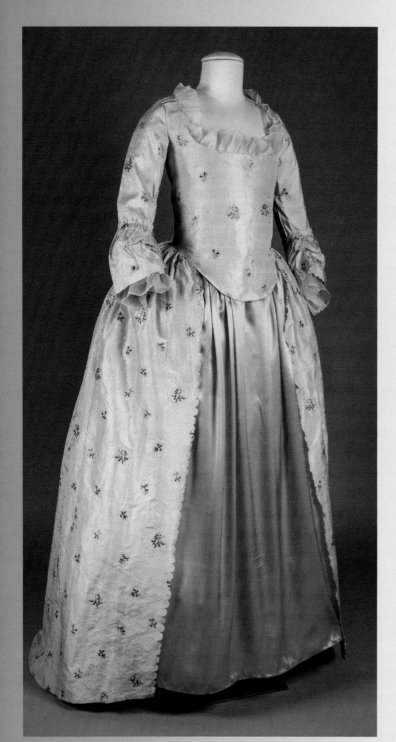

Embroidered Silk Taffeta Dress

1789

Worn by Sally Adams Hollingsworth (1761–1830)

Maryland Historical Society, The Anne Cheston Murray Collection from Ivy Neck, Cumberstone, Maryland, 2004.39.21

Prior to the 1790s, the silhouette of most women's clothing in the eighteenth century was defined by an elongated, conical torso and a full skirt. Eighteenth-century stays molded a woman's body into the desired shape by flattening her front, pushing her breasts high, and flattening her back, all of which compelled the wearer to stand with shoulders drawn back. The 1780s saw the last version of the style in which the skirt fullness was supported by petticoats worn over a bustle, called a bum roll. Dresses like this one opened in the front, showing a final decorative petticoat, which was often beautifully quilted. Sally Adams Hollingsworth's original coral-pink quilted petticoat worn with this dress survives, but during the 1920s, a descendant transformed it into an evening cape.

Sally Adams Hollingsworth wore this embroidered silk dress in 1789 when she and her husband, Samuel, traveled to New York City and attended a ball honoring George Washington's presidential inauguration. In 1814, Sally received the honor of being listed among other patriotic ladies of Baltimore for donating old linen and food to the city hospital in anticipation of an attack on Baltimore during the War of 1812.

This dress is exhibited through the generosity of the National Society of the Colonial Dames of America in the State of Maryland.

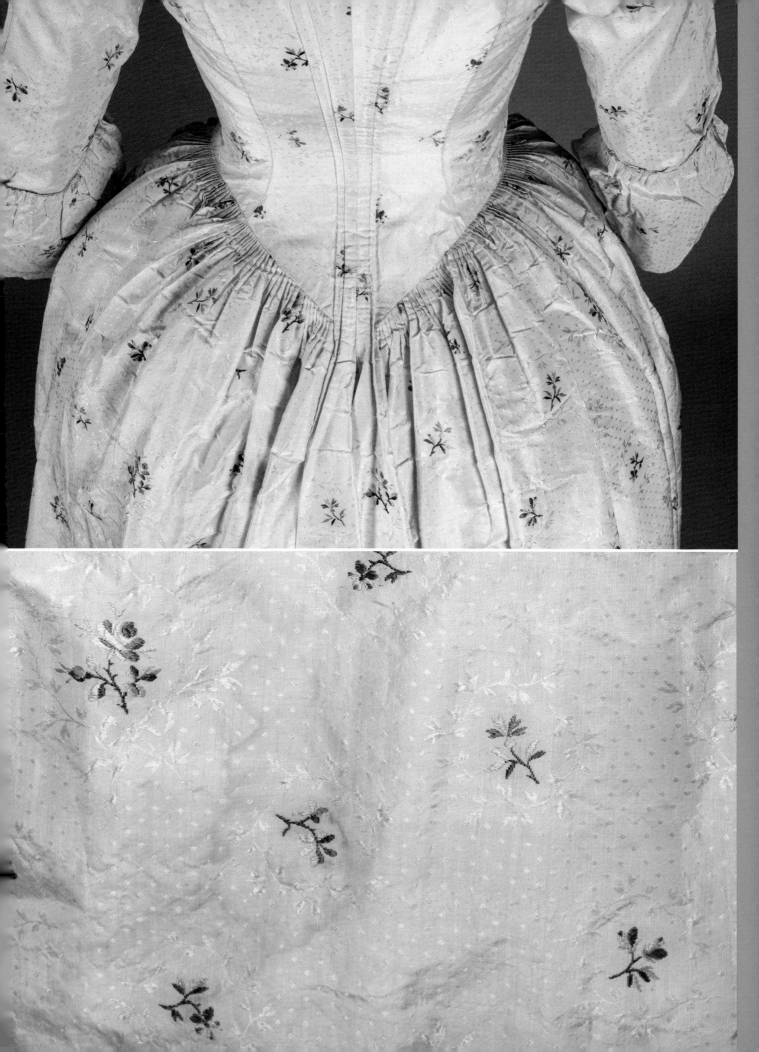

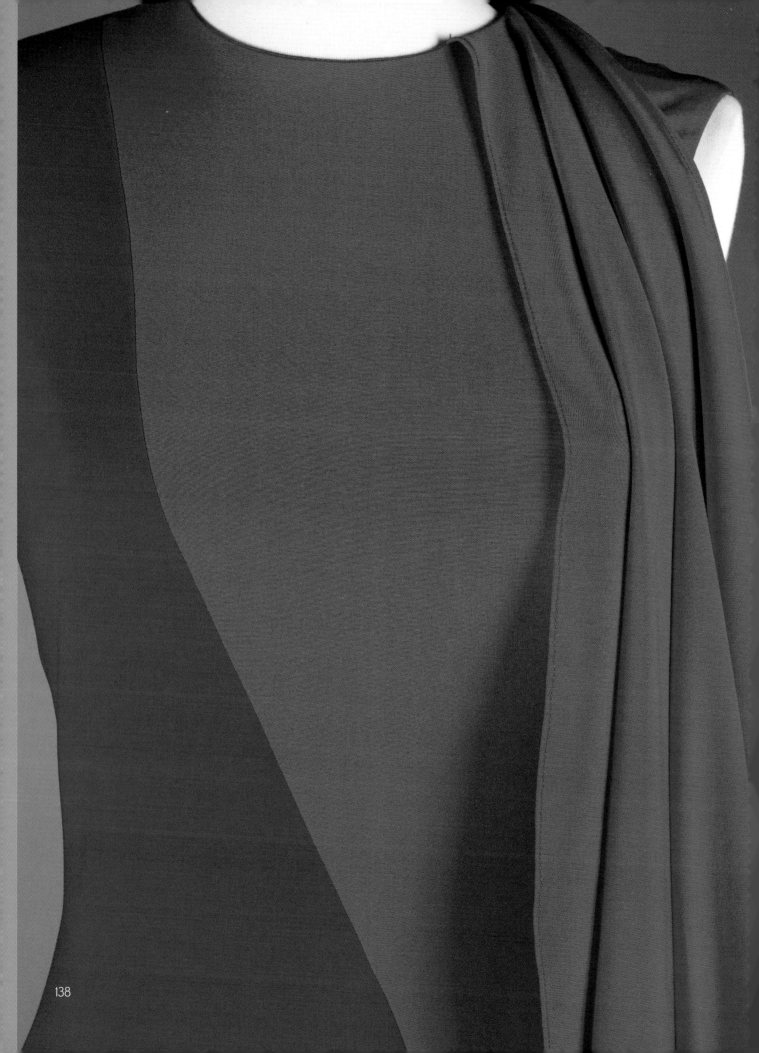

Silk Evening Dress

2018
Designed by Christian Siriano (1985–)
Unknown wearer
Maryland Historical Society, 2019.12

To celebrate the tenth anniversary of his eponymous brand, Christian Siriano hosted a fashion show at New York Fashion Week featuring seventy-two looks, including this two-toned silk gown. Born and raised in Annapolis, Maryland, Siriano attended the Baltimore School for the Arts before studying at American InterContinental University in London, where he interned under industry giants Vivienne Westwood and Alexander McQueen. In 2008, Siriano became the youngest contestant to win *Project Runway*, receiving national attention at New York Fashion Week for his winning show. Siriano has built a thriving couture house since that time, all the while pioneering diversity and inclusivity in fashion. In 2015, Siriano appeared in the Forbes 30 under 30 list, and in 2016 he was named both "Designer of the Year" at the AAFA American Image Awards and "Designer of the Decade" at the Cure for a Cause Awards. This two-tone silk gown illustrates Siriano's mastery of color and structure, as the bright pink and red collide at a curved front seam that echoes the cascading line of the one-shoulder drape.

This dress is exhibited through the generosity of Caroline Griffin and Henry E. Dugan, Jr.

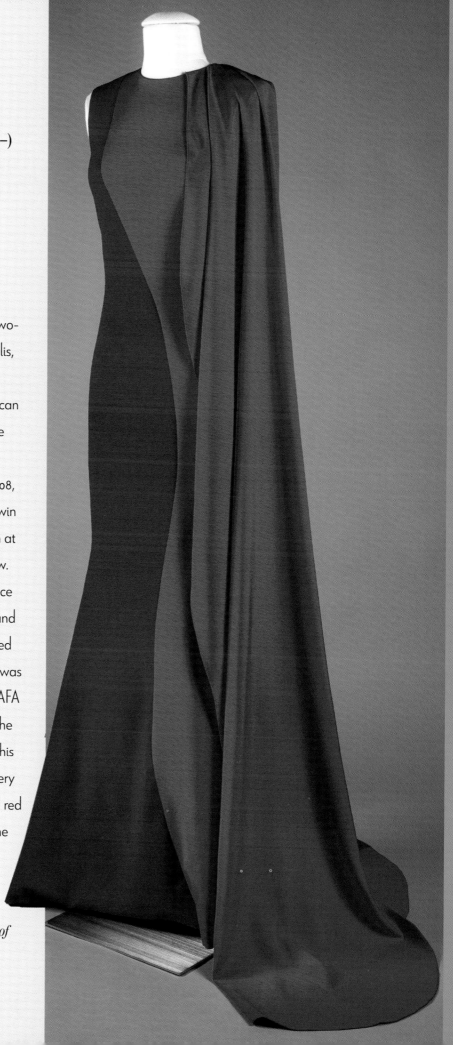

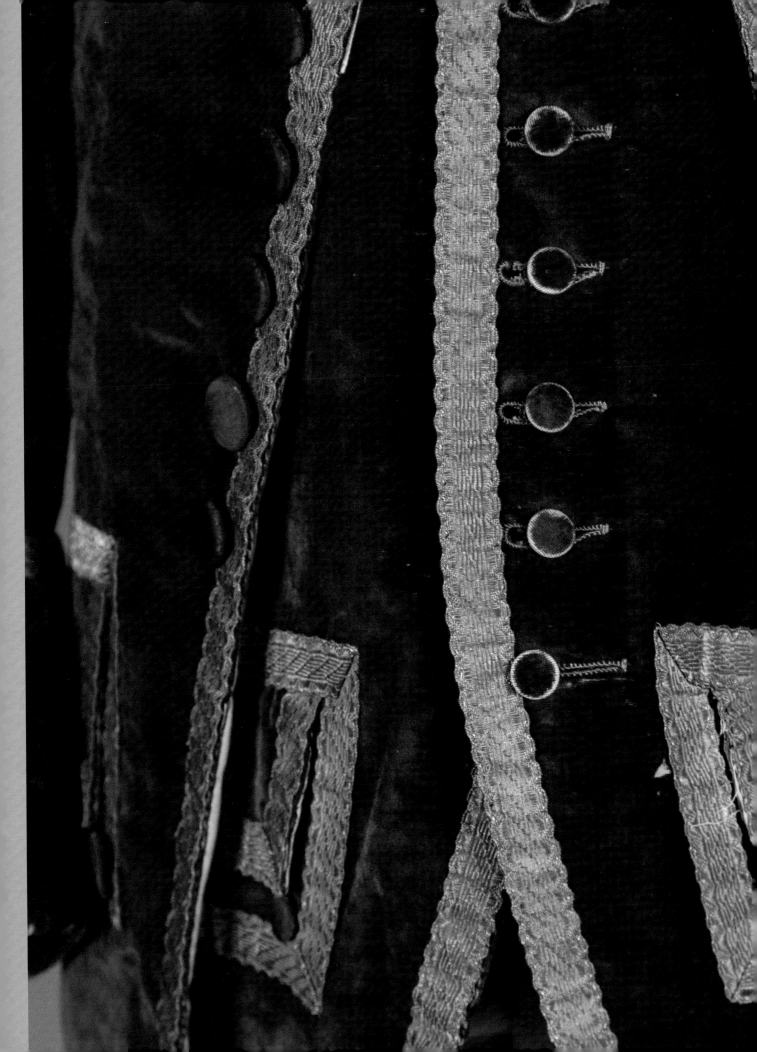

Silk Velvet & Wool Livery

1840–1849

Worn by an unidentified enslaved man

Maryland Historical Society,
Gift of Miss Constance Petre,
1946.3.3

Enslaved men and servants placed in highly visible jobs, such as coachmen or waiters, wore liveries—uniforms that visually showcased and symbolized a family's wealth. Liveries often incorporated eighteenth-century clothing details, such as breeches and the gold gilt that trims this unknown enslaved man's coat and waistcoat. Not only did these features announce a family's financial standing, a livery's antiquated style ensured no one mistook an enslaved person or servant as a freeman or freewoman.

This livery is exhibited through the generosity of Curt Decker.

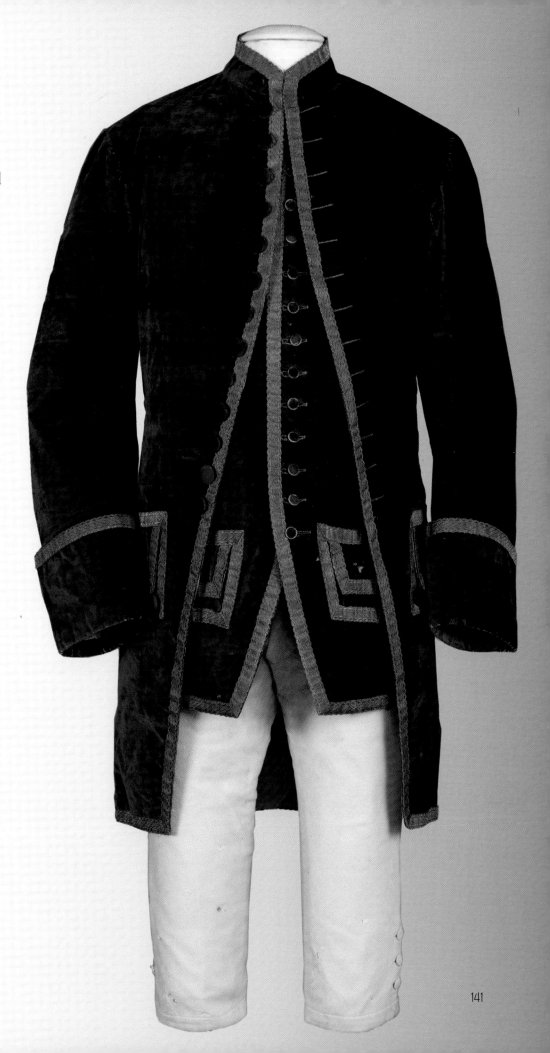

Silk Crêpe Waistcoat

1855–1859
Worn by George Coale (1819–1887)

Maryland Historical Society, The Redwood Collection, Gift of Mrs. Francis
Tazewell Redwood, xx.4.30

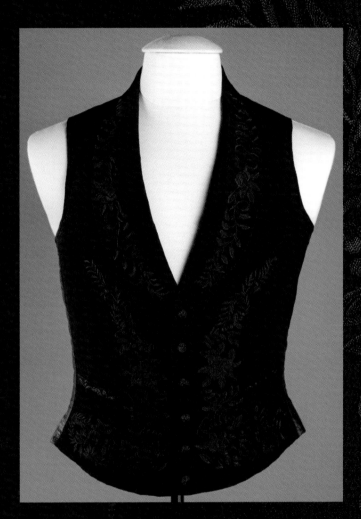

George Coale most likely wore this vibrant purple waistcoat at his wedding to Caroline Dorsey around 1857. Coale was a leader in the Baltimore insurance market, but also renowned for good manners and as a connoisseur of art, literature, photography, and drama. Most men's suits of the mid-nineteenth century were subdued in color, usually black, and elaborate waistcoats introduced additional colors and patterns to their outfits. The delicate silk crêpe fabric used in this waistcoat is decorated with an embroidered floral motif along the lapels, center front, and waistline, showcasing the aesthetics of the wearer or perhaps his future wife, who was likely the embroiderer.

Silk Damask Dress

Fabric c.1740, Dress 1838–1840

Worn by Elizabeth Evans Hoogewerff (1803–1888)

Maryland Historical Society, Gift of Mrs. Addison F. Worthington, 1949.4.1

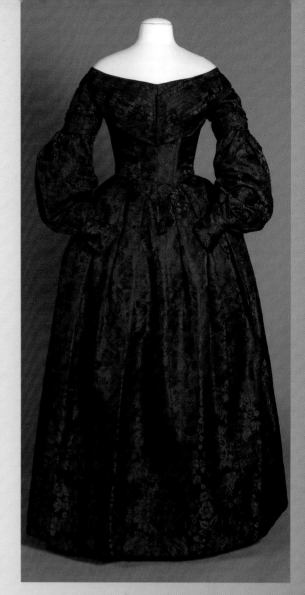

Born in Lancaster, Pennsylvania, Elizabeth Evans Hoogewerff was known as "the Rose of Lancaster" and married a Baltimore merchant, Dutch-born Jacobus Jan Hoogewerff, in 1823. Elizabeth is said to have danced with Lafayette during his stop in Baltimore on his 1824–25 tour of the United States. The style of this dress dates to about 1840, but its draw-loom silk damask has been authenticated as dating to about 1740. Because of its unusual deep purple color, it was thought that the fabric might have been re-dyed but careful examination of the selvages in the skirt fabric indicate that this is its original color. There is also no evidence that the dress was restyled from an earlier garment. The dress was donated with an accompanying linen *fichu* for daytime wear plus a lace bertha collar for evening.

This dress is exhibited through the generosity of Barbara Meger.

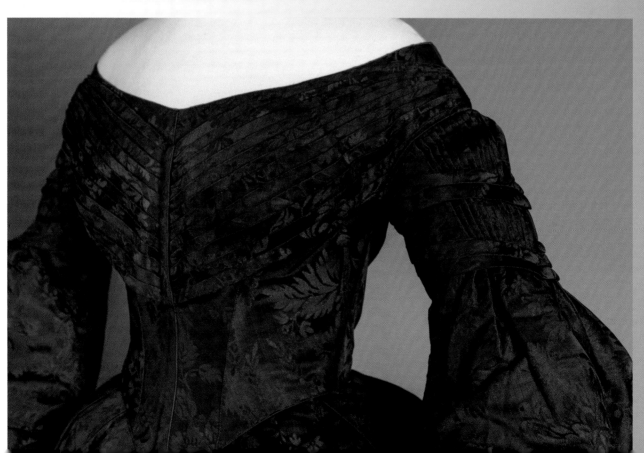

Silk Crêpe de Chine and Metallic Thread Evening Dress

1925–1929

Worn by Rose Shapira Freedman (1898–1965)

Maryland Historical Society, Gift of Miss Shirley Freedman, 1966.51.2

While 1920s fashion is probably best known for short, spangled evening dresses, their popularity was brief. The purple crêpe *foulards* or scarves attach at the dropped waist line of this dress and hang well below its knee-length skirt, giving a nod toward the revival of floor-length evening gowns that became stylish in the 1930s. This dress was worn by Rose Shapira Freedman, a first-generation American and one of seven children, including her twin, Bessie. After college, Rose married Sol Freedman, who, like Rose, came from a family of Polish immigrants. They settled in Baltimore near his dry-goods shop on Redwood Street.

This dress is exhibited through the generosity of Maxine Stitzer-Hodge.

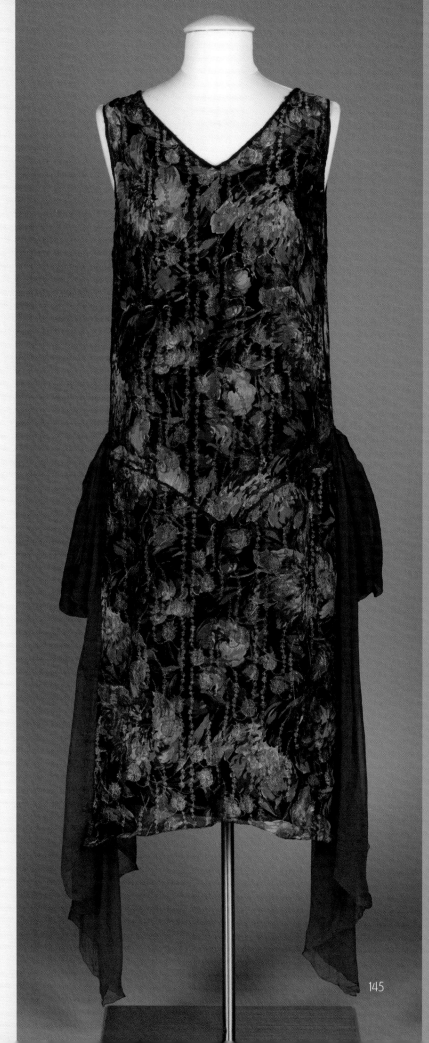

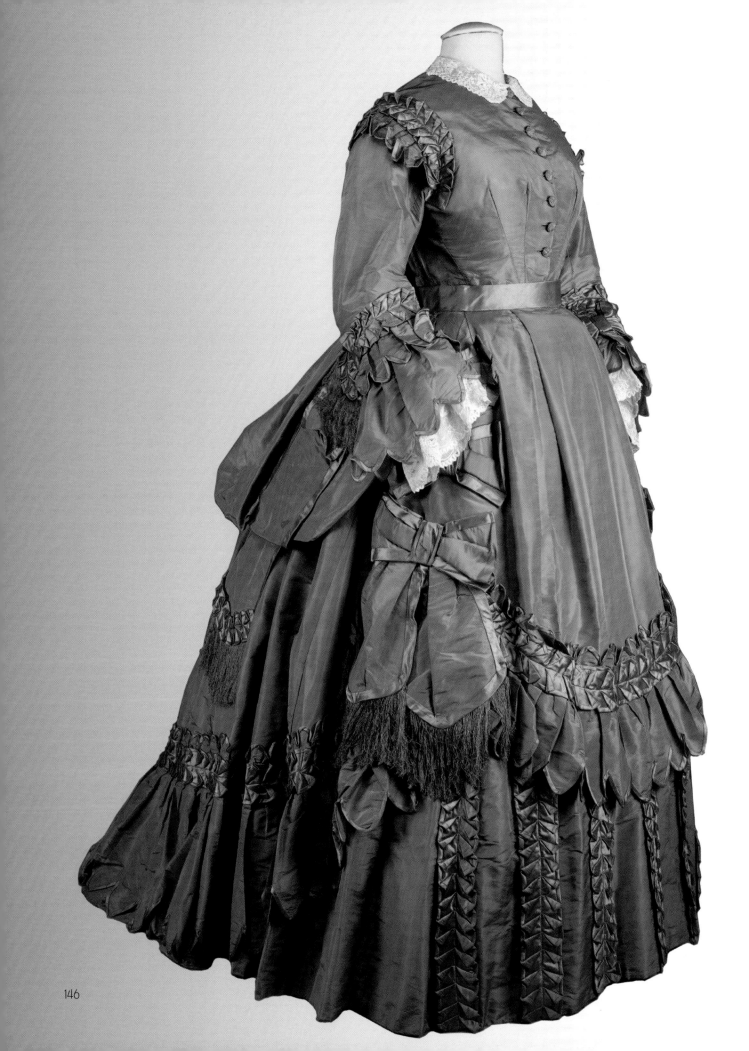

146

Shot Silk Taffeta Dress

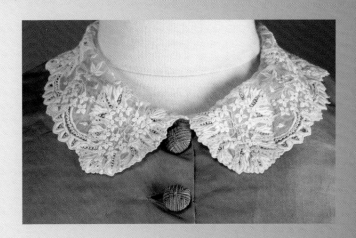

1869–1871

Worn by Anne "Annie" Campbell Gordon Thomas
(1819–1886)

Maryland Historical Society, The Estate of Mrs. Alice Lee Thomas
Stevenson, 1972.81.14 a-d

American fashion magazines circulated the latest trends,
providing women with detailed images and instructions for updating their wardrobes. Anne "Annie"
Campbell Gordon Thomas transformed her shimmering shot silk late-1860s' dress into a style
fashionable in the early 1870s with the addition of two draped overskirts and abundant machine-
sewn fringe and ribbons. By this decade, the sewing machine was in common usage, facilitating
such lavish ornamentation. Thomas had inherited a large fortune from her father, Bazil Gordon,
who is considered by various sources to be America's first millionaire. It is likely she hired a talented
seamstress to execute these extensive alterations.

This dress is exhibited through the generosity of the Joseph Mullan Company.

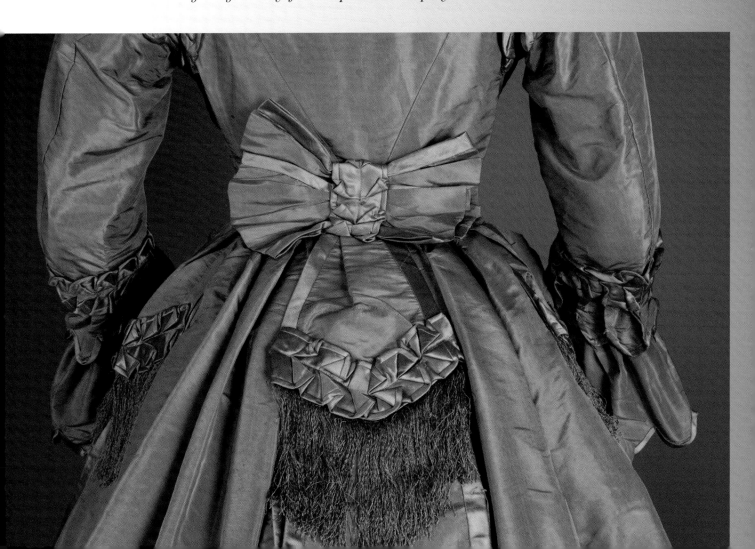

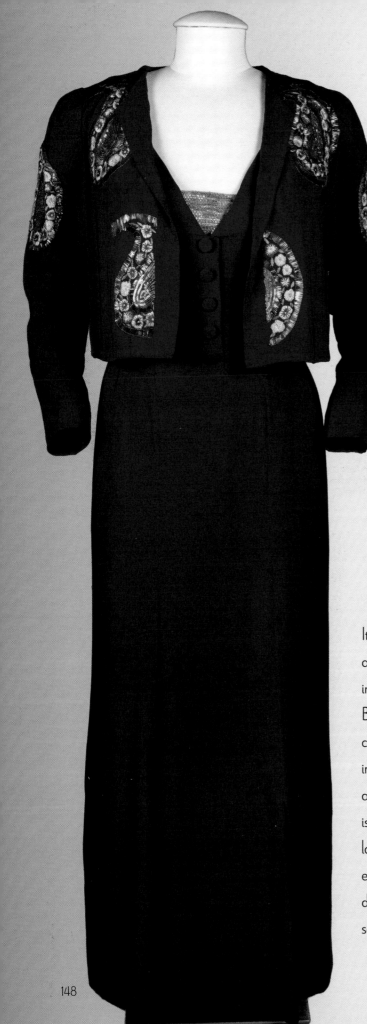

Rayon Crêpe Evening Dress & Jacket Ensemble

1937–1939

Designed by Ventura, Rome

Worn by Muriel Wurts-Dundas Boone (1906–1970)

Maryland Historical Society, Gift of
Mr. James R. Herbert Boone, 1973.48.11

It is unknown how Muriel Wurts-Dundas, descendant of
a wealthy Scottish family and possibly the richest orphan
in New York City, came to meet James Rawlings Herbert
Boone, a Baltimore man whose family fortune was made in a
cotton duck mill. The affluent pair were married in Baltimore
in 1930. They spent much of their time in Europe, and were
avid art collectors. Boone's appreciation of art and antiques
is illustrated in this Italian outfit which features a jacket with
large-scale paisley motifs filled in with smaller floral patterns
embroidered in metallic threads. This embroidery adds
dynamism to an otherwise austere ensemble, a contrast often
seen in fashions of the 1930s.

Polyester and Dupioni Silk Jacket, Skirt, and Sash

1987–1989

Designed by Maggie Shepherd

Worn by Barbara Meger (1949–)

Maryland Historical Society,
Gift of Barbara Meger 2018.11.2

Designer Maggie Shepherd learned to sew from her dressmaker mother and founded her fashion design business in the 1970s in her native Canberra, Australia. Shepherd favored comfortable, easily packable and non-crushable polyester fabrics for her garments. Her clothing was marked by bold and colorful, usually botanical, designs in colors that seemed to clash, but were the epitome of the psychedelic culture craze which carried into the 1980s. At its peak, Shepherd's company had eight stores in Australia and eleven in the United States, including one at the Galleria in downtown Baltimore. This purple and emerald green dress with its brightly colored dupioni silk sash was purchased at the Galleria in the late 1980s by its wearer, Maryland resident Barbara Meger. Its heavily padded shoulders and puffed sleeves are typical of '80s fashion. The semi-fitted top is accented with a silk-trimmed pocket, into which the wearer, an expert in historical lace and textiles, added a vintage lace and linen handkerchief.

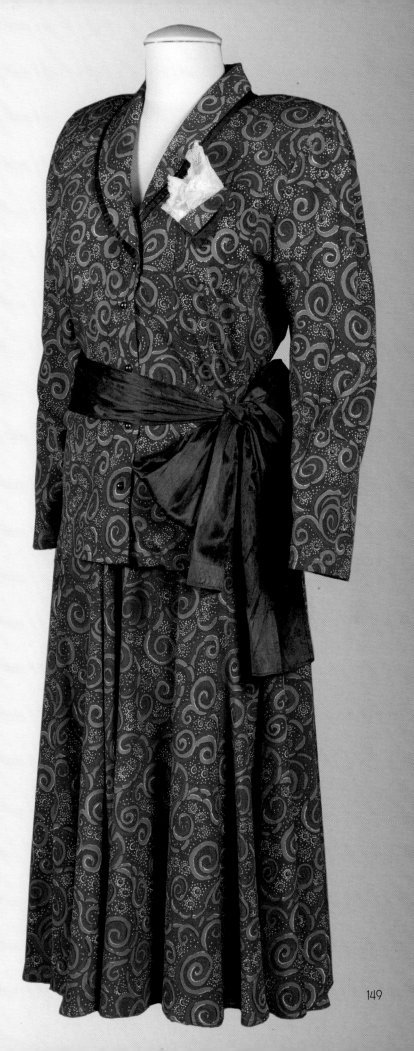

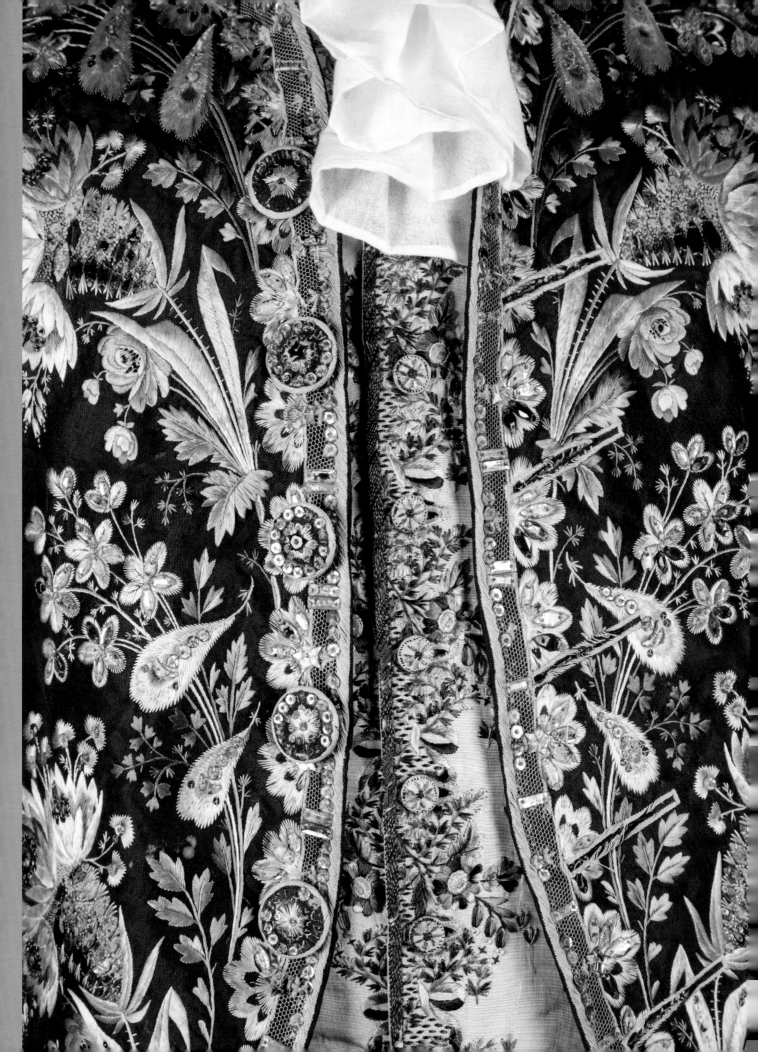

Silk Faille Court Coat

1800–1803

Probably French

Unknown wearer

Maryland Historical Society, Gift of
Mr. James R. Herbert Boone, 1973.48.12

Displayed with silk faille court waist-
coat, 1805–1807, probably English,
worn by William Pinkney (1764–1822).

Maryland Historical Society, Gift of
Mrs. Lawrence R. Carton, 1956.75.23

Even after men's clothing for
everyday wear became less
elaborate, ceremonial court attire
mimicked the aristocratic fashions
of previous eras with its abundance
of silver and gold embroidery, rich
colors, and exquisite faux glass
jewels. By wearing such exuberant
ensembles, a man publicly validated
his elite status and proximity to the
monarch. Although court clothes
reflected past trends, silhouettes
continued to change to follow current
styles, as seen in this 1800 court coat's
high standing collar, cut-away front,
and tight sleeves.

This coat is exhibited through the
generosity of Mark B. Letzer in honor
of H. Furlong Baldwin.

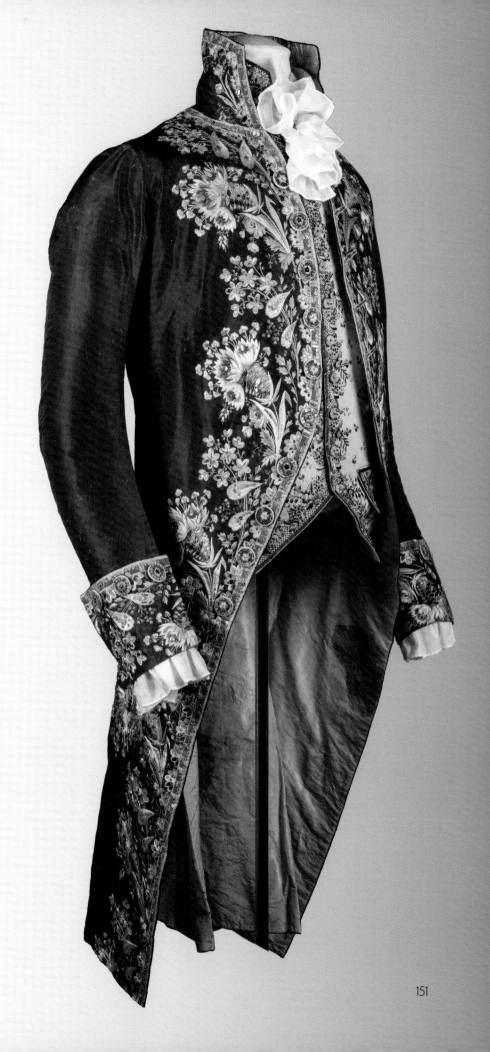

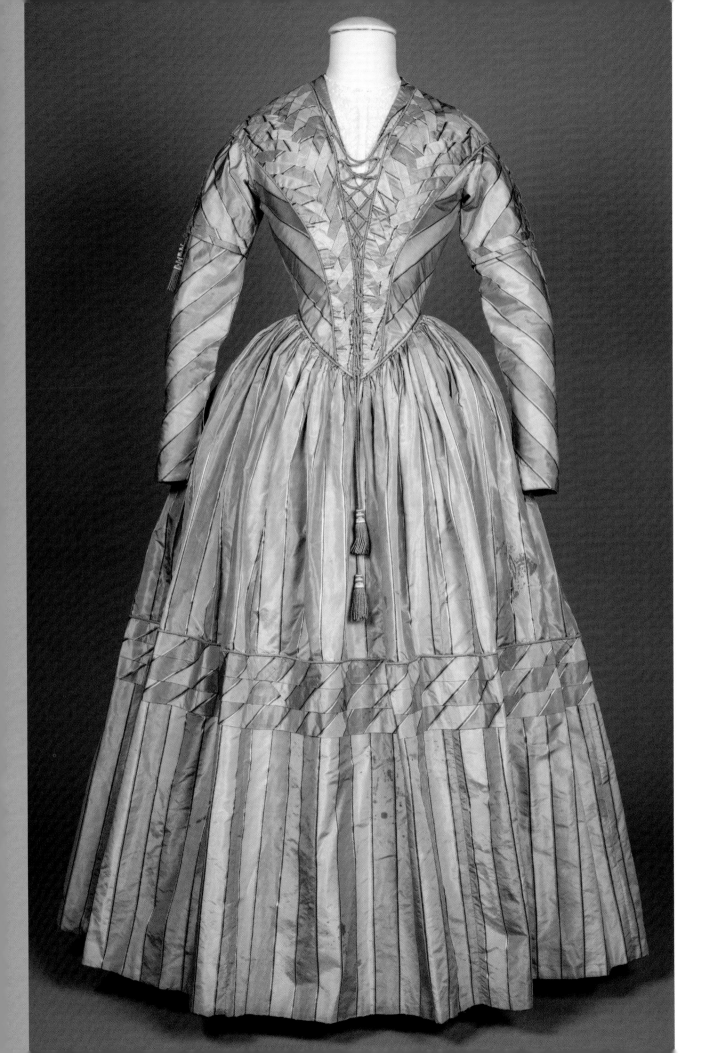

Silk Taffeta Dress

1845–1850

Unknown wearer

Maryland Historical Society, Gift of Miss Doris L. Kramer through Mrs. Charles Klepper, 1978.107.15

Fashions of the 1840s characteristically favored more subtle and subdued silhouettes, yet the meticulous manipulation of fabrics and patterns maximized a dress's visual interest. This pale green and lilac striped dress showcases the masterful sewing skills used to manipulate the striped fabric. Clever pleating at the bodice creates a chevron design and the three strips of bias-cut fabric decorating the skirt create the illusion that it has two tiers.

Typical of the decade, the dress's elongated torso indicates the conical corset women wore that was stiffened by a wooden or ivory busk. Multiple layers of petticoats, with at least one stiffened with *crin*, or horsehair, supported the desired volume in these skirts.

This dress is exhibited through the generosity of Mrs. Barbara P. Katz.

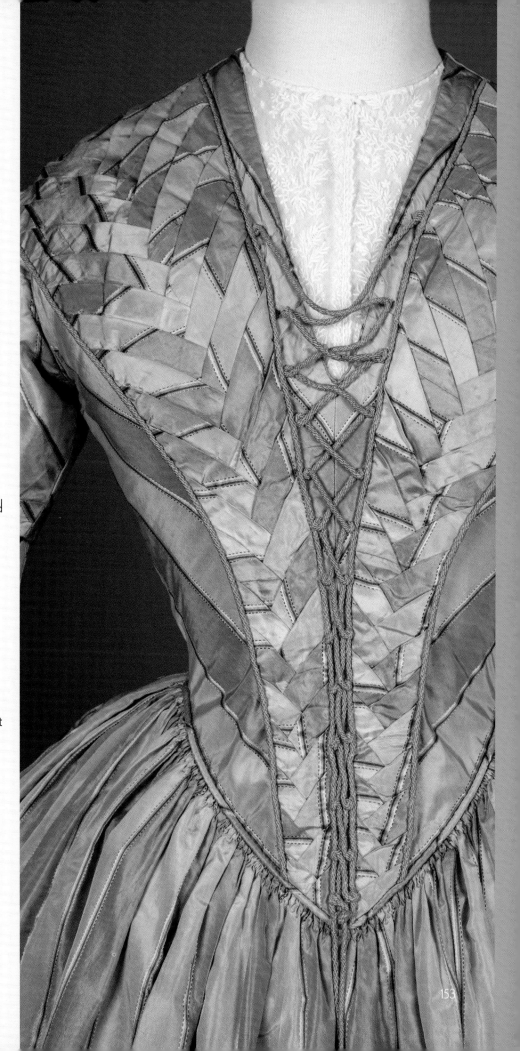

153

Cotton Dress

1950–1957

Worn and Made by Adina Mae Via Robinson (1937–1966)

Maryland Historical Society, Gift of Franklin A. Robinson, Jr., 2015.18.2

Born to a farming family from Ferndale Farm in Prince George's County, Adina Mae Via Robinson's love for sewing is reflected in this dress. Robinson added her own stylish touches with her choice of a floral and umbrella-patterned fabric and two large, faux pearl buttons for the back closure. Not only representative of the larger trend of home-sewn clothing, Robinson's dress speaks of her own family's traditions and culture of frugality.

Adina Robinson passed away in 1966 at the early age of 29, yet her trove of clothing was lovingly washed and packed away, transferred from "closet, to attic, and back again — but never thrown away," eventually being donated to the Maryland Historical Society. When presenting at the Society of American Archivists Convention in 2012, Adina's son, Franklin A. Robinson, Jr., recalled how "my experience of the farming people I come from is that one very seldom throws anything away, clothing included, because you might someday need it or be able to use it."

This dress is exhibited through the generosity of The Robinson Family of Serenity Farm.

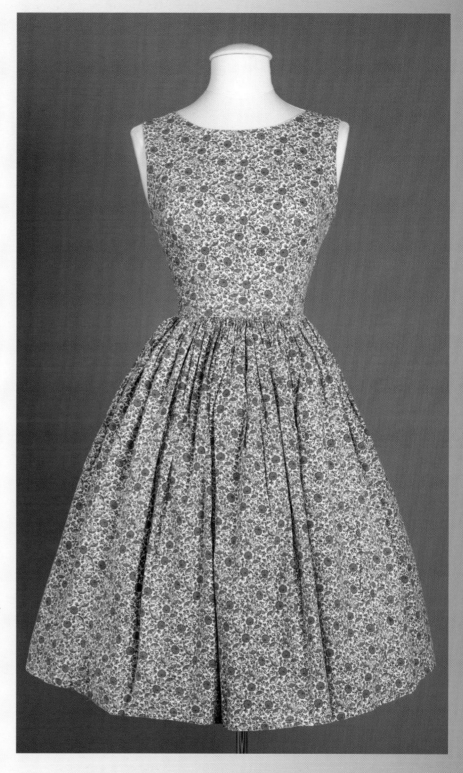

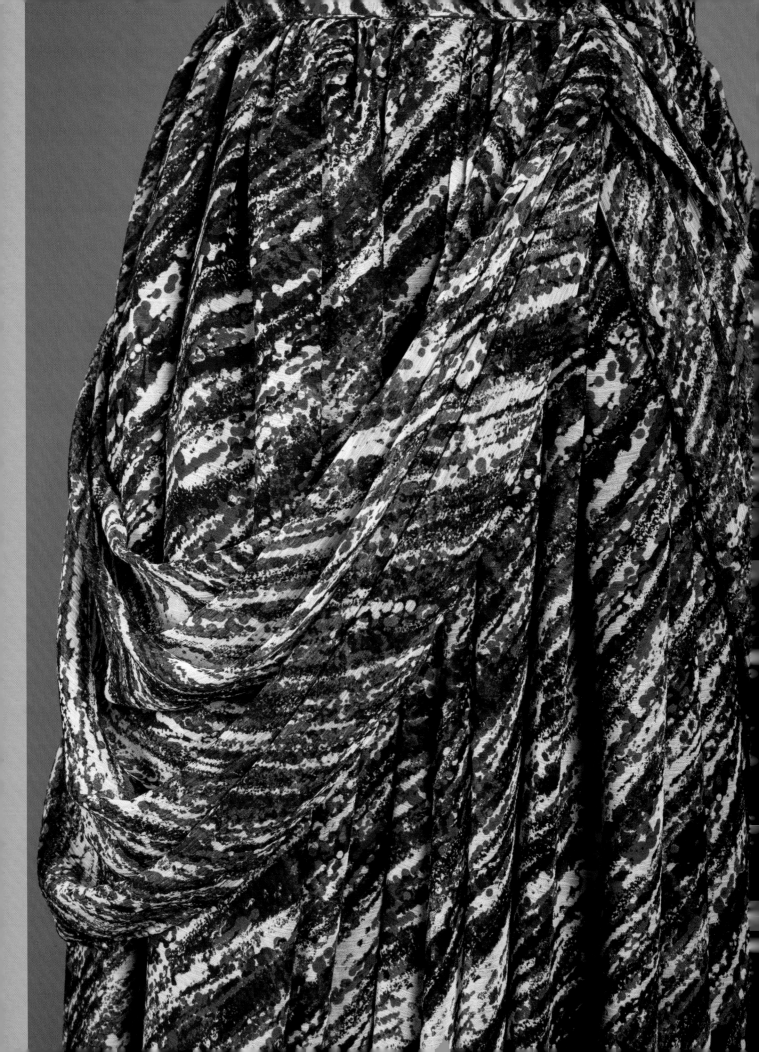

Silk Crêpe
Evening Dress

2009
American
Designed by Bishme Cromartie (1991–)
Maryland Historical Society Collection, 2019.11.1

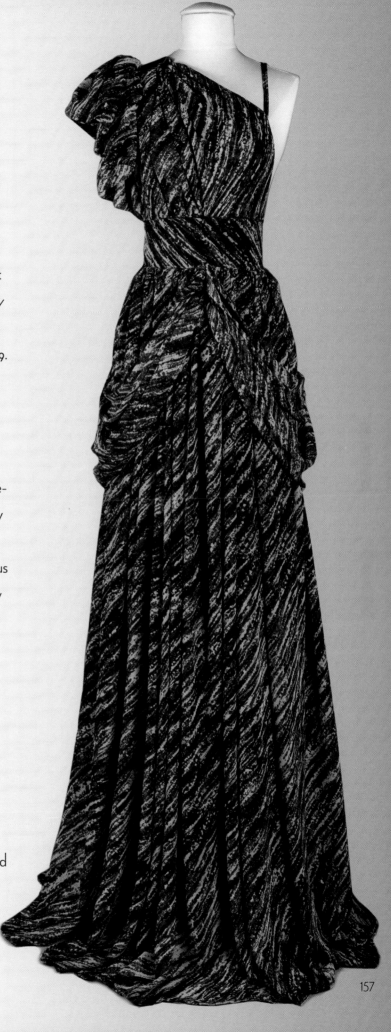

Baltimore native Bishme Cromartie, a self-taught designer and a season-seventeen *Project Runway* contestant who progressed to the final four, designed this multi-colored silk crêpe dress in 2009. When a New York stylist requested two readily available, floor-length gowns for a photoshoot, Cromartie confirmed, despite only having the fabric. Cromartie, then seventeen, successfully designed and sewed both dresses within the three-day deadline. Such a commission was particularly impactful because that same week, Cromartie received news of his rejections from two prestigious design schools, the Fashion Institute of Technology and Parsons School of Design. Ultimately, *ELLE Vietnam* published a photograph featuring one of his dresses from this commission, a significant milestone in Cromartie's career.

Cromartie received no formal fashion training, only that of his great-aunt Faye Dean Lacy, who taught him his initial sewing basics at nine years old. From sewing miniature outfits for his G.I. Joes to designing many of his classmates' prom dresses, Cromartie has passionately pursued a career in fashion since an early age and is now internationally recognized for his work.

This dress is exhibited through the generosity of Mr. and Mrs. Ross P. Flax.

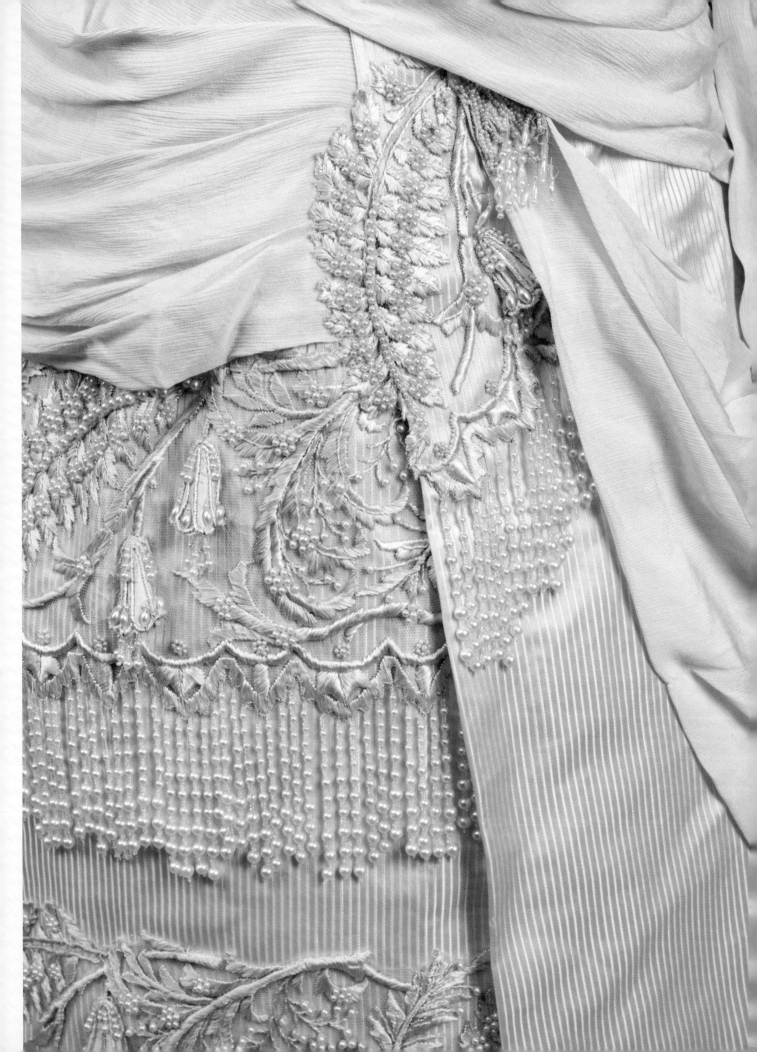

Silk Satin, Crêpe, and Pearl Wedding Dress

1883

Designed by Patten of Baltimore
Worn by Judith DeFord Worcester Martins (b.1869)

Maryland Historical Society, Gift of Miss Katherine Martins, 1960.66.1

This ornate wedding dress was worn by Judith (called "Jennie") DeFord Worcester, an organist at Christ Church, at her marriage to Frank Martins on October 8, 1883. The light ivory color of this dress may have been the expected choice in 1883, but it was surprising when Queen Victoria chose an off-white gown for her marriage to Prince Albert of Saxe-Coburg and Gotha earlier in 1840. From that point, fashion deemed white or ivory as the most beautiful and appropriate colors for a bride. Although little is known about the designer and maker, Patten of Baltimore, this dress has clear French influence and is the epitome of the fashionable 1880s silhouette with its fitted, lace-trimmed bodice, draped overskirt, substantial bustle, and long train. Hand-sewn three-dimensional flowers appear throughout the dress, showing the amount of time and effort that went into this creation.

This dress is exhibited through the generosity of Margaret Allen Hoffberger.

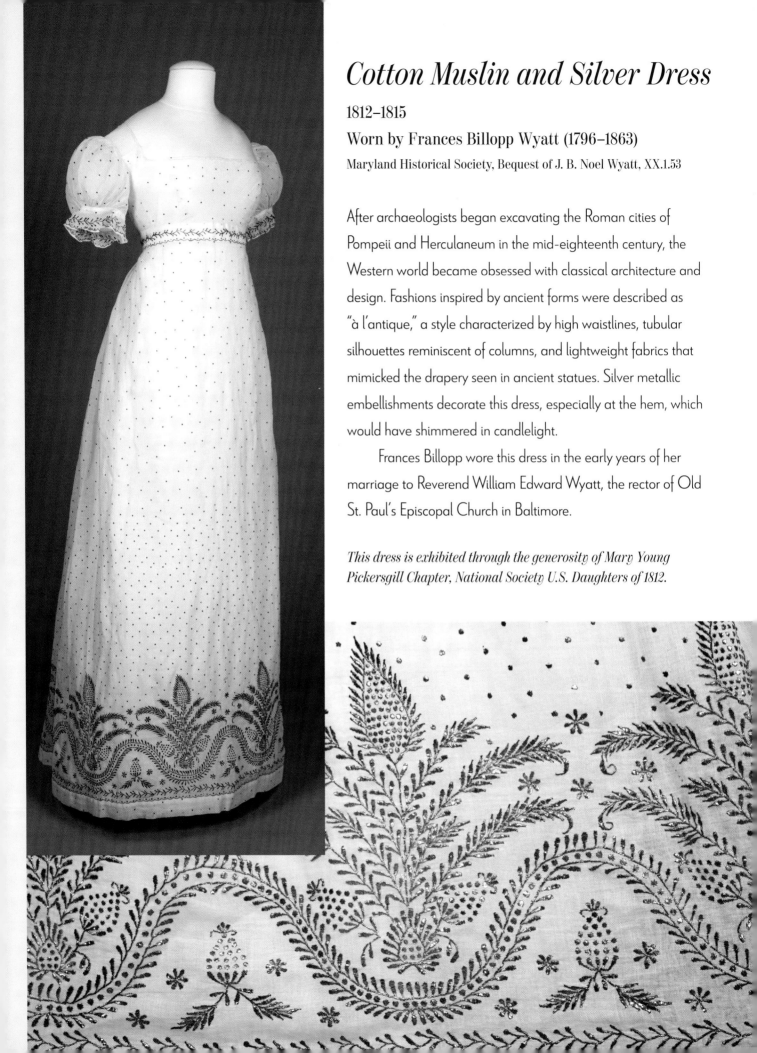

Cotton Muslin and Silver Dress

1812–1815

Worn by Frances Billopp Wyatt (1796–1863)

Maryland Historical Society, Bequest of J. B. Noel Wyatt, XX.1.53

After archaeologists began excavating the Roman cities of
Pompeii and Herculaneum in the mid-eighteenth century, the
Western world became obsessed with classical architecture and
design. Fashions inspired by ancient forms were described as
"à l'antique," a style characterized by high waistlines, tubular
silhouettes reminiscent of columns, and lightweight fabrics that
mimicked the drapery seen in ancient statues. Silver metallic
embellishments decorate this dress, especially at the hem, which
would have shimmered in candlelight.

Frances Billopp wore this dress in the early years of her
marriage to Reverend William Edward Wyatt, the rector of Old
St. Paul's Episcopal Church in Baltimore.

*This dress is exhibited through the generosity of Mary Young
Pickersgill Chapter, National Society U.S. Daughters of 1812.*

Cotton Muslin Dress

1805–1810

Worn by Elizabeth Patterson Bonaparte (1785–1879)

Maryland Historical Society, Gift of Mrs. Charles J. Bonaparte, XX.05.150

Born at a time when women were defined by their domestic accomplishments and their husband's wealth, Elizabeth Patterson Bonaparte rebelled against the dictates of nineteenth-century society. After her ill-fated 1803 marriage to Jérôme Bonaparte, Napoleon's youngest brother, Elizabeth chose to live independently. In a glamorous life split between Baltimore and Europe, which offered her the celebrity she craved, Elizabeth intrigued onlookers on both sides of the Atlantic Ocean. Despite this, Elizabeth suffered from melancholy. Though her life's complexities began with her royal alliance with Jérôme Bonaparte, this short-lived marriage also established the course of her life and began her ongoing quest for an imperial legacy.

This relatively simple dress, inspired by classical Greek and Roman gowns, is characterized by its extremely long train, which indicates its suitability for formal occasions. Except for its embroidered openwork sleeves, the dress has no other ornament and its beauty stems from its elegant construction. Gores on either side of the skirt pull the gown back and allow the train to flow behind it. Although by modern standards this is not a daring gown, its sheerness and unstructured lines would have caused a stir among certain circles in the early 1800s.

This dress is exhibited through the generosity of Mr. Jeffrey C. Palkovitz in memory of Jill Palkovitz.

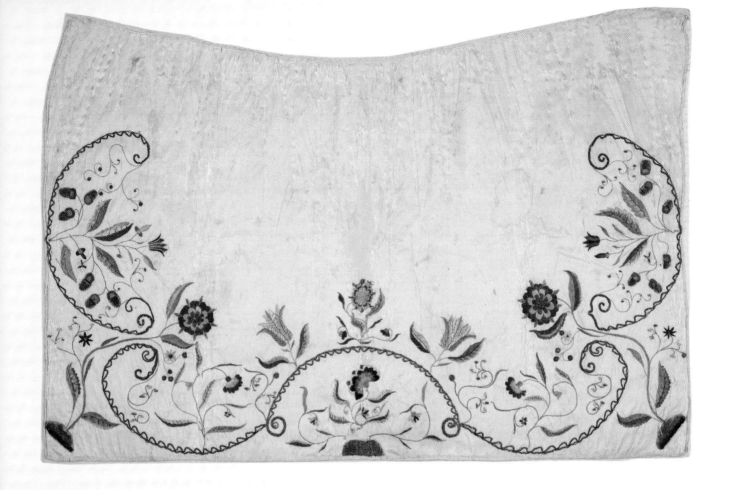

Embroidered Silk Wedding Apron

1724

Worked and worn by Anne Chew Thomas (1706–1777)

Maryland Historical Society, Gift of Mrs. William Woodyear, 1931.5.1

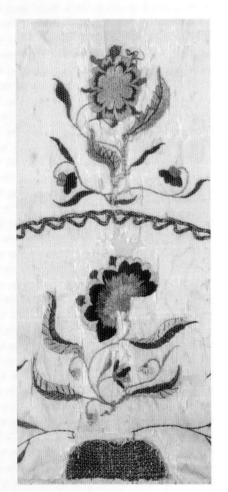

Anne Chew embroidered her silk apron in anticipation of her marriage to Phillip Thomas on August 11, 1724, in Anne Arundel, Maryland. Being decorative rather than functional, delicately wrought aprons of the early eighteenth century displayed a woman's high social standing and needlework skills. Ornamental aprons, such as Anne Chew's, added richness to fashionable ensembles with their lush colors, gold or silver gilt thread, and metallic sequins.

Rediscovering this almost three-hundred-year-old textile revealed its fragile condition and necessary conservation. Impressive stabilization and a custom mount allows the displaying of Chew's exquisitely embroidered apron, the earliest known piece in the Maryland Historical Society's Fashion Archives.

Linen Summer Suit

1855–1859

Unknown wearer

Maryland Historical Society, Gift of the Misses Dobbin, 1946.44.22 a-c

During the sweltering months of a Maryland summer, wearing linen and other lightweight fabrics offered men and women reprieve from the heat. As seen in this summer suit with its wide, tubular trousers, men's clothing of this decade featured fuller silhouettes that complemented women's widening skirts, as the cage crinoline emerged in the late 1850s. Checks and plaids were particularly popular for menswear in the 1850s, a trend represented by a reproduction checked silk cravat.

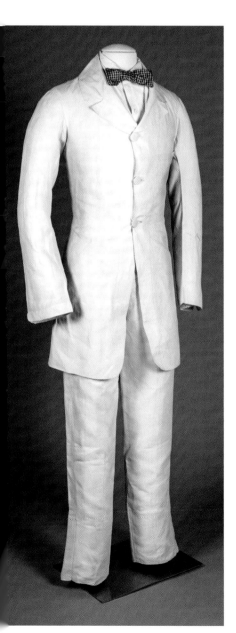

This piece is exhibited through the generosity of Dr. Richard M. and Sandra C. Milstead.

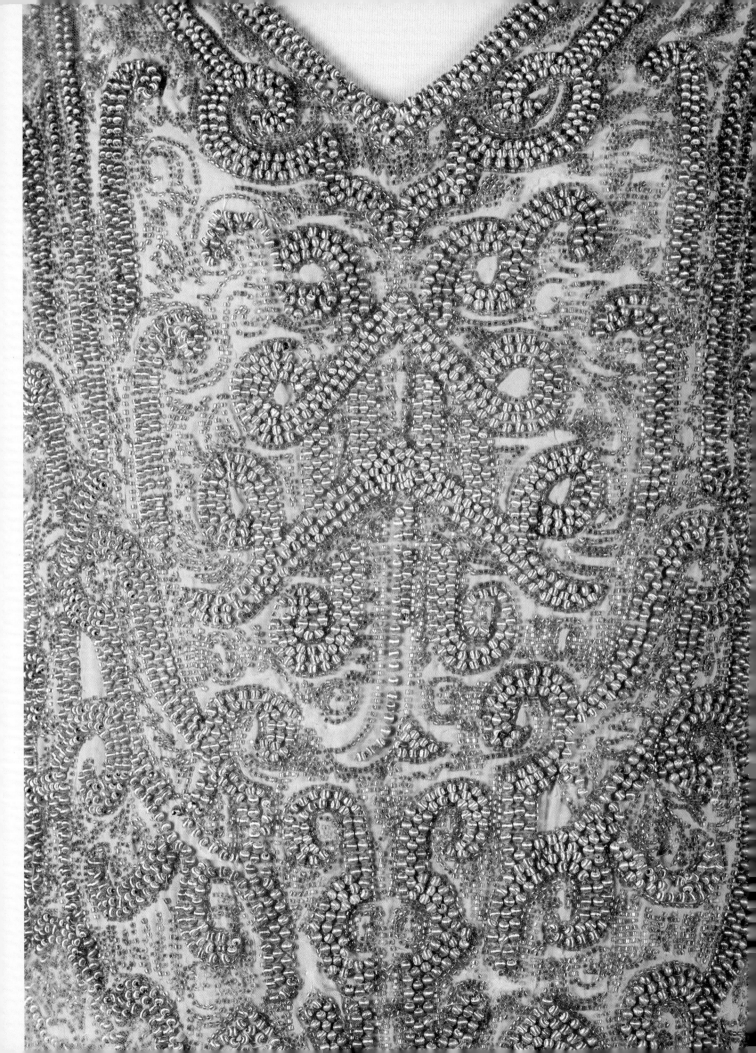

Silk Chiffon with Glass and Metal Beading Evening Dress

1915

Worn by Amelia Himes Walker
(1882–1974)

Maryland Historical Society, Gift of Mrs. Robert Hunt Walker (née Amelia Himes), 1948.89.2

Amelia Himes Walker wore this dress at her last public concert in 1915. Though a singer by profession, Amelia Walker more often made headlines in the *Baltimore Sun* for her efforts in the women's suffrage movement. After attending the Baltimore annual meeting of the Society of Friends in 1915, at which they resolved to endorse the suffrage movement, Walker dedicated her life to the cause. By 1917, she was a member of the Just Government League and regular picketer at the White House. In July of that year, she was among those who spent time in deplorable conditions at a workhouse after being arrested during a demonstration. Walker and her fellow suffragists were not stifled by their experience and spoke publicly about their mistreatment. Notably, in 1918 Walker did a transcontinental tour by train dressed in clothing similar to the uniform from the workhouse, an ensemble dubbed "the prison special," a dramatic contrast with her spangled stage dress from just three years earlier.

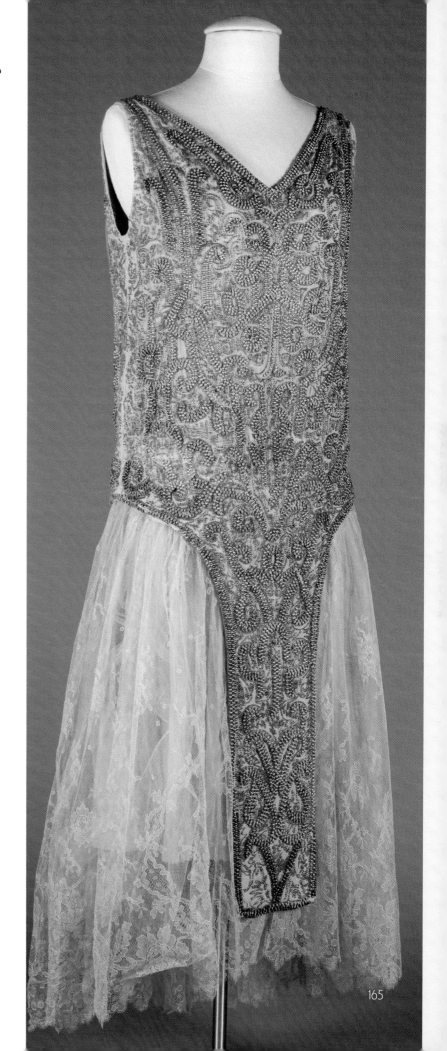

165

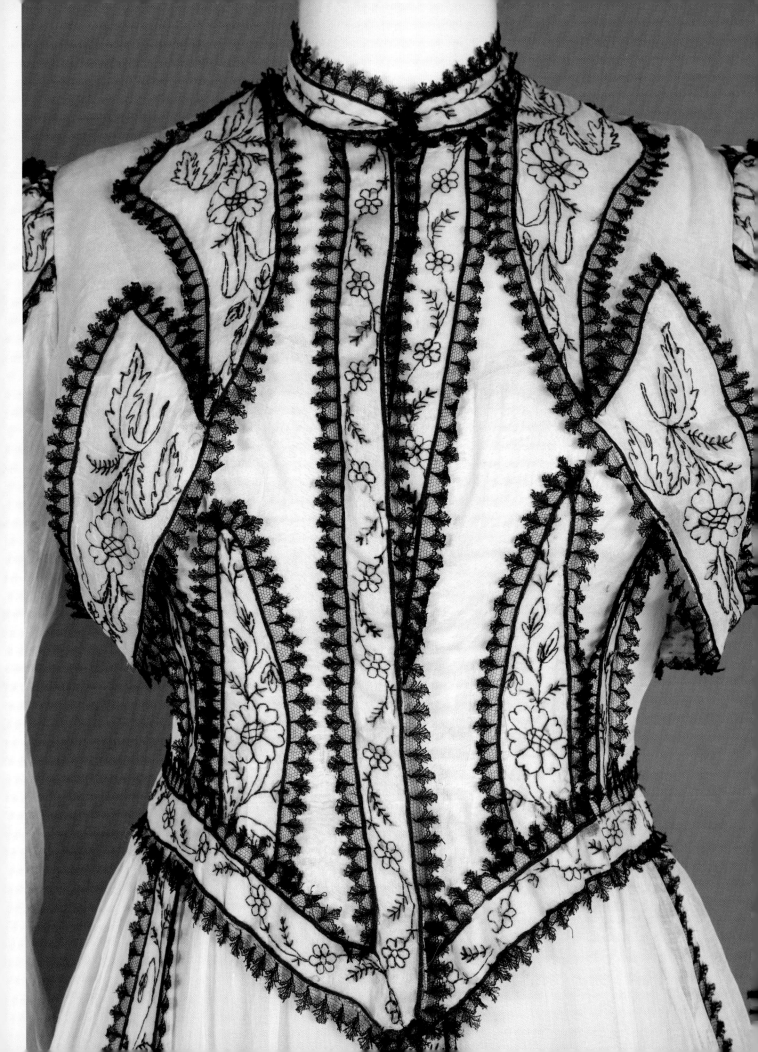

Cotton Muslin Dress

1904–1906

Worn by Helen Rolfe Hopkins Thom (1869–1948)

Maryland Historical Society, Gift of Mrs. Robert Dixon Bartlett, 1950.91.5

Helen Rolfe Hopkins, who was listed in the 1915 publication of *Woman's Who's Who of America*, wore this sheer white muslin dress, which features a striking design of black braided trim entwined in elegant floral motifs. After attending the first class of the Woman's College of Baltimore City, now Goucher College, and graduating from Bryn Mawr College in 1891, Helen taught natural science in private schools for two years. She then served as the principal of Green Spring Valley School until her marriage to Hunt Reynolds Mayo Thom in 1900. Helen supported woman's suffrage and was a member of the College Equal Suffrage League.

This dress is exhibited through the generosity of Colleen Callahan and Newbold Richardson of The Costume and Textile Specialists.

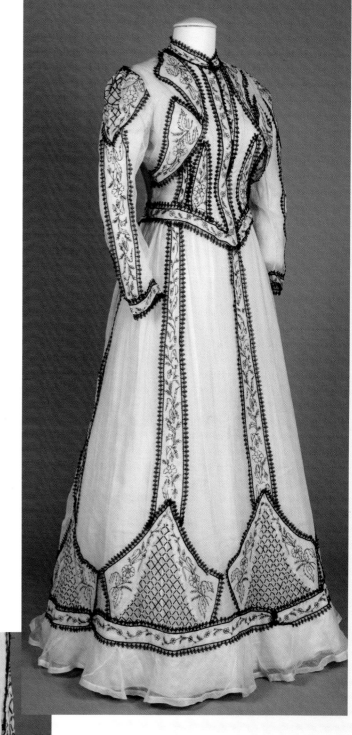

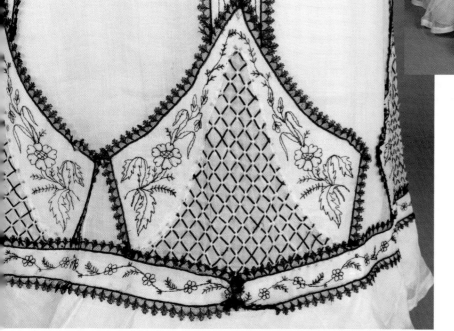

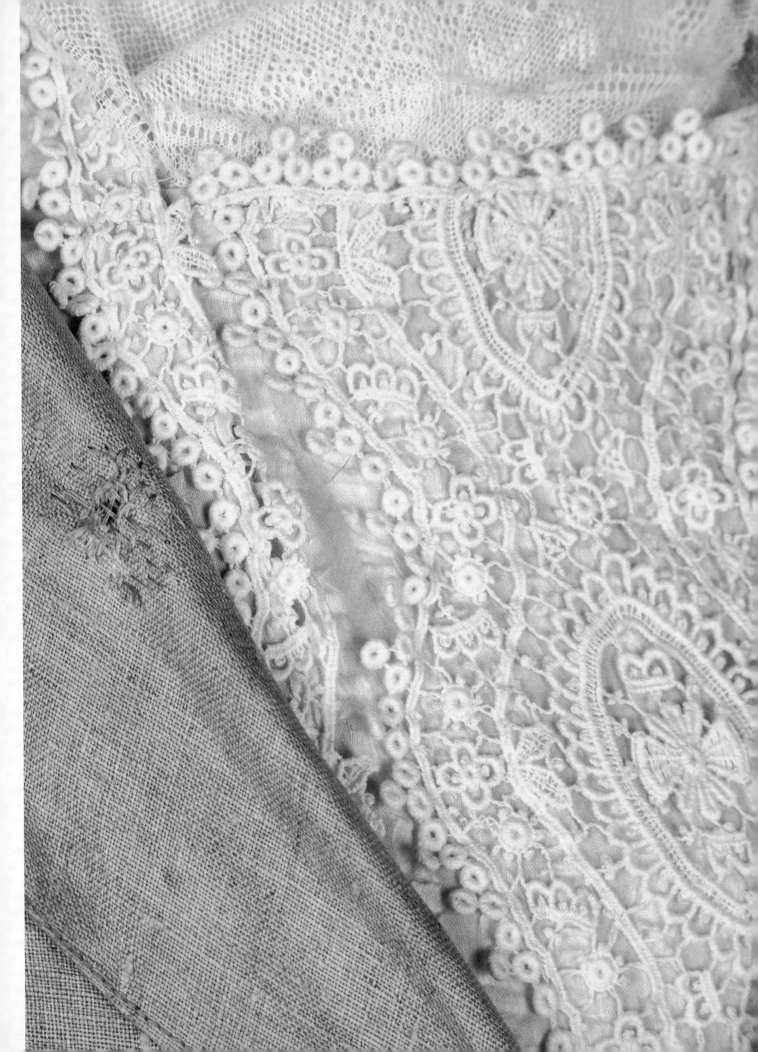

Linen Duster Coat

1900–1905
Worn by Sallie Webster Dorsey
(1860–1937)

Maryland Historical Society, Gift of Mrs. James
Hooper Dorsey, 1951.14.10

At a time when few women held prominent state offices, Sallie Webster Dorsey was Maryland's state librarian from 1912 till 1916, earning her a listing in the *Woman's Who's Who of America 1914–1915*. Dorsey also had an active social presence in the Baltimore community, in part because of her prominent family, but also in her own right as a member of the Woman's Literary Club of Baltimore, Daughters of the American Revolution, and president of the Cambridge Woman's Club.

Dusters were light-weight coats, typically worn to protect clothing against dirt or dust (hence the name) when the wearer was driving or riding in automobiles. This serviceable linen duster is an unusual garment to be associated with a Baltimore socialite and it is likely connected to Dorsey's time working as state librarian. The coat was probably new in the early 1900s and is cut like a man's coat. It has many meticulous mends on the collar, sleeve, and lapel. It is clear that Dorsey put much care into conserving this favorite garment.

Silk Organdy Embroidered Evening Dress

Spring/Summer 1954
Designed by Hubert de Givenchy
(1927–2018)
**Worn by Wallis Warfield Simpson,
the Duchess of Windsor (1896–1986)**
Maryland Historical Society,
Gift of Her Grace the Duchess of Windsor,
through Mrs. Clarence W. Miles, 1961.85.1

Photograph by Bradford Bachrach, c.1965,
Maryland Historical Society, H. Furlong Baldwin
Library, 1961.85.1

Growing up in Baltimore, Bessie Wallis Warfield could never have imagined how she would affect the British monarchy. After meeting the soon-to-be King Edward VIII in the early 1930s, however, she did just that. In 1936, King Edward abdicated the throne to marry the twice-divorced Wallis Simpson: a scandalous act, the consequences of which followed them both for the rest of their lives.

The controversial couple were style icons from the 1940s to the 1960s. This dress, a silk organdy evening dress decorated with embroidered monkeys playing instruments and organic swirls, was purchased for a special ball. The design was part of Givenchy's haute-couture collection from spring/summer 1954. Monsieur Givenchy was inspired by depictions of monkeys on a wall painting which he saw in the Cabinet de Singes in the Hôtel de Rohan in Paris. After it was donated to the Maryland Historical Society, the Duchess of Windsor agreed to have Bradford Bachrach photograph her in the dress. This photograph was the cover image for the *Baltimore Sun Magazine* in 1968.

This dress is exhibited through the generosity of William Wallace Lanahan III, Michael Bruce Lanahan, Barbara Lanahan Mauro, and Julia Browne Sause in memory of Eleanor Addison Williams Lanahan Miles.

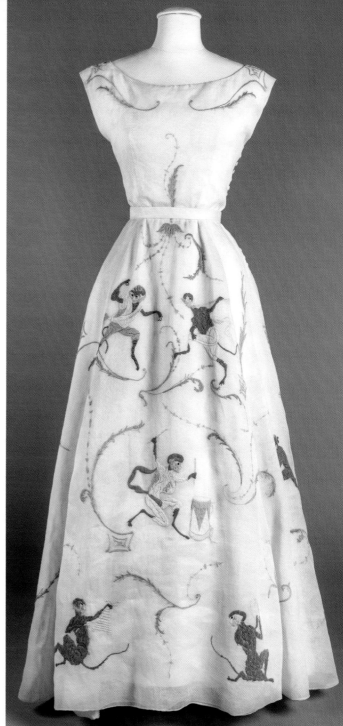

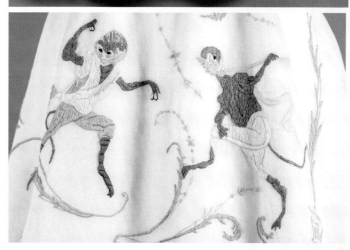

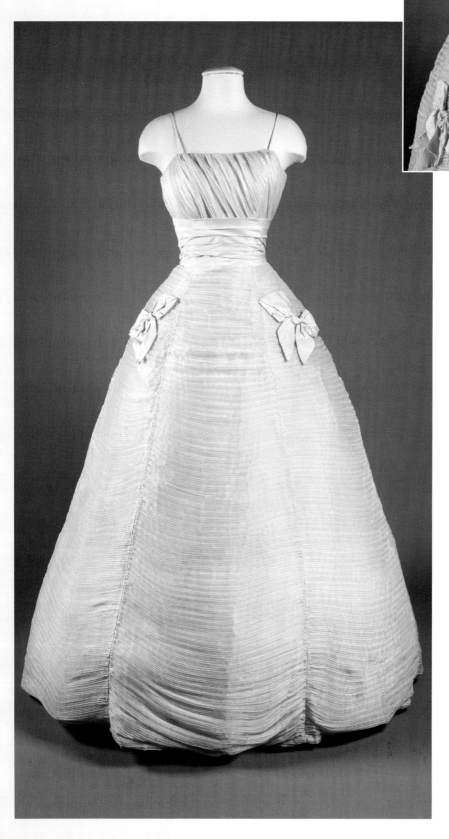

Silk Chiffon Evening Dress

1959
Designed by Mollie Stone, New York
Worn by Mary "Lawrie" Lawrence
Pitcher (b.1941)

Maryland Historical Society, Gift of Mrs.
William H. Pitcher, 1973.53.1

On January 8, 1959, Mary Lawrence Pitcher performed as a New Orleans Maid at the New Orleans Day Ball. For her performance, the fashionable Baltimorean wore this ivory tulle gown by Mollie Stone of New York, who drew direct inspiration from Irish designer Sybil Connolly's evening dress published in a 1954 *Vogue*. Stone's interpretation showcases the phenomenon of haute couture fashions trickling down to ready-to-wear clothing lines seasons later.

This dress is exhibited through the generosity of Mr. and Mrs. Tim Krongard.

Wool Suit with Silk Satin Lapel

1905–1910

Worn by Mary Sophia Knapp (1864–1942)

Maryland Historical Society, Gift of Mr. and Mrs. Gordon
Knapp, 1989.65.1

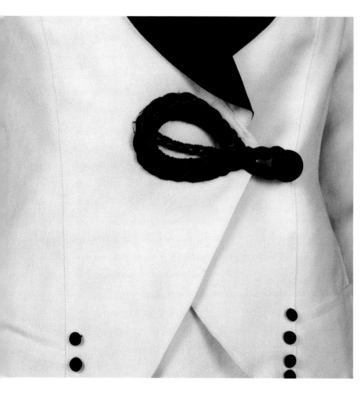

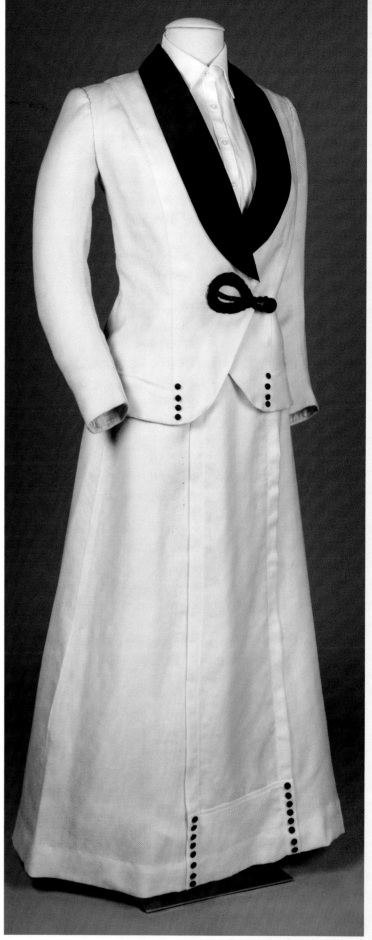

Easily adaptable and simple in design, tailor-made
suits like this one were more practical than the highly
decorated styles of the late 1800s. This suit also shows
a transition from the exaggerated s-bend of the turn
of the century toward a silhouette more conducive
for movement. Tailor-made suits utilized masculine
details, like the contrasting black silk satin shawl collar
on this ivory wool ensemble, which allowed women
to fit into male-dominated offices as more women
entered the workforce.

*This suit is exhibited through the generosity of
H. Clay Braswell, Jr.*

ABOUT THE CONTRIBUTORS

Emily Bach, the Research Assistant for the Fashion Archives at the Maryland Historical Society, is a graduate of Shippensburg University in Shippensburg, Pennsylvania. Prior to her work on this exhibition, she was a summer intern in the Fashion Archives from 2015 to 2018 and a 2018 Historic Deerfield fellow.

Nora Ellen Carleson is a doctoral student at the University of Delaware. Her scholarship explores American fashion and material culture during the Progressive Era and Gilded Age with an emphasis on the creation of a national style and the recovery of forgotten designers. She is a graduate of the Smithsonian/George Mason University and Monmouth College in Monmouth, Illinois.

Alexandra Deutsch, the lead curator of the *Spectrum of Fashion* exhibition, served a decade-long tenure at the Maryland Historical Society, first as Chief Curator and, from 2017 to 2019, as Vice President of Collections and Interpretation. A graduate of Vassar College in Poughkeepsie, New York, and the Winterthur Program at the University of Delaware, she is currently the Director of Museum Engagement at the Winterthur Museum in Winterthur, Delaware.

Dan Goodrich, Imaging Services Technician and Staff Photographer, joined the Maryland Historical Society in 2017. He has been photographing fine and decorative arts full-time since his graduation from the University of Maryland, Baltimore County.

Barbara Meger, a volunteer curatorial assistant at the Maryland Historical Society since 2012, is passionate about history and fashion. An award-winning seamstress and needleartist, she has previously shared her skills as a contributing editor to needlework publications and as a workshop teacher across the country.

Allison Tolman, the Vice President of Collections at the Maryland Historical Society, formerly served as the institution's Registrar and Associate Curator of the Fashion Archives. A graduate of the University of Delaware and of Johns Hopkins University, she was a practicing paintings conservator before beginning her work with museum collections.

Norah Worthington has been the Resident Costumer at the Baltimore School for the Arts (BSA) for the past twenty-six years. In addition to her independent scholarship of period clothing, she has coordinated historical partnerships with BSA and multiple museums for the past 12 years. She is a graduate of Haverford College.

FASHION

Silk Banyan

1780–1789

Worn by Solomon Etting (1764–1847)

Maryland Historical Society, Eleanor S. Cohen Collection, 1918.06.58

Embroidered Silk Wedding Apron

1724

Embroidered and worn by Anne Chew Thomas (1706–1777)

Maryland Historical Society, Gift of Mrs. William Woodyear, 1931.5.1

Silk Brocade Dress

1780–1789

First worn by Elizabeth Woodrop Davey (1726–1782) and later worn by Catherine Davey McKim (1766–1860)

Maryland Historical Society, Gift of Miss Katherine S. Montell, 1943.48.1

Cotton and Wool Challis Dress

1831–1834

Worn by Eliza Eichelberger Ridgely (1803–1867)

Maryland Historical Society, Gift of Mr. John Ridgely, 1944.76.1

Silk Damask Pelisse

1815–1820

Possibly worn by Eliza Eichelberger Ridgely (1803–1867)

Maryland Historical Society, Gift of John Ridgely, 1944.76.24

Wool Livery Cape and Overcoat

1888

Worn by Tom Brown (.28) and Tilghman Davis (.26)

Maryland Historical Society, Gift of John Ridgely, 1944.76.26 & .28

Silk Velvet and Wool Livery

1840–1849

Unknown wearer

Maryland Historical Society, Gift of Miss Constance Petre, 1946.3.3

Linen Summer Suit

1855–1859

Unknown wearer

Maryland Historical Society, Gift of the Misses Dobbin, 1946.44.22 a-c

Silk Velvet, Satin, and Net Evening Gown

1925–1928

Designed by Max Cohen, Inc.

Worn by Doris Cohn

Maryland Historical Society, Gift of Mrs. Herman E. Cohn, 1946.52.21

Silk Satin and Tulle Evening Dress

1915–1919

Probably French

Worn by Ethel Cryder Higgins Fowler (1882–1964)

Maryland Historical Society, Gift of Mrs. Arthur W. Fowler, 1946.56.11

Silk Brocade Evening Dress

1913

Designed by Cauët Sœurs, Paris

Worn by Laura Patterson Swan Robeson (1881–1973)

Maryland Historical Society, Gift of Mrs. Andrew Robeson, 1948.58.2

Silk Chiffon with Glass and Metal Beading Evening Dress

1915

Worn by Amelia Himes Walker (1882–1974)

Maryland Historical Society, Gift of Mrs. Robert Hunt Walker (née Amelia Himes), 1948.89.2

Silk Brocade Waistcoat

1835–1840

Worn by Dr. Charles Jennings Macgill (1806–1881)

Maryland Historical Society, Gift of Miss Louisa M. Gary, 1948.93.1

Silk Damask Dress

Fabric c. 1740, Dress 1838–1840

Worn by Elizabeth Evans Hoogewerff (1803–1888)

Maryland Historical Society, Gift of Mrs. Addison F. Worthington, 1949.4.1

Cotton Muslin Dress

1904–1906

Worn by Helen Rolfe Hopkins Thom (1869–1948)

Maryland Historical Society, Gift of Mrs. Robert Dixon Bartlett, 1950.91.5

Linen Duster Coat

1900–1905

Worn by Sallie Webster Dorsey (1860–1937)

Maryland Historical Society, Gift of Mrs. James Hooper Dorsey, 1951.14.10

Silk Velvet and Satin Dress

1881

French

Worn by Eliza Ridgely (1858–1954)

Maryland Historical Society, Estate of Miss Eliza Ridgely 1956.15.27

Silk Faille Evening Dress

1840s

Probably French

Unknown wearer

Maryland Historical Society, Estate of Miss Eliza Ridgely, 1956.15.30

Watered Silk Visiting Dress

1868–1870

Probably French or English

Worn by Margaretta Sophia Howard Ridgely (1824–1904)

Maryland Historical Society, Estate of Miss Eliza Ridgely, 1956.15.47

Silk Faille Court Waistcoat

1805–1807

Probably English

Worn by William Pinkney (1764–1822)

Maryland Historical Society, Gift of Mrs. Lawrence R. Carton, 1956.75.23

Silk Gauze Evening Dress

1820–1823

Unknown wearer

Maryland Historical Society, Gift of Mrs. Olive Rutter Parks and Miss Mary Alice Rutter, 1956.84.6

Silk Satin, Crêpe, and Pearl Wedding Dress

1883

Designed by Patten of Baltimore

Worn by Judith DeFord Worcester Martins (b.1869)

Maryland Historical Society, Gift of Miss Katherine Martins, 1960.66.1

Silk Dress

1883–1885

Worn by Anna Elizabeth Creckenberger (1861–1931)

Maryland Historical Society, Gift of Mrs. David F. Rife, 1960.78.9

Silk Organdy Embroidered Evening Dress

Spring/Summer 1954

Designed by Hubert de Givenchy (1927–2018)

Worn by Wallis Warfield Simpson, the Duchess of Windsor (1896–1986)

Maryland Historical Society, Gift of Her Grace the Duchess of Windsor, through Mrs. Clarence W. Miles, 1961.85.1

Wool Suit

1890–1899

Maryland Historical Society, Gift of Mr. Paul Edel, 1962.105.1

Silk Crêpe de Chine and Metallic Thread Evening Dress

1925–1929

Worn by Rose Shapira Freedman (1898–1965)

Maryland Historical Society, Gift of Miss Shirley Freedman, 1966.51.2

Silk Satin Brocade Evening Gown

c.1892

Designed by Jean-Philippe Worth (1856–1926)

Worn by Mary Carroll Denison Frick (1865–1937)

Maryland Historical Society, Gift of Mrs. John R. Montgomery, 1968.78.4

Wool Printed Challis Dress

1845–1850

Worn by Mary Elizabeth Dorsey Farnandis (1795–1888)

Maryland Historical Society, Gift of Mrs. H. Irvine Keyser, 1969.26.1

Silk Brocade Evening Dress

1940–1945

Worn by Jeannette Eareckson Straus (1898–1969)

Maryland Historical Society, Bequest of Mrs. Henry L. Straus through her sister Mrs. C. Herbert Baxley (Leila Eareckson), 1969.78.1

Silk Moiré and Silk Satin Dress

1899–1902

Designed and made by Lottie Barton (1852–1902)

Worn by Mary "Mollie" Cromwell Riggs (1866–1937)

Maryland Historical Society, Gift of Mrs. Richard C. Riggs, 1969.122.7

Velvet Evening Dress

Winter 1911

Designed by Jeanne Paquin (1869–1936)

Worn by Mrs. Alice Lee Thomas Stevenson (1884–1972)

Maryland Historical Society, The Estate of Mrs. Alice Lee Thomas Stevenson, 1972.81.10

Shot Silk Taffeta Dress

1869–1871

Worn by Anne "Annie" Campbell Gordon Thomas (1819–1886)

Maryland Historical Society, The Estate of Mrs. Alice Lee Thomas Stevenson, 1972.81.14 a-d

Silk Satin and Silk Chiffon Evening Dress

1911

Made by Fuechsl, Baltimore

Worn by Alice Thomas Stevenson (1884–1972)

Maryland Historical Society, The Estate of Mrs. Alice Lee Thomas Stevenson, 1972.81.54

Crêpe Silk and Sequined Evening Dress

1935–1939

Worn by Muriel Wurts-Dundas Boone (1906–1970)

Maryland Historical Society, Gift of Mr. James R. Herbert Boone, 1973.48.1 a-c

Rayon Crêpe Evening Dress and Jacket Ensemble

1937–1939

Designed by Ventura, Rome

Worn by Muriel Wurts-Dundas Boone (1906–1970)

Maryland Historical Society, Gift of Mr. James R. Herbert Boone, 1973.48.2

Rayon Crêpe Evening Dress & Jacket Ensemble

1937–1939

Designed by Ventura, Rome

Worn by Muriel Wurts-Dundas Boone (1906–1970)

Maryland Historical Society, Gift of Mr. James R. Herbert Boone, 1973.48.11

Silk Faille Court Coat

1800–1803

Probably French

Unknown wearer

Maryland Historical Society, Gift of Mr. James R. Herbert Boone, 1973.48.12

Silk Chiffon Evening Dress

1959

Designed by Mollie Stone, New York

Worn by Mary "Lawrie" Lawrence Pitcher (1941–)

Maryland Historical Society, Gift of Mrs. William H. Pitcher, 1973.53.1

Silk Satin and Silk Velvet Evening Dress

1922–1925

Likely made in France

Worn by Amelia Prescott Allison (1899–1989)

Maryland Historical Society, Gift of Mrs. Campbell Lloyd Stirling, 1974.14.2

Silk Satin and Net with Metallic Embroidery Evening Dress

1900–1905

Designed by Jacques Doucet (1859–1929)

Worn by Eliza Waller Beale Wilson (1853–1933)

Maryland Historical Society, Gift of Mrs. William S. Hilles, 1974.62.9

B&O Railroad Uniform

1941–1974

Worn by John L. Heavner (1910–1974)

Maryland Historical Society, Gift of Mrs. John L. Heavner, 1974.94.1

World War II American Red Cross Motor Service Uniform

1942–1944

Worn by Virginia Newcomer (1900–1982)

Maryland Historical Society, Gift of Mrs. Frank Newcomer, 1976.54.1

Printed Velvet and Fur-Trimmed Cocoon Coat

1925–1929

Probably French

Worn by Gretchen Hochschild Hutzler (1888–1977)

Maryland Historical Society, Gift of Mrs. Albert D. Hutzler, 1977.12.1

Wool Dress

1948

Designed by Claire McCardell

Worn by Claire McCardell (1905–1958)

Maryland Historical Society, Gift of Mr. and Mrs. Adrian McCardell, 1977.68.5

Polyester Knit Pantsuit

1969–1970

Designed by Max "Mr. Dino" Cohen (active in the 1960s and 1970s)

Worn by Mary Curtin Sadtler (1930–1989)

Maryland Historical Society, Gift of Mrs. William C. Sadtler, 1978.48.13 a-c

Silk and Velvet Dress

1895

E. Craig, Importer

Worn by Mrs. Elizabeth Vickers Anderson (1868–1930)

Maryland Historical Society, Gift of Mrs. Kent Groff, 1978.95.63 a-b

Silk Taffeta Dress

1845–1850

Unknown wearer

Maryland Historical Society, Gift of Miss Doris L. Kramer through Mrs. Charles Klepper, 1978.107.15

Velvet and Silk Embroidered Evening Coat

Possibly 1891–1892, altered 1909–1911

Worn by First Lady Frances Folsom Cleveland (1864–1947)

Maryland Historical Society, Gift of George M. Cleveland, 1978.111.3

Sequined Evening Dress

1928–1929

Made in France

Worn by Carolyn Fuld Hutzler (1909–1996)

Maryland Historical Society, Gift of Mrs. Joel G. D. Hutzler, 1979.15.1

Silk Kimono and Silk Pajama Set

1934–1936

Worn by Albert H. Cousins, Jr. (1907–1998)

Maryland Historical Society, Gift of Mr. Albert Cousins, 1979.85.2-3

Twilled Cotton Cycling Suit

1890–1899

Worn by George Franklin Frock

Maryland Historical Society, Gift of Mrs. Albert W. Rhine, 1980.26.1 a-b

Silk Dress

1950–1952

Hutzler's Dress Salon

Worn by Amelia Prescott Allison Stirling (1899–1989)

Maryland Historical Society, Gift of Mrs. Campbell Lloyd Stirling, 1984.27.3

Silk Gauze Embroidered Dress

1868–1870

Possibly worn by Mary Garrettson Evans (1841–1918)

Maryland Historical Society, Gift of the Scott Family of Western Run Valley, Baltimore County, 1984.57.1-2

Wool Suit with Silk Satin Lapels

1905–1910

Worn by Mary Sophia Knapp (1864–1942)

Maryland Historical Society, Gift of Mr. and Mrs. Gordon Knapp, 1989.65.1

Silk and Linen Crop Top, Skirt, and Shorts

1969–1970

Designed by Madame Grés (1903–1993)

Worn by Wallis Warfield Simpson, the Duchess of Windsor (1896–1986)

Maryland Historical Society, Gift from the Stiles Ewing Tuttle Memorial Trust and Stiles T. Colwill in memory of Eugenia Calvert Holland, 1998.4.24

Wool Suit

1942–1945

Made by Metzel, New York, and H. Harris, New York

Worn by Edward VIII, the Duke of Windsor (1894–1972)

Maryland Historical Society, Gift from the Stiles Ewing Tuttle Memorial Trust and Stiles Tuttle Colwill given in memory of Eugenia Calvert Holland, 1998.4.26

Printed Cotton and Wool Knit Dress

1955

Designed by Claire McCardell (1905–1958)

Worn by Natalie Mendeloff

Maryland Historical Society, Gift of Natalie Mendeloff, 1998.19 a & b

Silk Faille Evening Dress

1940

Designed by Claire McCardell

Worn by Claire McCardell (1905–1958)

Maryland Historical Society, Gift of Robert McCardell, 1998.43.27

Embroidered Silk Taffeta Dress

1789

Worn by Sally Adams Hollingsworth (1761–1830)

Maryland Historical Society, The Anne Cheston Murray Collection from Ivy Neck, Cumberstone, Maryland, 2004.39.21

Silk Satin Robe à la Polonaise

1780–1785

Unknown wearer

Maryland Historical Society, The Anne Cheston Murray Collection from Ivy Neck, Cumberstone, Maryland, 2004.39.30

Wool United States Army Hospital Corps Uniform

1942–1945

Made by Carey, Baltimore

Worn by William Donald Schaefer (1921–2011)

Maryland Historical Society, Gift of the Estate of William Donald Schaefer, 2012.35.1

Cotton Dress

1950–1957

Worn and Made by Adina Mae Via Robinson (1937–1966)

Maryland Historical Society, Gift of Franklin A. Robinson, Jr., 2015.18.2

Wool Suit

1960s

Worn by Helen Delich Bentley (1923–2016)

Maryland Historical Society, Gift of Mrs. Helen D. Bentley, 2015.20.1

Cotton Dress

1970

Worn by Nancy Lee Kimmel (1948–1976)

Maryland Historical Society, Gift of Mr. Ross Kimmel 2016.6.3

Silk Chiffon and Velvet Dress

1920s

Worn by Mary George White Bates (1885–1963)

Maryland Historical Society, Gift of the Frances B. Wells Estate, 2016.11.2

Silk Chiffon and Silk Faille Dress

1910–1919

Worn by Mary George White Bates (1885–1963)

Designed by Liberty & Co of London

Maryland Historical Society, Gift of the Frances B. Wells Estate, 2016.11.4

Silk Chiffon and Silk Satin Dress

1915–1919

Worn by Mary George White Bates (1885–1963)

Maryland Historical Society, Gift of the Frances B. Wells Estate, 2016.11.11

Silk Minidress

1965–1969

Designed by Pierre Cardin, Paris

Worn by Barbara P. Katz

Maryland Historical Society, Gift of Mrs. Barbara P. Katz, 2017.5.6

Wool Crêpe Maxidress

1969–1970

Designed by Geoffrey Beene (1927–2004)

Worn by Barbara P. Katz (1933–)

Maryland Historical Society, Gift of Mrs. Barbara P. Katz, 2017.5.8

Silk Chiffon and Lamé Evening Dress

1922–1926

Worn by Mrs. Marion Booz Galleher (1898–1992)

Maryland Historical Society, Gift of Dr. Earl P. Galleher, Jr., 2017.23.1

Silk Skirt and Jacket Ensemble

c.1980

Made by Hermès

Worn by Gertrude Louise Poe (1915–2017)

Maryland Historical Society, Gift from the Estate of Gertrude L. Poe, 2018.2.26

Silk Beaded Evening Dress

1980s

Designed by Judith Ann Creations

Worn by Gertrude Louise Poe (1915–2017)

Maryland Historical Society, Gift from the Estate of Gertrude L. Poe, 2018.2.34

Polyester Dupioni Silk Dress

1987–1989

Designed by Maggie Shepherd

Worn by Barbara Meger (1949–)

Maryland Historical Society, Gift of Barbara Meger, 2018.11.2

Silk Brocade Evening Dress

1868–1870

Worn by Mary Johnson Morris (1822–1915)

Maryland Historical Society, Gift of Sylvia Wallis, 2019.6.1

Silk Crêpe Evening Dress

2009

American

Designed by Bishme Cromartie

Maryland Historical Society Collection, 2019.11.1

Silk Evening Dress

2018

Designed by Christian Siriano

Unknown wearer

Maryland Historical Society, 2019.12

Cotton Muslin and Silver Dress

1812–1815

Worn by Frances Billopp Wyatt (1796–1863)

Maryland Historical Society, Bequest of J. B. Noel Wyatt, xx.1.53

Silk Crêpe Waistcoat

1855–1859

Worn by George Coale (1819–1887)

Maryland Historical Society, The Redwood Collection, Gift of Mrs. Francis Tazewell Redwood, xx.4.30

Cotton Muslin Dress

1805–1810

Worn by Elizabeth Patterson Bonaparte (1785–1879)

Maryland Historical Society, Gift of Mrs. Charles J. Bonaparte, XX.5.150

ACCESSORIES

Cane

Bohemia Manor, Cecil County, Maryland

c.1785–1878

Hackberry branches, antler

Maryland Historical Society, Gift of George Johnston of Elkton, Cecil Co., 1878.2.1

Shoe Buckles

Owned by Colonel Edward Lloyd (1779–1834)

c.1800

Maryland Historical Society, Gift of Miss Mary Howard Lloyd, 1948.38.1 a,b

Pocket Watch

Unknown maker

Owned by Charles Carroll of Carrollton (1737–1832)

c.1800

Gold, enamel, glass

Maryland Historical Society, Gift of Mrs. Edmund R. Purves, 1982.39.1

Sunglasses

Designed by Claire McCardell

c.1950–1957

Maryland Historical Society, Gift of Robert McCardell, 1998.43.11

Sunglasses

Designed by Claire McCardell

c.1950–1957

Maryland Historical Society, Gift of Robert McCardell, 1998.43.12

Pocket Watch

George W. Webb and Co., Baltimore

c.1880

Rose gold, glass, metal

Maryland Historical Society, Gift of David B. Brewster, 2012.34

Beaded Necklace

Unknown maker

Glass beads, thread, metal

Maryland Historical Society, Gift of Mrs. Francis Tazewell Redwood, xx.4.37d

Brooch

Unknown maker

Early 1800s

Gold, onyx, glass

Maryland Historical Society, Gift of Mrs. Charles J. Bonaparte, xx.5.339

PAINTINGS

Thomas Bordley (1682–1726)

Gustavus Hesselius (1682–1755)

c.1720–1726

Oil on canvas

Maryland Historical Society, Bequest of Frank M. Etting, 1891.2.1

Mrs. John Tayloe III (1772–1855) and Daughters

Bouché (Working: 1794–1800)

1799

Oil on canvas

Maryland Historical Society, Gift of Mrs. Thomas C. Jenkins in memory of Mrs. George C. Jenkins, 1952.15.7

Mrs. Robert H. Stevenson (Alice Lee Thomas) (1883–1972)

Alfred Partridge Klots (1875–1939)

1911

Oil on canvas

Maryland Historical Society, Gift of the Estate of Mrs. Alice Lee Thomas Stevenson, 1972.81.7

Gerda Erwine Fischer (1893–1977)

Carl Bersch (1834–1914)

c.1900

Oil on canvas

Maryland Historical Society, Gift of the Estate of Gerda Erwine Fischer Vey, 1977.27.7

Woman in a Gold Turban

Alfred Partridge Klots (1875–1939)

c.1910–1920

Oil on canvas

Maryland Historical Society, Gift of Mrs. Trafford Partridge Klots, 1979.1.2

Perry Hall from the East

Francis Guy (1760–1820)

c.1805

Oil on canvas

Maryland Historical Society, Dr. Michael and Marie Abrams Memorial Purchase Fund, 1981.3.1

Catherine Cave Diffenderffer (1799–1875)

Jacob Eichholtz (1776–1842)

c.1833

Oil on canvas

Maryland Historical Society, Bequest of Mrs. Grace D. Warfield in memory of Charles M. Diffenderffer, 1988.42.2

Margaret Ann Buck Porter (Mrs. Robert Porter) (1810–1881)

Unknown artist

c.1840–1845

Oil on canvas

Maryland Historical Society, Gift of Page Reid Haizlip and Kenneth Clayton Watson, Jr. from the estate of their mother Virginia Porter Engalitcheff and John Engalitcheff, Jr., 1990.39.2

Saraband #16

Keith Morrow Martin (1911–1983)

1979

Oil on canvas

Maryland Historical Society, Baltimore City Life Collection, Gift of Mr. David McIntyre, BCLM-1990.49.56

George Washington (1732–1799)

Unknown artist

c.1850

Oil on canvas

Maryland Historical Society, Baltimore City Life Museum Collection, Donated in memory of Dr. Michael A. Abrams by Dr. and Mrs. Robert C. Abrams, BCLM-MA.8875 (1975.33)

WORKS ON PAPER

Baltimore in 1752
John Moale, Jr. (1731–1798)
1752
Watercolor on paper
Maryland Historical Society, Gift of Samuel Moale, 1845.1.1

Have you really tried to save gas by getting into a car club?
U.S. Government Printing Office
1944
Ink on paper
Maryland Historical Society, H. Furlong Baldwin Library, Poster Collection

Cream, Baltimore Civic Center, November 3, 1968
Unknown artist
1968
Ink on Paper
Maryland Historical Society, H. Furlong Baldwin Library, Poster Collection

OBJECTS

Presentation Sword
United States Navy
c.1835
Maryland Historical Society, Gift of Miss M. Trippe Kennedy, 1886.4.1 a-b

Sugar Bowl
Charles Louis Boehme (1774–1868)
c.1792
Silver
Maryland Historical Society, Gift of Eleanor S. Cohen, 1938.7.21

Coffeepot
John Walraven (1771–1814)
c.1792
Silver
Maryland Historical Society, Gift of Eleanor S. Cohen, 1938.7.18

Teapot
John Walraven (1771–1814)
c.1792
Silver
Maryland Historical Society, Gift of Eleanor S. Cohen, 1938.7.19

Card Table
Attributed to John and Hugh Finlay (Working: 1799–1840)
c.1800–1820
White pine, poplar, oak
Maryland Historical Society, Gift of Katherine Riggs Poole and Martha Sprigg Poole, 1972.53.1

Side Chair
Unknown maker, possibly Baltimore
c.1840–1870
Maryland Historical Society, Gift of John J. Clark, 1978.103.4 b

Crazy Quilt
Kate Henry Lloyd (1848–1937)
c.1880
Silk, velvet, cotton
Maryland Historical Society, Gift of Mrs. E. DeWitt Battams, 1979.32.1

Two-Handled Cup
Robert Peake, and later Aiken
1702–1703
Silver
Maryland Historical Society, Gift of Mrs. C. Gordon Pitt, 1981.80.3

"Manhattan" Cocktail Shaker

Designed by Norman Bell Geddes (1893–1958)

Revere Copper & Brass Company, Rome, NY

c.1930–1940

Silver

Maryland Historical Society, Gift of Mrs. Edward Blind, 1987.134.1.2

Cocktail Glasses

E. & J. Bass, New York (1890–1930)

c.1920–1930

Silver plated

Maryland Historical Society, Gift of Richard Goodman, 1992.7.1

Bannister Back Armchair

Unknown maker

c.1710–1740

Maryland Historical Society, Gift of David McKinnie, 1992.16.1

Side Chair

Unknown maker, Baltimore

c.1880

Maryland Historical Society, Bequest of Miss Mary Ringgold Trippe, 1997.9

Radio

Atwater Kent Manufacturing Company

Philadelphia, PA

1931

Maryland Historical Society, Baltimore City Life Museum Collection, Bequest of Mr. Richard Steiner, BCLM-1990.15.60.1

Goblet

John Frederick Amelung (Working: 1784–1791)

New Bremen Glass Manufactory, New Bremen, MD

c.1790

Maryland Historical Society, Dep 337

Goblet

Unknown maker

c.1936

Glass

Collection of Mark B. Letzer, L2019.4.1

Teapot

Samuel Kirk (1793–1872)

c.1835

Owned by John Ridgely (1790–1867)

Silver

Collection of Mark B. Letzer, L2019.4.2

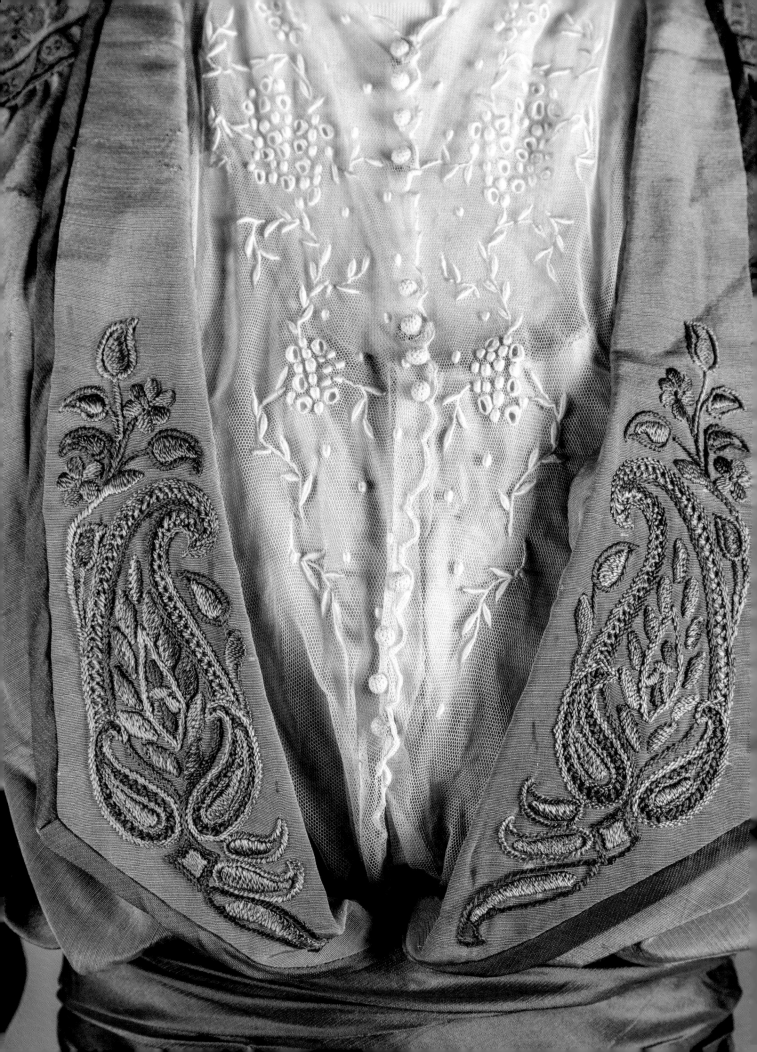

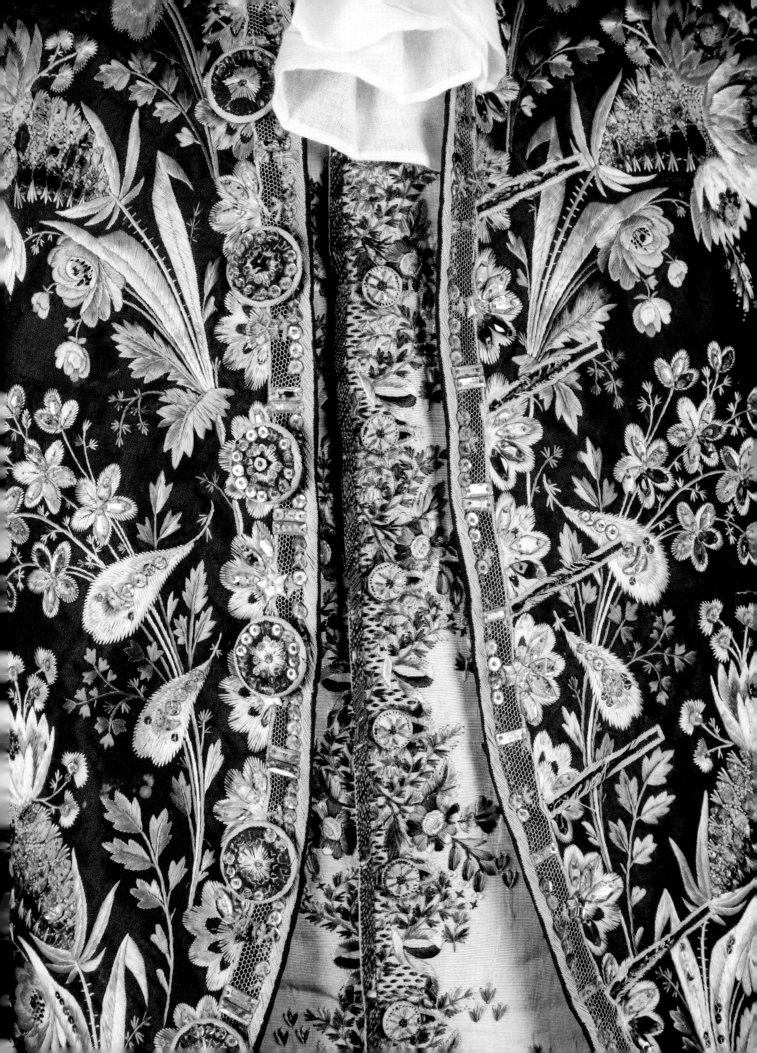